ZONES OF CONTENTION

SUNY Series,
INTERRUPTIONS: Border Testimony(ies) and Critical Discourse/s

Henry A. Giroux, editor

ZONES OF CONTENTION

*Essays on Art, Institutions,
Gender, and Anxiety*

Carol Becker

State University of New York Press

Published by
State University of New York Press, Albany

©1996 Carol Becker, Ph.D.

For information, address State University of New York Press,
State University Plaza, Albany, NY 12246

Production by Christine Lynch
Marketing by Fran Keneston

Library of Congress Cataloging-in-Publication Data

Becker, Carol.
 Zones of contention : essays on art, institutions, gender, and
anxiety / Carol Becker.
 p. cm. — (SUNY series, Interruptions — Border
testimony(ies) and Critical Discourse/s)
 Includes index.
 ISBN 0–7914–2937–7 (cloth). — ISBN 0–7914–2938–5 (pbk.)
 1. Art and society — United States — History —20th century
 2. Artists and community — United States. 3. Sex role in art.
 4. Creation (Literary, artistic, etc.) I. Title. II. Series.
 N72.S6B383 1996
 701'.03'0973—dc20 95-32373
 CIP

10 9 8 7 6 5 4 3

For Laurette

CONTENTS

PART IV: GENDER AND CREATIVITY

FOREWORD:
CONTENDING ZONES
AND PUBLIC SPACES

HENRY A. GIROUX

The elusive relationship between politics and art has generated endless debates among artists and cultural critics about the role of art and the responsibility of artists. In many ways these debates have attempted to provide a new integrative language for reconstituting the space of the artist as a public intellectual. Seizing upon the role that art might play as part of a broader oppositional strategy of engagement, cultural critics have attempted to create a new language through which people can understand and produce culture within democratic and shared structures and spaces of power. Rejecting the well-policed distinctions that pit form against content, beauty against politics, and subjective experience against objective representations, cultural critics and critical artists have endeavored in different ways to break down the rigid boundaries between official and popular culture, privileged sites of display and those sites of learning that encompass daily experiences.

Refiguring the role of the artist as a public intellectual does more than recover the responsibility of the artist as a social critic, it also illuminates the complexity of politics and the centrality of the politics of difference to any substantive notion of democracy. Within this reconstituted recognition of difference, audiences become more diverse, sites of learning expand and become multiple, identities overlap and become porous, and the notion of the public enlarges while becoming more invigorated.[1]

While the concept of the public intellectual has a long history in the United States, it has often been reduced to the achievements of a small group of New York intellectuals located in fashionable critical literary magazines. As the bohemian romantic aura of the public intellectual

has receded, the concept of the public intellectual has been recon-
structed around various progressive critics housed in the academy writ-
ing on popular subjects for broader popular audiences. Safely elitist and
insular, the notion of the public intellectual seems to be an oxymoron
waiting to discover the contradictory tension between its public func-
tion and its institutional insularity.

More recently, a number of artists and cultural critics outside the
university have sought to redefine the artist as a public intellectual. This
is particularly evident in the work of a number of feminist artists and
critics such as Barbara Kruger, Arlene Raven, and Jenny Holzer. It is also
evident in what has been called the "new genre public art," visible in the
work of such artists as Jim Hubbard, Guillermo Gómez-Peña, Suzanne
Lacy, Olivia Gude, Rick Bolton, and others. What is so remarkable
about the work of these artists and cultural critics is their willingness to
cross borders, invent new forms of representation, and at the same time
interrogate the quality of social life by addressing the language of sexu-
ality, social exclusion, identity, and power while avoiding a doctrinaire
politics or narrow critique of the sites in which art is produced. Com-
mitted to a vision of art that encourages participatory democracy, new
genre public artists emphasize public art that privileges community
involvement rather than the traditional emphasis on individual author-
ship.[2] Refusing to take honored places in either the academic disciplines
or the museum, many of these artists and critics do not isolate them-
selves from the larger society, from the stories, experiences, and histo-
ries of those others who inhabit less privileged spaces and sites of learn-
ing while struggling to survive.

What is so remarkable about Carol Becker's book, *Zones of Conten-
tion,* is that it imaginatively rewrites the role of the artist as a public
intellectual. In this instance, Becker appropriates critically a number of
theoretical traditions about the meaning and significance of art and
public life, but in doing so she reinvigorates these discourses and creates
something new and more vital than the traditions she interrogates.
Consequently, the reader is introduced to a wide-ranging work in
which Becker addresses the meaning of art as a complex form of cul-
tural production through which theory, skill, imagination, and com-
mitment serve to engage the past while simultaneously demanding
forms of self- and social-representation that merge art, politics, and
morality. Writing from a variety of disciplines and sites, Becker does
more than comment on and assert the necessity for engaging the social
responsibility of the artist; she redefines such a responsibility within a

broader political project that takes radical democracy and transformative pedagogy as its defining principles. Whether writing about "such problems as the place of the artist in society, the education of artists, the importance of art and art making, the need to see art within an historical context, [or] the urgency of arts institutions to diversify and to establish strong ties with their larger communities," Becker always makes the pedagogical primary both to possibility and to what I would call the "language of critique." Pedagogy in this sense refers to the complicated processes by which knowledge is produced, skills are learned meaningfully, identities are shaped, desires are mobilized, and critical dialogue becomes a central form of public interaction. For Becker, understanding the complexity of the art process and its relationship with multiple publics is, in part, a pedagogical process that serves to deepen our understanding of how identities are formed, artworks produced, and responsibilities engaged so as to enable or close down the possibilities of democratic public life.

Zones of Contention demonstrates how art and cultural criticism serve as pedagogical practices registering, in part, the conditions that address the complicated task of getting artists, cultural workers, students, and diverse public audiences to cultivate the capacity for critical judgment, link imagination to resistance, and embrace the indeterminate, disorienting power of art as a precondition for engaging the unrepresentable in the ongoing construction of a democratic society. By linking the imaginative power of art to the pedagogy of power and representation, Becker makes clear her own desire for a borderline art that registers its transformative power through its obligation to make a difference in the world rather than to simply reflect it. This is not an art for consumers or free market enthusiasts, but art that collapses the boundaries between politics and aesthetics, formalism and pedagogy, the national and transcultural in order to rewrite the mutually related discourses of commitment, desire, and representation as an act of public vigilance and strategy of social engagement.

A moving and engaged writer, Becker demonstrates what a public intellectual is, not only through the vision of democratic struggle that informs her project, but also through the range of issues she addresses in a clear and compelling language. Moreover, she conveys vividly in each of her chapters a warmth, empathy, and compassion that collapses the boundaries between the personal and the public and in doing so creates a work that is vivid, passionate, and filled with hope.

Notes

1. For a succinct but incisive essay on the relationship among art, democracy, and pedagogy, see Richard Bolton, "How Can Art Become Relevant Again?" *Sculpture* (May–June 1995), pp. 22–23.

2. Examples of such work can be found in Carol Becker, ed., *The Subversive Imagination: Artists, Society, and Social Responsibility* (New York: Routledge, 1994); Mary Jane Jacob, Michael Brenson, and Eva M. Olson, eds., *Culture in Action: A Public Art Program of Sculpture in Chicago* (Seattle: Bay Press, 1995); Suzanne Lacy, *Mapping the Terrain: New Genre Public Art* (Seattle: Bay Press, 1995); Olivia Gude, "Beyond Monological Monuments," *Public Art Review* (Spring/Summer 1995), pp. 32–33.

ACKNOWLEDGMENTS

When finishing a book it always becomes apparent that there are people without whom the project would never have come into being or have reached completion. In this case there was, first, Henry Giroux. He gave me the original idea to publish a selection of my essays and then offered the opportunity by including this text in his series for State University of New York Press. His belief in my work, his loyalty, and his generosity have encouraged me from our first encounter. Jean Fulton did the major edits of these essays, kept the book and me on track and on schedule, while being insightful and considerate at every stage. I could not have finished this book on time without her. My agent, Jane Jordan Browne, worked hard and long on my behalf. Laurie Palmer came in at the end with editorial assistance, allowing us to meet our deadline. And Priscilla Ross at State University of New York Press believed in this book and made sure it achieved its best possible incarnation. I must also thank my good-tempered assistant Laura Mosquera for continually staving off the potential chaos.

My friends in Chicago, as always, inspired my own creative efforts with their fascinating lives and the quality of their work. I would like to thank Alda Blanco, Andries Botha, Susanna Coffey, Gale Graubart-Roman, Ronne Hartfield, Kathryn Sapoznick, Lin Hixson, Matthew Goulish, Jacobo Konigsberg, Claudia Vera, Roberta Lynch, Frank Orrall, Robyn Orlin, Judy Raphael, Carole Warshaw, and Jack Murchie. I especially want to thank Brigid Murphy. She has strengthened me with her amazing resilience and the largeness of her spirit.

I am also grateful to my friends in La Jolla. Herb and Anita Schiller challenged me in conversation, made me laugh, invited me to dinner, and walked with me by the sea. Don Wayne read several parts of the manuscript, offering his tempered, honest, and sound advice. Iris and Carlos Blanco lent me their wonderful house so that I could escape the inner-city summer and finish this book in solitude.

And finally it is to Laurette Hupman, my former editor and dear, dear friend, that this text is dedicated.

INTRODUCTION

*For the critic must attempt to fully realize, and take
responsibility for, the unspoken, unrepresented,
pasts that haunt the historial moment.*

—Homi Bhabha[1]

I grew up in Crown Heights, Brooklyn, for me the original zone of con-
tention, where the conflict between Hasidic Jews and blacks was well
under way in the 1950s.

It was there after World War II, in a neighborhood comprised of
many camp survivors, that as a half-Polish-Catholic, half-Russian-Jew-
ish child I developed a healthy sense of what it meant to have a com-
plex identity and to be, at that moment in history, a radical mix. I suf-
fered my own contradictions there, as well as those that comprised the
world of which my own hybridity was only a small part. Because I lived
among Jews—Hasidic, Orthodox, and Reformed—and thought of
myself as a Jew, but was not allowed to call myself a Jew according to
Jewish law, and because I did not consider myself Catholic (although
half my family was Catholic), and because my friends were both Jewish
and black (although my family was wary of blacks), I was thrown into
what I later learned to call the construction of race. As a result, I soon
grasped how conflictual American society could be, how easily cultures
could collide, and how little interest, understanding, or compassion
can exist for that which is Other.

Because my own identity was itself the site of a problem, I learned
early on the value of problematizing situations and plundering their
complexity for its richness. I also learned how to move through many
worlds, to recognize their sameness and difference, and to realize that
groups often find their own experience and ideology absolute and, in
wanting to keep it so, become dogmatic and blind to the perspectives
and needs of others. But perhaps most important, it was on these
streets, in the midst of what often felt like—and has since proven itself

to be—life-threatening conflict, that I became committed to analysis, to the act of serious reflection which, as Susan Sontag says of Syberberg's films, "takes up where reality leaves off."[2]

The social tensions I lived and did not understand were never actually explained to me at that early age. Although the adult world offered their simplistic representations of "the problem," these often led them to adopt racist sentiments I did not share. Issues of difference—the actual sources of conflict—were not made explicit. It was only later, through my early study of history, literature, and art, that I saw this multilayered experience accurately portrayed and contextualized. Only after discovering James Baldwin and Isaac Bashevis Singer almost at the same time was the discordant reality of the lives of those blacks and Jews who surrounded me lucidly revealed. That reality came alive in all its dimensionality through their novels, stories, and essays.

Perhaps this is why I decided quite early on to study literature, to be trained as a literary critic. I desperately wanted to be "educated," primarily because I believed that it was through a solid grasp of the past that one's understanding of the present would become large enough to imagine a more progressive future. I also wanted to learn to interpret language, metaphor, analogy, imagery, perspective, point of view, and motivation in order to understand how the many voices of society either emerge or are squelched within what is called a nation's literature. As my interests evolved and my desire to study cultural phenomena grew, I became committed also to functioning as a culture critic, trying to analyze the collective psyche from the center when possible and more often from the margins, to stand both as part of it and outside of it, to take its pulse, to utilize any tools, any systems of thought that would enable me to get closer to the realities I was trying to understand.

In my efforts not to be an ideological or academic purist—to have been so would have challenged my own dual identity—I allowed myself to function in different roles when necessary—as an anthropologist, for example—interested in how cultural phenomena evolve, what they tell us about how we construct our world, about the terms through which we understand our situation, and how all of what we do is determined by and determines history—the agreed-upon, and more often disputed, collective narrative.

These various systems of thought helped me to measure the health of society—to diagnose its dis-ease—which illuminated my interest in issues surrounding race, class, gender, and, in particular, my five-year absorption with the conflicts of contemporary women as manifested in

the experience of anxiety. This inquiry led to my first book, *The Invisible Drama: Women and the Anxiety of Change.*

There I sought to find a methodology—an approach to the problem reflected in the symptom of anxiety that would allow me to be theoretical as well as accessible. Because the issue of women and anxiety had too often been posited in pop-psychology/self-help discourse, I wanted to create a serious framework that located the issues within society and not solely in the individual. Anxiety, I had come to believe, was a social phenomenon camouflaged as an individual problem. I also wanted to take what was useful from feminist studies, literature, psychology, philosophy, art, sociology, history, anthropology, cultural studies—all those systems of thought that could help to articulate a resolution—and translate these ideas into an accessible form without losing their complexity.

With this first book I set myself the goal of becoming a public intellectual—writing outside the confines of the Academy. I had a large audience of women in mind and hoped the issues would cut across race, class, and age. And in this sense the strategies of the book were successful. I appeared on many radio and television talk shows (often following such pressing concerns as "Rising Hemlines for the Fall") and struggled to keep the integrity of my analysis while translating the issues into the language of popular media. And then, through the book's many foreign editions, the ideas extended to an even larger international audience than I had ever anticipated. This process was fascinating and I wanted to continue to work at placing complex ideas within mass culture to learn how far one could affect popular thinking while still maintaining a theoretical framework.

During this time I had already begun teaching at the School of the Art Institute of Chicago. There in the art-school, art-making context, I found the perfect home—a studio/academic institution where no one discourse, methodology, or point of view prevailed, and where productivity, instead of being judged by some external and quantitative academic standard, was measured by how well one pursued one's own creative development as an artist or a writer/intellectual. Form was as important as content, often more so, and experimentation was encouraged and applauded. This environment legitimized my own interest in the integration of form and content and changed forever how I positioned myself and my writing in the world.

It was there that I first began seriously writing about art. Because I was now close to the art-making process, I often found myself asked by

my artist colleagues and associates to write about their work. The challenge of utilizing the tools I had developed to understand literature in examining the contemporary art world became an engaging possibility, raising for me difficult questions about the relationship between text and image and the responsibility of the critical voice to the artwork it sought to unravel. These resultant chapters comprise part 3 of this volume, "Writing on Art." They are focused on those ideas that are central to the artists' intent—the relationship of women to their bodies, the spiritual to art, and the historical moment to the individual; the tensions between form and content—as well as the success of these artistic efforts to tackle such difficult issues in two, three, and four dimensions. I have had the privilege of knowing the process of many of these artists quite intimately, and in each instance I have positioned their work within the history of ideas rather than within the history of art. My own writing on art is therefore less art criticism than it is a reflection of the contemporary concerns of creative people as manifested in art.

As I became acquainted with the art making of those around me and increasingly involved in the workings of the school, the issues I focused on in my writing began to change. I found myself concerned with such problems as the place of the artist in society, the education of artists, the importance of art and art making, the need to see art within an historical context, the urgency for arts institutions to diversify and to establish strong ties with their larger communities. I began to see the relationship between my writing and my work as an administrator as that between theory and praxis. My continuing attempt to refine theory as I learn from the environment in which I work is matched by my ongoing efforts to engage with an administrative team of faculty, staff, and an ever-changing but always daring student body to perfect the institution and its relationship to society as new ideas about art making and pedagogy come into existence. The chapters that resulted from these concerns comprise part 2, "The Education of Artists."

Although I never consciously set out to construct these relationships between parts of my own identity, they became more and more apparent and significant to me as we at the School of the Art Institute of Chicago were embroiled in contentious art-related political conflicts whose immediate resolutions demanded theoretical debate and strategic planning. Watching my own institution struggle with these questions, observing students confronting serious conflicts around censorship and race (as analyzed in part 1, "Art in Society"), helped me to clarify what educational goals were still unmet. Learning from artists

how they felt about the pressures that have been brought upon them also enabled me to evaluate what must change in American society if art is to achieve its potential value as a social force. At times I have been confounded by the degree to which artists as well as intellectuals remain on the peripheries of society, unwilling to jump into its center, but I am also critical and increasingly aware of the social structures that keep artists in these marginal positions while discounting and deliberately distorting the meaning of their efforts when they do engage with society.

In the same vein, the chapters on women and institutions (part 4, "Gender and Creativity") also have resulted from observing myself and other women in our various attempts to reach an appropriate professional level. I have been working in hierarchically structured institutions my entire adult life and I am fascinated by the social dynamics that are created by these organizational structures, especially those between men and women. My time in administrative roles has allowed me to observe that although it has been more than twenty-five years since the resurgence of the women's movement, women have still not made enough significant advances within American society for their influence to be palpable. In fact, it has been somewhat unsettling for me to observe how timely my writings on these issues still are. Women continue to be positioned outside, struggling to gain a place of respect within established institutions and conflicted about their own power once inside. These dynamics were evidenced by Hillary Clinton's media-led demonization. Once the press and public denounced her for her strength and assertiveness, her intelligence and determination, she herself backed down, disowning her former stridency while opting for a "softer image."

The chapters to follow represent almost a decade of thinking about contemporary social issues. Often presented as papers, they have had many lives: read at various conferences or published in several versions to reach diverse audiences. Some have had their greatest distribution as underground photocopied pieces sent to those interested in such concerns. Quite a few have never been published in any form. One, "Social Responsibility and the Place of the Artist in Society," has had broad appeal as a pamphlet used in art schools and art departments around the country for debate and discussion. Its success as a pedagogical tool led me to recognize the need for my second book, *The Subversive Imagination: Artists, Society, and Social Responsibility* (Routledge, 1994), which attempts to broaden the scope of the debate and make it international, to show that the artist and the role of the artist is an historical and social construct. This book, like the pamphlet, is also having an

active life in classrooms where discussions about artists, their responsibilities, and daily survival take place.

My goal as a writer has been to respond quickly to social and cultural conflicts when they appear, to put the ideas out in writing as fast and to as many people as I can without sacrificing their necessary complexity, to cross boundaries and intellectual disciplines as needed, and to test the viability of certain hypotheses by actively engaging with them in the world. I have always agreed in spirit with Hannah Arendt's observation that "finding the right words at the right moment, quite apart from the information and communication they may convey, is action."[3] Writing can function as such when it challenges the issues facing contemporary society and attempts to push that society to conscious intentionality about the decisions it is making in the present to provide for its future. These essays have been written with such goals in mind.

Lakeside, Michigan
August 1994

Notes

1. Homi Bhabha, *The Location of Culture* (New York: Routledge, 1994), 12.

2. Susan Sontag, "Syberberg's Hitler," in *Under the Sign of Saturn* (New York: Farrar, Strauss, Giroux, 1972), 158.

3. Hannah Arendt, *The Human Condition* (Chicago: University of Chicago Press, 1958), 26.

ART IN SOCIETY

Art Thrust into the Public Sphere

To grasp the severity of the events I am about to describe, it is necessary to understand that in Chicago, unlike New York or other major cities, there is *one* cultural institution considered the most prestigious, and that is the Museum of the Art Institute of Chicago. Joined to it, physically and corporately, is the 125-year-old School of the Art Institute.

It is therefore that much more astounding to realize that on the morning of May 11, 1988, while a school committee of faculty and staff met to decide what to do about a student painting that was infuriating members of the City Council, nine African-American Chicago aldermen, in an unprecedented act, stormed the school. Three of them removed the painting in question from the lobby wall. They all marched it into the president's office and threatened to burn it on the spot. This was the beginning of the end of the school's revered status in the city and also of its political naiveté, both of which were put to rest for good the following spring, when the notorious flag incident once again rocked the school to its core.

In the first instance: As part of his entry in the traveling fellowship competition (an annual schoolwide exhibition that used to take place in the school's main building, physically connected to the museum), David Nelson, a graduating senior, hung a portrait of the late Mayor Harold Washington dressed in flimsy women's underwear. The painting was a provocative image—an overweight Washington, feet splayed to the sides, looking dumpy and ridiculous. As a self-defined iconoclast, the artist believed it was his responsibility to smash the image of Washington, who he thought had become far too elevated. It is no wonder the painting illicited such a dramatic response. Harold Washington, the first black mayor of Chicago, had died in office only months before of a sudden heart attack, leaving the city in turmoil; he had been greatly loved

by many Chicagoans, both black and white. Only minutes after the painting was hung, someone notified Chicago's City Council about the image. A group of enraged black aldermen then marched to the school—police, press, and minicams in tow—to chastise the student and the school for daring to show such a work. Once the aldermen removed the painting from the wall, tearing one corner in the process, a police lieutenant, acting on orders from the superintendant and attempting to forestall a riot, "arrested" the painting by taking it into custody. It was never shown at the School of the Art Institute of Chicago again.

The next day, various school instructors and officials, myself included (I was the school's Graduate Division chair at the time), flew to Springfield, the state capital, where our lobbyist had arranged for a meeting with the ten-member black legislative caucus to try to stop their proposed resolution to cut state and federal funding to both the school and the museum. Here the legislators evidenced having the same misconceptions that the aldermen had expressed. For one thing, both groups had confused the school with the museum. Each thought the painting had been bought by the museum (which is subsidized by Chicago Park District funds) to be displayed among the "great works" in its collection. These representatives also assumed that had it been a painting of a white political leader—Governor James Thompson, for example—it would have been removed immediately. We explained to them that in the history of the school we had never removed or refused to hang a painting because of content, no matter how intense the pressure. Concerns that the school was a racist institution were in no way assuaged, however. The caucus suggested that they themselves form a citywide multicultural board to help us make decisions about what student work to show. We of course rejected this proposal.

In all the three days spent resolving the first stages of this conflict there were seventeen bomb threats against the school and museum. There were also many demonstrations. The press was unrelenting in exploiting the situation. Ultimately, school officials agreed to take out full-page ads in major Chicago newspapers, apologizing not for the content of the painting but for any "distress" it might have caused those mourning the late mayor. But to this day we wish we had not bowed to the pressures exerted by the city and state at all. We at the school were severely criticized by members of the art community and the American Civil Liberties Union for not bringing suit against the aldermen immediately. They themselves still face a pending lawsuit filed by Nelson

against them.[1] But at the time our backs were against the wall. There was no precedent for what had occurred, and we still had a great deal more to learn about playing hardball with manipulative politicians.

The school's position was further complicated by the fact that there was some truth to the accusations of racial insensitivity and elitist isolation from the life of the inner city. The museum especially could easily be seen as a bastion of the white, male, Eurocentric art establishment. We did not believe the school "fostered" a racist environment or "encouraged" such a painting. But like most art schools, it was, and is, a predominantly white institution, with an 18 percent minority faculty, staff, and student body, which did not come close to reflecting the 57 percent combined black, Latino, Asian, and Native-American populations of Chicago. And we recognized that we had *not* done enough to engage the various multiethnic and racial communities of the city in the life of the school. To our credit, however, we began to change this situation immediately, both internally and externally, by hiring more minority faculty and staff while attempting rigorously to recruit a more diverse student body. We also began meeting with top African-American educators, gallery owners, and administrators in Chicago to elicit their help in changing the demographics and insular attitudes of the school and in helping to place our African-American students in good positions once out of school. But while busy attempting to act upon our own contradictions and guilt, we were too slow to grasp the local political implications of what was happening.[2]

This incident initially took only days to resolve, but it put great stress on many of our students, especially our minority students, faculty, and staff, who were caught between world views. As artists they understood the demand for unequivocal artistic freedom, but as people of color, some also felt the painting was racist and homophobic. Our gay students and faculty also found themselves caught in contradictions. There seemed to be no way to discuss these complex issues publicly. When one defended Nelson's right to make and display the work, the African-American community and the Hispanic community called such opinions insensitive and racist. If one questioned Nelson's motives, timing, and the homophobic nature of the piece, the art world saw this as censorship. Bowing to pressure from the art world and pressure from the African-American community, unwilling to risk further attack, we pulled in to protect ourselves, precisely when we should have opened up the school and the museum to real debate. And because this was the first such onslaught most of us had ever experienced, we took it to be an iso-

lated occurrence and naively thought we could relax when it was finally over. It had not been the criticism per se that we had feared, but rather the safety of our students, our relationship with Chicago's minority populations and the totality of the Chicago art community, of which we are a significant component. But it was not until School of the Art Institute student Scott Tyler unveiled his flag piece, nine months later, in February 1989, that the repercussions of this episode were truly felt. It was then also that we could see that in not fighting back aggressively when we were first attacked we had opened ourselves to further violation and manipulation.

The show in which Tyler's installation appeared, ironically, was a direct response to the events of the previous spring. The Ethnic American Student Union, of which Tyler was a member, had claimed that the "racist Washington painting" might never have been painted were there a greater black presence at the school. We all agreed that there was a need for a multicultural student show; however, when the slides for it were submitted, the faculty jury had some reservations about the legality of Tyler's installation, which positioned an American flag on the gallery floor, under a ledger inviting comments to the query: "What is the proper way to display a U.S. flag?" These words were printed above a small photomontage of flag-draped coffins and South Koreans burning an American flag. While writing in the ledger or looking at the montage the viewer could easily step on the flag. It was not the political statement of the piece that worried the jury, who had seen this type of work before; rather, it was its possible illegality. When the school's lawyers had vetted the piece, the jury chose it for the show.

This installation caused an even greater and more national controversy than did the Nelson painting, which had stirred a furor mostly in the Chicago area, and presented a whole new cast of characters, including local politician Edward Vrydolyak, whose failing mayoral campaign was looking for a boost, and Illinois state Senator Walter Dudytch, who sought to save the flag and enhance his career by erecting his own flagpole, stuck in a bucket of sand. There was no end to the absurd behavior mobilized in reaction to this piece. Tyler had his own political agenda, which fit perfectly with the opposition's worst nightmare image of a flag desecrater. He also knew how to play the media. Appearing often in person on TV and radio, he declared himself to be a member of the Revolutionary Communist Party. He wore a Che Guevara beret, a T-shirt decorated with a large portrait of Chairman Mao, and a Palestinian

scarf. He used words like *fascist* and *imperialist*, publicly likening flag fanaticism to Nazi worship of the swastika.

The combination of players was incendiary and somehow thousands of Chicagoans were convinced by trumped-up hysteria that this small student installation was the biggest problem facing them—far greater than inner-city crime, crack, homelessness, racism, toxic waste, cutbacks to public education. There, at the School of the Art Institute, for all to see, was a symbol of an attack on the American way of life. Even senior citizens in wheelchairs bought this line and organized against the school, as did Vietnam veterans and any number of other groups. The media loved this event, playing it for all they could, while the art community seemed unable to pose images of equal power to counter the popular fixation with the flag-on-the-floor. This unleashed rage put the school on the defensive once again, making us fearful of those who were attacking us. The level of protest was so intense and continued for so long that this time there was virtually no possibility of any coherent dialogue. Had we wanted to establish a rapport with these factions of the city—the Veterans of Foreign Wars, blue-collar workers, conservative suburbanites—we would have had to do so prior to this confrontation. The issue here was related to that of the Nelson painting incident: To whom did the image of the flag belong? Whose was it to use and interpret? Those who had fought to protect the "land of the free and home of the brave" thought it was theirs. Scott Tyler, enraged at American society, thought it was his.

Although the psychic pain of the Nelson painting, with its accompanying accusations of racism, caused the school more direct internal division, the flag piece cost it money. We estimate a cost to the school of several hundred thousand dollars in 1989, and in 1990, as a result of a freeze on Illinois Arts Council funding, the school lost considerably more, while the museum also suffered greatly. Ironically, that funding withheld by the arts council would have been used to supplement our most successful community outreach programs—the Video Data Bank, the Visiting Artists Program, the Film Center, and the BASICS Program, which sends artists into public schools to train instructors to teach art. There are probably donors who still refuse to give money to the museum as a result of these incidents. Even so, the school also made friends among some people who believe in freedom of expression and who continue to support the school as a result of the strong positions we have taken in refusing to remove the work. We may have regretted the pain the work had caused people and, in the case of the Nelson

painting, might even have questioned the merit of the work, but we have stood behind our students' right to exhibit it.

Certainly a great deal of good has come out of all this. We, as individuals and as an institution, have become somewhat smarter, stronger, more strategic as well as more collectively committed to academic freedom. We have concurrently become more critical of our own institution—of our method of training art students, which at times feeds their romantic, ahistorical notions about being an artist and does not help them understand the diversity of the world in which they live. Although the art community likes to talk about the "other" and multiculturalism, and is well versed in postmodernist theory, we at the school had to admit that the majority of our students did not have any idea how to cope with real diversity when angry leaders of the African-American community called them racists, or enraged veterans in camouflage garb reviled them as Communists.

We have also learned that we must wage a counter-offensive battle against our opponents. We need a revival of progressive muckraking in the form of writing, video, and film that will go after some of these politicians as they have gone after us, to challenge their credibility as they have challenged ours. We need to understand who they are, whom they represent, what their agenda is, and why we, the art world, are even on it. We need to politicize our response. I think, in fact, that this has been happening gradually, as the art community has addressed the issue of content in the Andres Serrano and Robert Mapplethorpe incidents in particular,[3] and has begun to recognize which works are being challenged and why. Related to this, the School of the Art Institute has adopted a more strategic approach to the media.

The school was accustomed to isolation, to its privileged place, and to talking primarily to the art world. *Political* and *controversial,* for many of our students and faculty, were terms designating art-world genres. Although there was much talk about doing so, few students or studio faculty had ever actually engaged a larger political arena in their work. Nor had they had to deal with work whose effect in the world they could not control. We certainly did not know how to *use* the media; we did not know how to keep our statements simple, to create our own sound bites, how to beat the media, the politicians, and an organized opposition at their own game. We presented ourselves defensively and offered an analysis too complex, sophisticated, or intellectual for the one-dimensional discourse of television. We finally brought in a consulting team to help us formulate a simple but coherent statement that the media

would pick up. What we ended up with was: "Don't Tread on the Bill of Rights."

As a result of these events, I personally have also come to understand that it is simply not enough to defend an artist's rights, on principle. This is why the response of Artists Space to a similar attack by the National Endowment for the Arts (NEA) has been useful to all of us. They fought back by trying to explain the disputed work, its purpose, and its political context. Since the art world is now drawn into controversy daily, we should at least wrest back, and redefine, the terms of the controversy, using them to raise the questions *we* deem educationally important. This is why it was clearly dangerous for the National Endowment for the Arts to talk about the Serrano and Mapplethorpe funding as a small percentage of "mistakes" in a greater percentage of successes.[4] It misrepresented the issue, backed away from its own prior decisions, and betrayed the integrity of peer-panel judgment. Funding the work of such artists was never a mistake. It was based on careful, educated evaluation by serious artists of serious artists whose work broadens, stimulates, intensifies the public's understanding of art. There should be no apology or fear of work that provokes controversy and debate in a supposedly pluralistic and democratic society.

This brings us to two very basic problems: The first is that there is no clear, popular understanding of what art is and how it might ideally function in American society. A government agency, the NEA, does exist to administer minimal funds to institutions and individual artists, but there is no articulated consensus about the complex place and importance of art within this society. This has made both artists and the funding process vulnerable to ruthless politicians with their own agendas. In some European and Latin American countries artists and their work are *expected* to help raise the collective consciousness. Familiar with an avant-garde tradition that seeks to challenge daily life through art, these governments subsidize and protect their artists and generally manage to do so without demanding political loyalty from them. In this country, however, art is relegated to a place of nostalgic longing, high culture, or entertainment. Most people, if asked, would say that art exists to infuse the world with beauty and vitality. It is not understood, except by the art world itself, as a legitimate arena for controversy and debate. In this society, art is not defined within the arena of real power—namely, politics. But then, how is it that the art world now finds itself in the middle of a political debate?

The second problem, already alluded to, and endemic to democracy as practiced in the United States, is that there is no clear understanding of who the public is and no attempt made to define the idea of the public as a diverse body with often contradictory goals and desires, which the government must try to meet.

The fury hurled at us at the School of the Art Institute was and is misplaced. The real enemy is not one institution that trains young artists but rather this society, which has not satisfied dreams, which has made people feel out of control, has taken resonant images and used them up—to sell religion, products, synthetic ideals, and candidates, stripping all groups of any coherent cultural identity. How did it feel for Chicago's black community, having finally gained real political representation in a deeply segregated city, to lose Harold Washington? And how then did it feel to have his image lampooned by a young, white art student? The art world must be willing to address honestly the complexity of these issues as it also must examine the overdetermined meaning of the American flag for those who now feel their way of life is threatened or invalidated.

The dramas I have described, which we understood primarily as the machinations of Chicago politics, now have become national issues. Until these events, artists remained isolated and notoriously unorganized, without a power base, and therefore easy to target. But they are not so any longer. Artists are now fighting back, as they did at the Corcoran Gallery after the Mapplethorpe debacle. They are creating their own images and events—such as A Day Without Art and the National Art Emergency—powerful enough to challenge the media and the thinking of society about what art is, what artists are, and what the place of art in society might be. They are smashing the image of the withdrawn, self-absorbed, narcissistic artist. They are organizing on the issue of diversity and expanding the debate over censorship and First Amendment rights to include a more broadly based political critique of all that is not said, all that is not heard, while struggling to make the myth of American pluralism a reality.

Notes

1. On 20 September 1994, as this book was being prepared for publication, a federal judge approved the city of Chicago's offer to settle the civil-rights lawsuit filed by David Nelson over the "arrest" of his painting *Mirth and Girth*. The

$95,000 settlement will be paid by the city to the American Civil Liberties Union to cover a portion of the legal fees incurred in the ACLU's representation of Nelson in the case. Nelson's ACLU counsel in the case, Harvey Grossman, indicated that the organization would share an undisclosed portion of the settlement monies with the artist. In an attempt to avoid a similar situation, the city agreed to issue a detailed set of procedures to Chicago police defining the limited circumstances in which materials protected by the First Amendment could be confiscated. The three aldermen named in the suit also agreed not to appeal a 1992 federal court ruling that they had violated Nelson's constitutional rights when they removed his painting from its display at the school.

Left unresolved at the time of publication was whether the aldermen's considerable legal fees would be paid by the city. The aldermen twice had lost in appeals to the City Council's Finance Committee, which determined that they had not acted in any official capacity in their removal of the painting. The U.S. District Court Judge who approved the September 20 settlement could make a decision in that dispute as well. (See *Chicago Tribune,* 21 September 1994.)

2. For a more detailed accounting of this incident and the political implications underlying it, see "Private Fantasies Shape Public Events: And Public Events Invade and Shape Our Dreams," in part 2 of this volume.

3. See the next chapter, "When Cultures Come into Contention," for additional discussion about the controversial works of Serrano and Mapplethorpe.

4. This summarizes an explanation that the NEA was still using in 1994 when work they had funded came under attack.

CHAPTER 2 ❧

When Cultures Come into Contention

The world of educating young artists, my day-to-day reality, is a vital place in which the making of art is an ever-changing force shaped by the caprices of fashion and history. It is also a very different world from that of the traditional museum. Art students are primarily concerned with process, experimentation, trial and error, risk taking, and, for many at present, the making of non-object objects. Because they are young and not always in control of their intentions, at times they rely on confrontation and provocation to achieve their desired effect. They may dye their hair green or shave it all off, wear rings in their noses, and dress in anti-fashion fashion. Although art historians, curators, and others love to tell stories about the antics of Duchamp, Dali, and Picasso and usually seem sympathetic to surrealist, romantic, and conceptual artists of the past, they are often ambivalent when forced to handle the theatrical irreverence and unpredictable behavior of many contemporary art students.

Such actions can be especially threatening to a museum, where the primary responsibility is to conserve, exhibit, and collect objects. Museums are committed to preserving the old and are, at times, understandably mistrustful of the new. Museum patrons, donors, and board members tend to be older, more politically conservative, financially better off, and better groomed than the average young artist. Despite the differences that exist between art schools and museums, however, even when they are physically and corporately connected as they are here in Chicago, the events of the past year in particular have made it very clear that the issues now confronting art schools and their students also have become the issues of the art world and the museum world in general. In

this chapter I would like to locate my analysis of the social, cultural, and historical framework for change in the American art museum in the confrontational events between young artists and the general public that have occurred at the School of the Art Institute of Chicago over the past three years. These events have informed my understanding and grounded my assessment of the current situation of the arts in this country and the responsibility, as I see it, of institutions, schools, and museums alike to enter the present debate rocking this country to the core—the debate over whose voice, whose perspective, and whose point of view will most inform and transform the prevailing ideology.

This battle for definition and identity that is raging over issues of race, women's reproductive rights, funding for AIDS research, ethnic and racial border disputes and immigration policies, foreign interventions, class, and homelessness is also focusing itself around the issues of art. The year 1990 was the year when art became hard news—not only because of the exorbitant prices paid for van Goghs, but also because art was targeted for the debate over what it would mean to be an American in the 90s.

The first touchstone for my analysis occurred in 1988, when graduating senior David Nelson chose, as part of his entry in the School of the Art Institute of Chicago's annual Traveling Fellowship competition, to hang a painting depicting the late Mayor Harold Washington, the first black mayor of Chicago, as an overweight transvestite dressed in flimsy women's underwear. The painting was titled *Mirth and Girth*— the name of a group of overweight gay men. Only hours after the painting was hung, a group of black Chicago aldermen, in an unprecedented act, stormed the school, removed the painting from the wall, and marched—police, press, and minicams in tow—into the president's office, threatening to burn the painting right on the spot. Fearful that the aldermen's actions and the presence of *Mirth and Girth* in the school might incite a riot, the police "arrested" the painting. There were many bomb threats, several demonstrations, and David Nelson was forced into hiding. Members of the African-American community gathered outside the school for several days, calling students racists, while the students called the community protestors fascists. For the first time, the larger community intruded into the autonomous space of the school, violated its sanctity, and we, school administrators, realized that it could easily happen again.

The hanging of *Mirth and Girth* generated a polarized and simplistic response among members of the student body. Most of the white art

students held the position that students, as artists, should have the right to display whatever work they choose. Most minority students, however, were torn between their allegiances to the community of artists, which seemed to mandate unconditional freedom of expression, and their connections to the black, Latino, and Asian communities, which involved a sensitivity to race and a need to challenge racist acts whenever they occurred. It is ironic that Scott Tyler, a young black student who objected to the painting of Harold Washington and asked for its removal on the grounds that it was racist, would himself create a work that would divide the community and nearly bring the school to its knees.

In February 1989 an exhibition was organized to present representative work by students of color. Scott Tyler's installation was one of many accepted, but it was his piece that was to cause even more unrest, unhappiness, and division than the painting of Harold Washington. Thousands of Chicagoans mobilized protests around this installation, whose provocative elements were an American flag spread out on the gallery floor directly below a shelf holding a ledger inviting viewers to respond to the query/title: *What is the Proper Way to Display a U.S. Flag?* Although it was difficult to write in the ledger without stepping on the flag, it *was* possible to do so.

"The flag on the floor," which is how the work came to be known in Chicago, galvanized an entirely new, racially different, politically more conservative opposition. This time the school had to contend with Vietnam vets, the Veterans of Foreign Wars, state senators, white aldermen, as well as civilian flag defenders. The press and the politicians heightened the intensity of the rhetoric until thousands of people were convinced that this student work presented an extremely pressing city problem. As a result of this piece, the school was further isolated and ostracized by the Chicago community and the state legislature.

The following spring, 1990, we at the school crossed our fingers, discussed all the possible disasters that might befall us, and prayed we would get through the year without a major blowup. Unfortunately, however, the dilemma we most feared came to pass. Scott Tyler was graduating, and we knew that he might choose to show the flag piece again in the Bachelor of Fine Arts show. We hoped he would not, but when he did, we were somewhat better prepared than before. This time the large group show was in a warehouse miles from downtown. It was not on Chicago Park District land, there was no state or federal funding directly involved, and, most significant, it was far from the museum. We

thought these circumstances would change the public's perception of the event. But three days before the show opened, the press misrepresented the situation by alerting the public that the "Art Institute was getting ready to show the flag again." DJs were fomenting anger, telling people to protest in front of the museum. Talk-show hosts were discussing it. Phone calls were pouring in. How could we explain to those who didn't understand why we showed the piece the first time that we were about to show it again? Anticipating all the threats, protests, and chaos that were to come, the school's president, Tony Jones, decided not to allow Tyler to show the piece. Many students pulled their work from the 161-person show in protest, and there was much frustration and many tears as each tried to determine the correct thing to do. This attempt to protect our students also incurred the wrath of some in the greater art world, many of whom had supported the school's actions the year before but now saw this as an act of censorship.

In each of these instances, it was clear that the art object was given meaning and definition—and became the focus of anger—as a result of the world moment, or as Bakhtin says: "It is not works that come into contact, but people who, however, come into contact through the medium of works."[1] The African-American community, for example, could not understand why a young art student like David Nelson would so irreverently take the image of Harold Washington, the first black mayor—an image they felt belonged to them—and transform it into an image of an overweight black transvestite in garter belt, bikini underwear, and stockings. Why, they asked, would someone want to do this, particularly at a time when people were mourning the mayor's death?

The next year, when Scott Tyler chose to attack this society, to present his point of view as an African-American man in American culture, the more conservative members of the white community thought: How dare this angry young student, who calls himself a Communist, use the flag, our flag, to protest this country? From their point of view, the flag belonged only to them—only to "true Americans," patriots who had fought in the wars or who were from families of men who had lost their lives defending the flag. It never occurred to them that Tyler might also be a true American and perhaps a descendant of the many black soldiers who had died defending this country. His blackness, combined with his Communist/Maoist ideological stance, invalidated him to them. He not only alienated them, he terrified them. They had to retaliate.

The important point in each instance was that the oppositional groups on each side of the argument seemed locked into one particular

paradigm, unable to step outside it, to question it. The real meaning of the respective art objects emerged within their historical context.

Certainly artist Andres Serrano's understanding of his work *Piss Christ*, for example, is different from that of the National Federation for Decency. Serrano is not simply an iconoclast, as that organization would believe. Although the title of the photograph may be blasphemous, the image itself is elegant, beautiful, moving, and romantic. One cannot understand this without actually seeing and experiencing the work, without knowing what the use of bodily fluids means for a Latino artist obsessed with Catholicism, fascinated with the crucified Christ and the sacrificed body. Only the words—the naming of this picture *Piss Christ*—lock in the meaning of the work and in so doing trigger a predictable response. Who can discuss the complexity of the use of bodily fluids to those unconsciously terrified of sex and/or the AIDS epidemic? Who can know how much *Piss Christ* churned up unspoken, repressed fear? Such fear, when understood, adds yet another story to what seems so simple a narrative when Jesse Helms holds up a reproduction of the photo in Congress and describes it as a "plastic crucifix in a jar of urine." Helms's version negates everything Serrano intended. Which story, or truth, about the photograph should we accept? It would seem that *all* meanings—those intended and those incurred—should be considered.

Why, for example, is there such a strongly negative reaction to the few explicit Robert Mapplethorpe photographs in the traveling exhibition of his work? Why are these enough to unnerve whole cities, almost destroy institutions, and threaten the imprisonment of a museum director?[2] Often at a loss to argue on behalf of these photographs, the art world would like to disown some of the images. Even artists themselves have difficulty defending Mapplethorpe's "XYZ Portfolio." They try to explain these photos in formalist ways, proving their artistic merit or relying on the art world's standard argument that any work should be allowed to be shown anywhere, anytime. Can it not be argued that these photographs, which are considered offensive and immoral by some, are in fact an expression of sexual acts as performed by a certain group of homosexual men? Why should this generate such fear? What in ourselves are we so afraid of? Are people simply not capable of accepting the range of human sexual activity that exists among consenting adults? Might not there be those who find Edward Weston's nudes of women and the romanticization and objectification of the female body obscene? For some, heterosexuality is offensive; certainly the massive display of straight sexual behavior on television and video and in films and advertising is stagger-

ing. Imagine trying to wipe all such images out of the culture because there were those who did not approve of them, whose own sexual inclinations were different. These are complex issues, and we need to confront them armed with as much cultural-theoretical artillery as we can.

Poststructuralism has left us a legacy through which to acknowledge complexity, but it is a contradictory system. On one hand, it insists on acknowledging the range of choices, issues, and perspectives until they become immobilizing. On the other, it presents all these options as liberating—a worldview comprehensive enough to embrace the entire range of difference. Combined with the second tendency, deconstruction becomes a very useful methodology, because, as Joan Wallach Scott says, it "allows one to study, systematically (though never definitively or totally) the conflictual processes that produce meanings."[3] These are the analytic tools that have become popular modes of defining the parameters of a situation. At this moment when so much controversy is configured around issues of "difference," we must ask of writers, artists, and all cultural workers, "From what discrete sets of cultural resources does [this person] construct his or her discourse?"[4] From what point of view, from what place, from what political orientation, from what racial perspective, from what understanding of the issues of gender, from what understanding of class, from what linguistic base—from what configuration of all of these does one take one's identity? Such are the tensions within which we now exist and out of which we must determine meaning, but as Andreas Huyssens writes:

> The point is not to *eliminate* the productive tension between the political and the aesthetic, between history and the text, between engagement and the mission of art, the point is to *heighten* that tension. . . . No matter how troubling it may be, the landscape of the postmodern surrounds us. It simultaneously delimits and opens our horizons. It's our problem and our hope.[5]

We are forced to ask even more provocative questions: What *is* the responsibility of art to society? Are we comfortable with the position art has taken in the past? Does the world we have come to call the art world really represent the many art worlds that exist? Does the art world take into account the entire spectrum of creative endeavors by women, blacks, Latinos, Native Americans, Asians, and gays?

We are forced to ask: Whom does most work address? For whom is it made? For whom is it exhibited? Who benefits from it? Who is

excluded—both from actually viewing it and from understanding the cultural, intellectual worlds it represents?

The questions we have asked each other for a long time, about the worth of certain work and the exclusivity of the art world, have now become the subject of public debate. As an educator I see a great deal that is positive in this upheaval, because it forces a recognition of the isolation that haunts us as we try to explain the form and content of work and its motivations to many for whom this work is "other," incomprehensible, and therefore alienating.

The real roots of what is occurring now and what we perceived as a right-wing backlash manifesting itself as censorship can be traced to the 1960s, when the political climate generated a movement so expansive in its global implications that we are still reeling from it today. A popular slogan at that time, one that could be found on bumper stickers, buttons, T-shirts, children's clothes, and posters, was the simple imperative: "Question Authority." At the core of that slogan was a fundamental mistrust of the established point of view, which was seen as oppressive, conservative, hierarchical, and rigid. At the base of the challenge was the women's liberation movement, which along with the civil rights movement, the Chicano movement, and the gay rights movement questioned the very foundations upon which society was constructed. The legacy of that time can be seen in our continued rethinking of the value system established by the ruling group of white, heterosexual, Eurocentric, middle-class males. Representing those qualities we have come to think of as patriarchal, this prototypical male becomes a platonic type.

Those of my generation who critique patriarchy and American society have had twenty years to perfect their analysis, to develop a strong philosophical base to accompany serious political action. Women, gays, African Americans, Asian Americans, and Native Americans have begun to engage in the tedious work of redefining their own position in society—in their own terms. They have done so both in small grassroots organizations and in major institutions. They are also doing so in writing and in art. They are challenging the concept of a dominant culture, and those perceived as on the margins have a great advantage in so doing, because those who have no power always understand those who have power, whereas those who have power rarely take the time to understand those who do not. With power comes arrogance, and with arrogance the sense that there is nothing to be learned by asking about the experience of the "other."

Whereas in the past, few texts could be found to illuminate the situation of women, entire bookstores are now dedicated to this topic. There are reevaluations of women in literature, of literature by women, and of women in history. Every imaginable aspect of women's situation has been examined through the voice of poetry and criticality.

The place of women in the arts has been similarly analyzed. Art historians have rethought every aspect of their own training. They have noted the perspective, the point of view, the male gaze found in generations of painting. They have challenged the canon and the criteria used to discuss art and to determine its worth. They have questioned the whole notion of worth by asking that it not be determined on the basis of taste, which is class and culture coded, but on the basis of its effect on society. Whom does the work serve? Whom does it continue to serve? Whose interests are excluded? How does this work perpetuate the objectification of the female? Women have fought for this new perspective. And they have fought for the place of art by women in museum collections and galleries.

Women artists have confronted the representation of the female body. How, they ask, can they paint themselves or other women without challenging all that has come before—the disempowering postures and devastation caused by the internalization of the male gaze? These issues are now debated in art-history classes, drawing classes, video classes, sculpture classes—in public forums around the country. In the same way, serious attention has been given to issues of race, to the ways in which society has represented, misinterpreted, and stereotyped blacks, Asians, and Latinos in criticism, fiction, poetry, film, and art. And the critiques are still coming. White people have been able to see, as never before, the dynamic of white/non-white relationships, just as men have been able to see for the first time how women perceive male-female relationships. The important point is that the idea of multiple realities, multiple points of view, can now be understood not from our assumptions about the other, but through the actual voices of those who live these realities and who thus understand their subtleties.

What has been so devastatingly disappointing is that this level of analysis has not been applied to the discussion around the events I described earlier. It seemed impossible for the groups within each confrontation to grasp the perspective of their adversary. The battle was always over which point of view would win out, with little attempt on the part of any group to step outside their own paradigm to look at the effect the work of art might have on someone else. But even were we to

want to step away from this multiplicity of points of views, we could not. These are the questions of American society at this moment. They cannot be obliterated, and the art world has found itself right in the middle of them. But the art world itself is divided on how to go about understanding all that is happening to it. There are even those who believe that art simply has no place in the controversy at all.

I participated in a conference on "Culture and Democracy" in March 1990, where two strains of thought were represented by the disparate voices of Hans Haacke, Luis Camnitzer, and Herb Schiller on one side and Samuel Lippman and Edward Banfield on the other. It was guaranteed to be a heated two days. At one point, Hans Haacke, through analogy, linked Hilton Kramer to fascism. Lippman actually stormed the stage, ready to come to blows over this. Lippman's portrayal of contemporary art at this conference made clear that he and the other conservatives present blamed the chaos and mess of American society on artists. Sounding like Harold Bloom in their longing for some classical past, they attacked contemporary art for creating a degenerate, nihilistic, decadent vision of contemporary life. They accused artists of encouraging narcissism, subjectivity, and fragmentation. It didn't seem to occur to them that perhaps artists were simply mirroring the decay of American society around them, or, as Donald Kuspit responded, "To propose beauty is to be obscene in an ugly world." How can one ignore the ugliness? How can artists stay out of the philosophical debates that mark their time? Lippman and others simply can't stand the fact that there are artists, who have as Nadine Gordimer said of Camus, "accepted the responsibility that the greater commitment is to society and not to art."[6]

At the same time that there are those who would reduce the meaning of art to the sublime and the beautiful, there are also those who have lost the ability in this society to think complexly, to understand the use of irony and the symbolic. This dangerous tendency to flatten reality is reflected in the present fear of intellectualism in American society. Jenny Holzer's aphorisms, which were supposed to air in Los Angeles as twelve television spots, were kept off the air because they were deemed too thought provoking for television. This position tells us how the media perceive their audience. Such one-dimensionality does not train people to deal with complexity—of this we are quite certain—but each year as the cutbacks in public-school art programs increase, the general populace becomes that much more art illiterate. Where can young people learn to read images, to think metaphorically, if this particular type of educa-

tion (should we say poetic education?) is removed from all aspects of society?

In fact, in this country art illiteracy has already reached dangerous levels. Serrano's and Mapplethorpe's work could not be misinterpreted and used by right-wing evangelists, as it has been, were people more sophisticated about what they were viewing. Also, the campaigns to discredit art and artists would never succeed if there were not something already terribly wrong with American society, if people were not already disenfranchised. Imagine, for example, how black Chicagoans must have felt losing Harold Washington so soon after his second election. Everyone knew what would come next—a split in the African-American community and the reelection of the old party machine, in the person of Richie Daley, Jr., the present mayor of Chicago.

Because the demographics of this country have changed dramatically in the last twenty years, many white people now wonder about their place in a society where the majority of Americans will be people of color. There is fear here, not just ill-founded racist fear but a more objective fear of possible retaliation for all that has been done to keep minorities down. Will the power struggle be bloody? Will whites try to hold on in some lesser version of what used to be understood as South African minority politics, and attempt to rule the majority? The group who responded to the flag piece with such violence, and who were ready to respond again this year, must feel that this country is being taken away from them. Their dreams have been shattered. The suburbs, for example, are full of drugs, pregnant teens, and high-school dropouts. Where has this come from, and where is it going? People are afraid. If they weren't, they would not rip paintings off the walls, shut down institutions, and risk the lives of twenty year olds. Whatever we do as educators, directors, artists, and writers, we must not underestimate the volatile period we are living in. In such times of great social upheaval, culture comes into contention. The struggle is not over any single piece of art. Rather, art has become the focus of a much larger debate over who gets to write, to speak, to visualize, to tell their story; who gets to frame and interpret reality, to position their text, as part of the cultural mastertext.

The problems of this country are staggering, in part because there has never been a more racially, ethnically, sexually diverse population, divided along so many class lines, living in such close proximity, pretending not to understand each other and yet so implicated in each other's lives.

Imagine that such a complex, heterogeneous society is represented by George Bush, a one-dimensional, white, male anti-intellectual who is both monolingual and monosyllabic. Something needs to change. This country is desperate for a new mythology, a new imagery, a new leadership, a new vision of itself, one that presents a future based on the concept of multiple cultural centers, collaboration, and cultural integration.

When art is hung today, when shows are curated, the process of selection takes place within all this unstated, unacknowledged, misunderstood rage and complexity. We have not, for example, done well grappling with these issues here in Chicago. Perhaps it is because Chicago has always been a segregated city, and the white art establishment is inexperienced in dealing with the African-American, Latino, and Asian communities. Perhaps it is because the mentality of cultural politics still permits those who now have the power to feel this power is theirs to dole out. Behind the scenes, they still try to control representation instead of shifting the whole paradigm, instead of going directly to women artists and minority artists and asking them how—really how—to help bring cultural diversity to the established institutions of this city.

It is for these reasons that I anxiously awaited the opening of the three-part exhibition, "The Decade Show: Frameworks of Identity in the 1980s," in New York at the Studio Museum of Harlem, the Museum of Contemporary Hispanic Art, and the New Museum of Contemporary Art. I knew that looking back to the past decade would help point us to the future. The show's themes of inner-city life, homelessness, gender, sex, class, race, AIDS, media, politics, the environment, and war pivoted around the concept of identity, which was presented as a constructed, changeable, and changing force. The exhibition was significant not only as a venue for a broad spectrum of artists concerned with multiple perspectives reflected in social as well as art-world issues, but as a model for collaboration, and collaboration goes hand in hand with multiculturalism. In this instance, three museums with their own directors, boards, and constituencies struggled with the issues, challenged their respective differences without obliterating them, and achieved a remarkable effect: museum-going came alive, integrated into the life of the city. It was a geographical feat, moving between neighborhoods to view the work. This traveling and this dislocated viewing experience created a contemplative time and space within which to study the work and in so doing ponder the deepest questions of contemporary society.

Those who would try to yank us back, repressing all that is perceived as "other" and recreating the myth of an assimilated melting pot, with an absolute cultural identity, are dangerous to such new goals. They play on the fear of America's decline. But such doom-mongering can be countered by artists, writers, educators, intellectuals, curators, and museum directors—all who have vision, a sense of responsibility, a shred of power, and a willingness to wage war against the tendencies to romanticize an imagined time of cultural homogeny.

The diversity, complexity, and multiplicity of this society is, and always has been, its strength. The struggle to give that diversity fair representation in all areas will either bring this country to its knees or point the way to its salvation. These are the only possibilities.

We in the art world have been handed a very difficult task. In the United States culture has become a battleground. Can we find ways to use images and the power of art to help heal the pain of a country that must finally come to terms with its own diversity? This is the challenge that has been given to us. Granted, we did not ask for it; yet if we take heart and inspiration from such achievements as "The Decade Show," we may be able to push up against our own boundaries, and those of our institutions, to reorganize and fight against the resistance to change.

Notes

1. M. M. Bakhtin and P. N. Meduedeu, *The Formal Method in Literary Scholarship* (Cambridge: Harvard University Press, 1985), 171.

2. For further discussion of these and other art-censorship occurrences see the following works: Steven C. Dubin, *Arresting Images* (New York: Routledge, 1992) and Richard Bolton, *Culture Wars* (New York: New Press, 1992).

3. Joan Wallach Scott, *Gender and the Politics of History* (New York: Columbia University Press, 1988), 7.

4. James Clifford, *The Predicament of Culture* (Cambridge: Harvard University Press, 1987), 276.

5. Andreas Huyssen, *After the Great Divide* (Bloomington: Indiana University Press, 1986), 7.

6. Nadine Gordimer, in *The Essential Gesture: Writing, Politics and Places*, ed. Stephen Clingman (New York: Penguin, 1988), 289.

Scott Tyler, *What Is the Proper Way to Display an American Flag?*, installation, School of the Art Institute Gallery, 1988. Courtesy of Michael Tropea.

CHAPTER 3 ❧

Social Responsibility and the Place of the Artist in Society

Art is the individual's way back to the collective.
—Ernst Fischer, *The Necessity of Art*[1]

This has been an amazing period for the art world. After the Harold Washington painting; the Scott Tyler flag installation; the Mapplethorpe, Serrano, and Artists Space exhibitions, artists and art students have been forced to rethink their position in relationship to the art world, to each other, and to society as a whole. Together we have watched in horror as serious work has been taken out of context, held up like pornographic smut on the floor of the Senate, defamed by the media. And we have seen congressional representatives—not the most art-literate authorities—make decisions concerning the fate of arts funding in the U.S. based on a literal, Neanderthal, reactionary reading of the work.

In another context, at another time, I would discuss these actions as attempts to reify the prototypical American as a white, male, heterosexual patriot. I would rant about increasing repression, the attempt to squelch diversity and to punish those who choose to project an opinion about American society and the nature of daily life different from that which Jesse Helms finds comfortable and comforting. And I would address, probably exclusively, the responsibility of society to create a supportive environment for the artist, while making reference to countries like the Netherlands, which for many years subsidized visual artists in the hope that they would challenge society. But here I want to confront a different and, for the art world, definitely more controversial, aspect of the problem—the artist's responsibility to society.

27

This is a sensitive issue, one that many in the art world systematically attempt to avoid because it makes everyone ill at ease, defensive, and insecure. But I believe that the unwillingness of American artists to debate this question is only in part the result of a kind of laissez-faire elitism and actually has more to do with fear: fear of accusations of those both inside and outside the art world who might label the work in question narcissistic, sexist, racist, classist, elitist, indulgent, hermetic, or at worst, naive and unpolitical. Instead of attempting to clarify the meaning of art in society, to validate the work they do, to struggle with the complex issue of the place of the artist in society, many artists simply refuse to address the issue—as if artists alone did not have the obligation to ask themselves how their work fits into the broader social framework of which they are a part.

I saw this pattern occur most blatantly around the Harold Washington painting incident, where it seemed impossible to address the complexity of the episode without discussing the content of the work; yet the art world focused primarily on the outrageous tactics of the aldermen. One was forced to choose: for or against the painting, for or against Nelson. That was, for the most part, the extent of the discussion. But this put many artists, especially many African-American and Hispanic artists, in a bind.

Why couldn't we all, as an art community that believes in freedom of expression, insist on David Nelson's right to make the painting while also insisting that we talk openly among ourselves about the issues of racism, homophobia, and accountability provoked by the image? Why couldn't we deconstruct the image in an attempt to understand, and thus perhaps ultimately to assuage its effect on, race relations in Chicago?

The silence among white artists around the content of David Nelson's painting disturbed me and continues to disturb me. Implicit in this silence was, and is, an unconscious complicity. In our reluctance to ask *how* work engages within the larger social context, we are attempting to protect art and the artist from censorship. In practice, however, we are participating in the bourgeois notion of the isolation of the artist from society and of so-called high culture from the debates of representation and plurality current in popular culture. Instead of healing the split between the flatness of mass media and the complexity of the art world, we are allowing the split to become an abyss. In our refusal to contextualize the work historically—not art historically, but world historically—we contribute to the relegation of art to the sphere of enter-

tainment and commodification. In our resistance to confronting the content of work and the emotions such work generates, we make it easier for the work to be rendered impotent and vulnerable by the voices of congressional representatives who would turn the process of evaluating art into McCarthy-like witch-hunts—the goal of the hunt not to ferret out communists but rather all those whose ideas might be considered deviant, subversive, or just down-right "un-American." To fight these battles we must not fear the more difficult debates.

As a writer, educator, and arts administrator, I have thought a great deal about these issues and have tried to analyze the problem in various essays I have written. In these works I have explored the elements of the art education process itself and have attempted to understand why the art world, as reflected in the art school environment, has not developed a stronger methodology and discourse for addressing issues of social responsibility and accountability.

I have observed, for example, that although we talk endlessly about postmodernism and now about post-postmodernism, in fact the way in which we educate our students is better suited to a romantic paradigm. We continue to envision the artist as a marginalized figure, cut off from the mainstream of society—operating out of what Freud calls the pleasure principle while the rest of us struggle within the reality principle, or within its present manifestation, the performance principle. Even though this model never did, and certainly now no longer does, fit the actual lived lives of artists, we nonetheless unconsciously expect creative, intuitive people to be ill-equipped to function in the adult world. We even tend to be suspicious, as Arthur Danto notes, of those artists who survive too well within the "straight" world. We wonder about their creative credentials. We tend to train people as we ourselves were trained and so the myth tends to lag behind the actuality. We do not, for example, add to this category of the childlike artist the new invention—the artist-businessman. Like Jeff Koons, stockbroker become artist, this artist stands in a postmodern parody of his own dilemma, a charlatan reflecting, with every work and every posturing, the lack of distinction between himself and the money-making world of art collecting that sustains him. Even in this era, when all categories have been thrown up for grabs, we continue to reinforce certain archaic dichotomies. For example, we separate the aesthetic acumen developed in the studio from the more linear intelligence cultivated in the classroom. We divide the physical space of the school and the credit hours in accordance with this division. At the undergraduate level a great deal of time is taken up devel-

oping technical skills. Students are trained to work in many media and technologies without equivalent time or guidance in determining what to make work about. It is assumed that students already have many of the intellectual tools they need to think through the dilemmas in the content of their work. Or that they will look inside themselves and find imagery already articulated or that the process of physically making the work will reveal its inherent contradictions. We relegate a proportionally small percentage of educational time to those courses that actually teach students how to think about their work. We rarely analyze to what extent we are all the sociological products of our individual upbringing as it converges with the collective condition. In the same vein, we do not force our students to challenge rigorously their ethnocentrism or to recognize that ahistoricity—the tendency to deny history—is endemic to this society. One need only listen to Chicago's ten-o'clock news to understand how on one night a fire in Joliet, Illinois, will be given more time and coverage than the overthrow of governments in Eastern Europe. The media, reflecting and creating the society, focus on what seems to affect us, the so-called American people, directly. The result, as it trickles down, is that American art students, like most American college students, tend not to be trained to think globally or politically about their own position.

This inexperience in dealing with broader societal issues becomes particularly apparent when students choose to make overtly political work. Because of this general isolation of art students from society, such work often takes its definition of "political" from what the art world defines as political, responding to ideas once removed from their societal framework. This work can therefore be naively informed, dogmatic, one-dimensional, dependent on shock and art world references, which means that it often becomes difficult for those outside the art world to respond to it sympathetically.

This issue of accessibility, which might in itself be a subject of political debate, is often not addressed as such within the art school environment. This is because art students, like other anthropological subgroups, together share knowledge of the hidden signifiers—the references to which the work alludes—and rarely notice that these signifiers are unknown to those on the outside. Added to these difficulties, student artists often are not taught carefully enough how to research their subject matter thoroughly so that, when appropriate, they can integrate what may be a sincere outrage at the world in which they live with the objective facts that might infuse their critique with meaning

and credibility. The work may therefore have a confrontational or heavy-handed feeling that assaults the viewer with its lack of subtlety and generosity to the audience it supposedly wishes to influence. Hence, the examples of political art many students encounter further convince them that work that is socially motivated is destined to be narrow, limited, literal, and defensive.

But perhaps the most dramatic, and at times disastrous, extension of the difficulties posed by educating artists within the romantic paradigm is that they often develop a very naive sense of artistic freedom, one that permeates the entire art world. Students become unable to separate the need to express and explore freely the entire range of ideas, fantasies, and creations within their studios from the decisive editing process necessary for artists to choose what they will show and how they will show it. They come to perceive *all* serious queries about the effect or potential social impact of their work as an impingement on freedom of expression—hence the resistance to real discussion around the Harold Washington painting; hence the limited analysis and narrowly defined debate in relation to the recent art-censorship events. Freedom for the artist thus comes to signify the right to do whatever one wants, however one wants, whenever and wherever one wants, without consideration of consequence. This does leave the artist alone, free to do whatever he or she imagines possible, but inevitably lonely, without an ongoing dialogue with a world larger than the art community.

By this definition of freedom, artists have been categorized, along with children and emotionally impaired adults, as the only members of society not held responsible for their actions. The historical result of such thinking is that it perpetuates an infantalized notion of the artist, keeping student artists at an arrested stage of development. Such polarizations also foster the notion that most people must relinquish the pleasure principle in order to enter the adult world, while the artist alone remains in a state of unobstructed childhood. But the fact of such an imagined condition of innocence disenfranchises the artist, who then becomes a blank screen upon which the rest of society projects its desire for a lost narcissism. The implication for the culture as a whole is that works of art, relegated to the world of culture, become objects of sentimental longing, intellectual curiosity, or that which may be consumed for economic gain. The implications for the art school are that it is forced into the role of permissive parent, while its students play out their respective parts as precocious and at times unruly children.

At this point we can begin to see the complicity of art education in this infantalization, and the consequences of relegating the artist and the art world to a position as "other," "different," or "exotic." These categories, which artists themselves often reinforce in their attempt to find self-definition, only further isolate the artist and his or her work from the society as a whole.

When Jesse Helms held up the Mapplethorpe and the Serrano and asked good God-fearing Americans if they wanted their tax dollars to fund such work, he was capitalizing on the myth of the artist and the artist's bohemian lifestyle to unnerve his audience. But however grotesque his manipulations may have been, they have forced the art world to ask some serious questions, the most significant to this discussion being: What *is* the place of art in American society? What *is* the place of the artist?

In the nineteenth century, American writers Walt Whitman, Melville, and others had a dream that the artist in America would be the voice of democracy, integral to the daily life of a pluralistic society, representing diverse, hidden, necessary points of view. But there have been only a few times this vision actually became a reality, as in the 1930s when the economy collapsed and artists aligned with workers and intellectuals to form a strong progressive movement—not unlike what we are now seeing in Eastern Europe. But modern art, as we know it in this country, has often existed outside the lives of many Americans. Although it does reflect the ontological changes of daily life, most find the forms employed by the art world to be incomprehensible and obscure because these forms are often dependent for effect on knowledge of the art-historical precedents that are removed from the recognized iconography of many people's daily lives. In other words: most people simply don't have the information or training that would allow them to "get it." When postmodernists attempt to use popular imagery to break down the distinction between high and low culture and to adopt forms already popularized by the mass media, they are in a bind, because many outside the art world see such work as a joke, a scam, perpetrated on them by artists. People outside the art world rarely understand the seriousness with which even humorous, parodic art is executed. And artists have often remained silent, unwilling or unable to explain their work to a popular audience—hence the hostility people feel to the art world that excludes them and that they fear deceives and mocks them as well. While all this is going on, artists themselves often feel alienated, misunderstood, and unsupported by mainstream society.

At this moment the art world and the general populace, although actually closer than ever in their shared postmodern dilemma, are nonetheless at a stand-off. Into this historical mess walks Jesse Helms, ready to make his name and build his career by furthering this confusion and aggravating this tension. But ironically, at the same time that artists in this country are personae non-gratae, fighting to be heard and understood, artists around the world are much in demand, asked to assume, of all things, politically useful positions.

Right now, while students, artists, poets, philosophers, and workers have made a revolution in Romania, and intellectuals are influencing the reunification of Germany and the transformation of Poland, Vaclav Havel, the playwright, has become the transitional president of Czechoslovakia. The only president in history, as the *Village Voice* proclaimed, "who can quote John Lennon, Samuel Beckett, and Immanual Kant." Havel has spent decades of his life in and out of prison opposing the governing ideology. But at this moment he is in the Prague palace as the voice of Civic Forum—a movement that brings together artists, intellectuals, students, and workers—a coalition of groups that is inconceivable at present in the U.S. Imagine, if you can, a person of creativity, morality, integrity, and vision—imagine an artist—who could also have enough mass support and backing to become president of the United States. Imagine if that person were a leading playwright. Imagine Sam Shepherd, for example. He might one day run for president. It's possible, but if he were elected it would not be because he makes serious work, has an artistic vision, a critique of American society, or a level of intelligence respected by his peers, but rather because he is a glamorous movie star who has appeared on the pages of *People* magazine—many times. Art in this society, like politics in this society, has been relegated to the realm of entertainment. The rest of the world understands this about the United States and felt it perfectly fitting, poetic justice that Ronald Reagan, a Hollywood actor, a bad actor, actually became president.

But the art world itself has been corrupted by this laughable, but infinitely, globally, dangerous capitalist system that can chew up, spit out, sell, and commodify controversy at will. The art world has been corrupted by the market's inflated prices and by the dream artists and art students alike have of making it big (whatever *it* is), like Jeff Koons, like Julian Schnabel, like Jenny Holzer. The market has taken the edge off the art world. The individualism, romanticism, and competitiveness of the art world has played right into the hands of the investors. The result is that even art that begins as a critique of society often becomes

depoliticized, objectified, institutionalized, consumable by those who have the money. Often it is work that somehow can be assimilated because at its core it does not threaten the prevailing ideology. It does not unmask the basic contradictions. Often it is work that challenges the art world itself but which stays safely within that arena, often devoid of emotion, uncritically embracing new technologies, obscure in form, incomprehensible to many outside, and finally comfortable within the exisitng social system.

What might the position of artists be were work not assimilated by the marketplace? If there were no marketplace? For twenty years, the works of five hundred Czech writers, Milan Kundera and Vaclav Havel among them, officially were banned. They were still stars, however. They mimeographed their manuscripts or smuggled them out of Czechoslovakia, printed them in the West and smuggled them back into Prague and other cities where there were Czech readers. They voiced the dreams and courage of the people. These writers were forced underground because they refused to infuse their work with the "obligatory optimism" demanded by the party in power. There was no comfort in their work, and there was no comfort in the life of the artist. There was no money to be made. There was no quantifiable success to be had. Success was measured by the strength of the work in conveying the complexity and absurdity of the Czech situation—poetically. Most artists went into exile, or to jail. Those out of jail, formally banned from the possibility of any established positions, were forced to work as waiters, waitresses, janitors, and furnace stokers, for low wages. When Joseph Papp tried to get Havel out of jail and to bring him to the Public Theatre as a dramaturgist, Havel agreed to go, but only if the Czech government also released all his co-defendants. The result: Havel did not go to New York. He spent the next years working in a prison foundry, where he almost died of pneumonia. The point is that these artists stayed true to a personal political vision that kept their spirits alive—kept them in touch with all those, in all areas of Czech life, who shared this vision. They appeared to be repressed and silenced, but in fact they were neither. They were preparing for history to take an inevitable turn, at which time they would be ready—intellectually and philosophically ready—to seize the moment and assume real political power.

Now, twenty years later, those with whom they aligned, who were in fact the majority all along (albeit seemingly silenced), have made Havel interim president. This will mean, as he acknowledges, that inevitably his writing will cease for a time, until the interregnum has passed.

And he has said he will miss the writing. Havel is reluctant to be a political leader, but, as he says, "history has overtaken me." His first identity is as a "citizen," and as a citizen he has assumed the challenge of a desperate economy and a country in chaos.

Why do I go on about Havel and make this analogy with Czech society? Because these dramatic changes are living proof that the role of the artist is an historical, social construction. It is not an eternal fixed role. It is not only romantic. It is not without context. It changes, evolves, grows, diminishes, dictates, and is dictated to, and by, history and the market economy. And as such, the creative vision of an artist can be utilized both to construct art and to construct a new society, because these goals each depend on bringing into creation that which does not as yet exist.

In many societies in Europe, Latin America, Africa, Asia, and here, artists use their voices to struggle against the master text, to create alternative narratives in visual imagery, dance, in music, in theater. They interweave all that is silenced, repressed, feared, hidden, and attempt to make it known. The difference between these countries and ours is that here there is no overt public recognition of the importance of art to daily life.

The recent "A Day Without Art: A National Day of Action and Mourning" was a brilliant, powerful, and successful attempt to make people recognize the place of art and artists in society, and the loss of both as a result of the AIDS epidemic. But imagine a day that was truly without art, not just a day with paintings covered in museums and galleries but one without architecture, interior design, graphic design, fashion, film, video, music, dance, magazines, books. Imagine every place where these would be, shrouded in black, and you can understand the power artists actually do have. They fill the void, give meaning to the tedium of everyday life, and make society civilization. We do not feel that collective power in the United States because art has been either placed on a pedestal, removed from daily life, or pushed to the peripheries of the society, manipulated by politicians or used as a means for rich people to become richer. And although artists in this country can produce what they want (as long as no public funding is involved), art actually has little direct societal impact. I believe we are beginning to see that in the 90s this will change and that the goals of the art world will change as well. I think we will be hearing more from those who may not have received visibility in the 80s but who have a great deal to say—those who cross over, move between cultures; those who have struggled to

raise serious issues of gender, class, and race; those who understand the process of self-definition to be a political act; those who refuse to allow the imagination to be colonized. I think these artists will find ways to seize visibility and to control the means of distribution. I think the more superficial aspects of postmodernism will die a natural death and from the best of this movement will evolve a new form, one which will attempt to reach out to audiences greater than just the art world and will not see it as enough to mirror the fragmentation, banality, and destructiveness of this society and its physical environment without also offering some vision for developing a less alienated future.

Artists in this country now appear to be refusing the place of isolation and marginality they have been given and which they themselves romantically have often confused with freedom. It is time for artists to challenge what they cannot live with and to bring into view what they refuse to live without. This task of confronting contradictions in all forms, at all levels, and of crossing beyond the parameters of the art world to do so, is not the work all artists will have the inclination to choose. It need not be understood so much as a responsibility—any more than the responsibility we all must assume for securing the survival of this planet—but rather as a possibility that I hope many will embrace.

Notes

1. Ernst Fischer, *The Necessity of Art* (New York: Penguin, 1963), 45.

Herbert Marcuse and
the Subversive Potential of Art

If pressed on the subject of the political significance of certain types of art, philosopher Herbert Marcuse often recounted an anecdote that pleased him a great deal. It was about the painter Victor Neep, who, when challenged to explain the alleged element of protest in Cézanne's A Still Life With Apples, responded, "It is a protest against sloppy thinking."[1]

In the 1970s, when the cultural world of America was in constant upheaval and many intellectuals were humanists, modernists, and Marxist-Leninists all at once, I was a graduate student at the University of California, San Diego, where I was fortunate enough to work closely with Herbert Marcuse. In what was then a truly pastoral environment, we often took long walks and debated issues: the viability of the women's movement, "repressive desublimation," the role of intellectuals and students in a prerevolutionary context. But the most contested topic of discussion by far was the relationship of art to social change.

Fundamental to Marcuse's understanding of the possibility of human liberation was his belief in the imagination—its regenerative abilities to remain uncolonized by the prevailing ideology, to continue to generate new ideas, and to reconfigure the familiar. It was within the imagination that the desire to envision the idealized state of utopia and to push the world to its realization resided. For Marcuse, the history of art and literature (at least in the West) reflected this ability: out of

repression came images of liberation, out of the bourgeoisie its inherent critique—the discomfort and displeasure that could lead to revolutionary thoughts.

But no matter how brilliantly the argument was presented, I was dubious. I thought Marcuse was trapped in modernism, unaware of how times had changed. The imagination, perhaps once freer to generate its own thoughts, had become virtually oppressed by the stifling effects of mass media. I argued that the pervasiveness of images on such a grand scale, in every aspect of daily life, was the inevitable cause of a colonization of the imagination, which was now held hostage by the prevailing culture it both created and reflected.

As the years have passed and I have spent more than a decade in an art school watching the process of art making, in all forms, I began to think we were both right. I was correct because the images generated by the media—by television, newspapers, Hollywood films, popular music videos—*do* permeate so much of the work of young and mature artists at this historical moment. The influence of popular culture can also be recognized in certain qualities that the work often displays: decentered and comfortable with fragmentation and overstimulation. Although there is work that attempts to reckon with these fragmenting effects, it often gets caught in them nonetheless. All of this seems inescapable.

However, Marcuse was also right. Within the creative process *is* resistance. In their making, images can be transformed, utilized, coopted, inverted, diverted, subverted. The personal can become political; the political can be appropriated as personal. The dictates of capitalist consumption are challenged when non-object art attempts to thwart the marketplace, while the sheer act of concentration necessary to produce art resists the defusion and fragmentation characteristic of postmodern society. Also, the labor in which artists engage is in many instances non-alienated because it is true to a particular vision—of historical reality, the artist's own psychic world, or the intersection of the two. If there is a utopian aspect to art, it is in the rare spaces where artists can free themselves from the expectations of the art market and the contingencies of their economic reality to actually immerse themselves completely in the making of their work. Or it is where, unable to free themselves from these concerns, artists are able to comment on them through a reconfiguration that becomes the art piece itself. Marcuse's own resistance to my media-based analysis was typical of his refusal to be caught too easily in the conflation of cause and effect. He always

struggled to articulate the ineffable, even when he knew his conclusions might be unpopular.

At this moment there is a great deal of confusion about where art fits into society, what function it serves and where its emphases should be placed. And within the complex art world itself there is a very particular debate about what is politically viable: What constitutes political work? For whom should work be created? Should art be for a "community?" If so, who constitutes that community? Or rather, which communities should it address? Are artists necessarily responsible to the world in which they live? If so, how? If not, what might their goals be?

The debates surrounding these issues have generally been limited. Art which is considered "political" by the art world often has little to do with the larger political arena. That which appears to address social concerns is often conspicuously one-dimensional. That which is complex, dealing with subjective or psychological concerns, is often considered obscure and inaccessible to the world outside the art world, and such work is especially suspect when it appears in a traditional medium like painting.

There are few theoretical models to examine as one attempts to address such issues. Therefore, it may be helpful to revisit the work of the Frankfurt School, those intellectuals whose historical and philosophical mission was to make sense of the senseless modern world. In particular, it may be useful to reconsider Marcuse's last book, *The Aesthetic Dimension*, in order to evaluate his ideas in light of this difficult post-postmodern era, when a sense of political urgency is accompanying widespread economic despair. And, however modernist it may seem, it is also a good time to try to take from his analysis a much-needed sense of possibility or, as Marcuse might say, hope.

A Return to *The Aesthetic Dimension*

The argument Marcuse presents in his efforts to examine the actual function of art, as well as the function it might serve, demands a careful and somewhat detailed analysis. He unravels his understanding slowly, beginning his book with a disarming apology:

> In a situation where the miserable reality can be changed only through radical political praxis, the concern with aesthetics demands justification. It would be senseless to deny the element of despair

inherent in this concern: the retreat into a world of fiction where existing conditions are changed and overcome only in the realm of the imagination.[2]

In this statement, written in 1976, Marcuse admits that he was beginning to lose faith in the possibility that the "miserable" political environment could be changed. In this crisis, as his optimism waned, he returned to aesthetics—his early, great love. He focused primarily on literature, about which he could speak with an unhesitating authority that was lacking in his knowledge of the visual arts. And when he went back to what first fed his own utopian ideals, he did so with a deliberate agenda. He attempted to use this reexamination to refute Marxist notions about the function of art in society, which he saw as limited, didactic, naive—an attempt on the part of the Left to impose utilitarian functions on art. He railed against the idea that art, which focuses on the "declining class" (i.e., the bourgeoisie), is decadent and that all art should therefore focus on the "ascending class" (i.e., the proletariat).[3] He was quite clear that art need not represent the social relations of production directly. Rather, the indirect ways in which art represents these social relations may well prove to be the more significant and profound. Of this he writes:

I shall submit the following thesis: the radical qualities of art, that is to say, its indictment of the established reality and its invocation of the beautiful image of liberation are grounded precisely in the dimensions where art *transcends* its social determination and emancipates itself from the given universe of discourse and behavior while preserving its overwhelming presence. Thereby art creates the realm in which the subversion of experience proper to art becomes possible: the world formed by art is recognized as a reality which is suppressed and distorted in the given reality. [4]

In its refusal to be absorbed within the reality principle (Freud's term for the world of work and obligation as constructed by the demands of civilization) or adhere to the rules of the reality principle, in insisting upon issues of subjectivity and the presentation of contradiction, art rejects the idea that there can be any simple transformation of society or that "all of that which art invokes and indicts could be settled through the class struggle."[5] But if art indicts, what comprises its indictment? According to Marcuse all humans have been forced to repress basic instincts in order to survive within civilization as it has

been constructed. Such is the premise of *Eros and Civilization,* in which Marcuse asks, "[H]ow can civilization freely generate freedom, when unfreedom has become part and parcel of the mental apparatus?"[6]

For Marcuse art is a location—a designated imaginative space where the experience of freedom is recreated. At times it is a physical entity, a site—a painting on the wall, an installation on the floor, an event chiseled in space and/or time, a performance, a dance, or video, a film. But it is also a psychic location—a place in the mind where one allows for a recombination of experiences, a suspension of the rules that govern daily life, a denial of gravity. It "challenges the monopoly of the established reality" by creating "fictitious worlds" in which one can see mirrored that range of human emotion and experience that does not find an outlet in the present reality. In this sense the fabricated world becomes "more real than reality itself."[7] Art presents the possibility of a fulfillment, which only a transformed society could offer. It is the reminder of what a truly integrated experience of oneself in society might be, a remembrance of gratification, a sense of purpose beyond alienation. Art can embody a tension that keeps hope alive—a "memory of the happiness that once was, and that seeks its return."[8]

In such a configuration there must be a sense that there is something beyond the reality principle, even if such a different state can only exist within the imagination. In its ability to conjure those dimensions of the individual's emotional life not dominated by the social system, art, according to Marcuse, is able to keep alive an image of humanness—the emergence of human beings as "species beings" capable of living in that community of freedom that is the potential of the species. The recognition of this potential is the "subjective basis of a classless society."[9] The image of the liberated human psyche can be communicated by art, not necessarily through a literal representation of the utopian dream, as in socialist-realist work, but in the emotions such work is able to elicit.

This range of emotional response can be transmitted by the struggles depicted in content and their embodiment integrated by form. Through form, art can portray humanness on a grand scale, beyond the class struggle. Here, where form becomes content, individuals can experience a spectrum of imaginative possibilities crucial to envisioning and manifesting a revolutionary process. For Marcuse, a great deal of the radical potential of art lies in its ability to play within, as well as outside of, the reality principle.

The act of viewing art may have a transformative effect on a person, but within a society of alienation this use value is often discounted. Marcuse might say that within a capitalist system the deepest purposes of art go against the basic premises upon which capitalism is constructed. Within capitalism the only justifiable place for art is as an object that can be bought, speculated upon, and sold for a profit. Or it might serve as a diversion or as entertainment. Its value as a tool that can regenerate the lost, hidden, creative, spiritual, intuitive aspects of human life has been denigrated by capitalism.

At its best, art serves a different master than capitalism, one whose values are not as readily discerned. Although its place in the order of things is not always clearly articulated, no one would publicly advocate a society that did not, at least in theory, encourage creative expression as manifested in art. A society without art would seem unimaginably impoverished. The necessary tension between the longing embedded in people's desire for a fuller life, a more complete self, and the world in which they live would have one fewer outlet. What is almost unspeakable, what cannot be contained is allowed to live through the forms of art. This is why at times art is perceived as subversive, not simply because it presents a world that appears immoral or licentious, as is frequently thought, but because it reminds people of what has been buried—desires their deepest selves actually dream and cannot manifest within the existing system.

Marcuse locates this vision of possibility within the well-articulated space of the aesthetic dimension, a place that stands in negation to the reality principle. It does not embody what is but what wants to be. "One of the foremost tasks of art," writes Walter Benjamin, "has always been the creation of a demand which could be fully satisfied only later."[10] In Benjamin's understanding, "later" could only mean within a revolutionary society—a potential condition that does not yet exist. This is an idea that many politically minded people in the United States have long ago abandoned, instead preferring the concept of slow, evolutionary change.

But works of art need not necessarily exist only within the domain of the pleasure principle to be successful. They could also easily be found within all those places where human potentiality is able to manifest itself. This might mean advocating art that embodies the possibility of change and struggle, the sense that through deliberate action or the transformation of consciousness and social conditions one's personal situation could also be altered. Art allows for this actualization through the vehicle

of form—a physical organization that captures a range of intangible experience. Artists, Marcuse says, are those for whom form becomes content. This is the source of their strength and alienation. Those outside the art-making process may not consciously understand why they respond to the work as they do. They may be unconscious of how beauty, coherence, properties of elegance, or a deliberate refusal to allow for the experience of beauty affects their ability to understand the content of the work intellectually as well as emotionally. Successfully executed art stands as both part of and not part of the society out of which it has emerged. It has not acceded to the demands of the "miserable reality." It has not accepted the limiting prejudices of race, class, gender, and sexuality. While commenting on these, it is also capable of moving past them. This is why, when art is effective in Marcuse's terms, it appeals to people with progressive interests. It may well contain a critique of the prevailing ideology. Or, as in Neep's understanding of Cézanne's *Still Life With Apples*, the clarity and integrity of form itself may prove subversive, especially when all else in society seems in disarray.

There is no doubt that this is a utopian vision of the place of art in society because it allows for the possibility that art could embody utopia and thus annihilate the reality principle. Marcuse is not ingenuous about how this transcendence will occur. He does not expect or want the experience to be easy. On the contrary, he rejects the notion that art should try to reach a large audience directly. He does not think that art is life or that it should attempt to appear as simulated reality. According to Marcuse, the strength of art lies in its Otherness, its incapacity for ready assimilation. If art comes too close to reality, if it strives too hard to be comprehensible, accessible across all boundaries, it then runs the risk of becoming mundane. And if this occurs, its function as negation to the existing world is abandoned. To be effective, art must exert its capacity for estrangement. There is certainly work that in its utter banality becomes dislocating, often because it is unexpected within an art venue. Here the context may provide the necessary tension. It must dislocate the viewer, reader, audience by its refusal and inability to become part of the reality principle or to in any way anticipate the needs of the performance principle (Marcuse's term for the manifestation of the reality principle at this historical moment in Western society). It should not help people become assimilated into the existent society but at each turn challenge the assumptions of that society, whether it be through the demands of intellectual and visual rigor and/or the heightened recognition of pleasure and pain it provides.

Political Art and Uncompromising Estrangement

The ideas of *The Aesthetic Dimension,* which might have seemed dated only a few years ago, now present themselves as useful once again. As the debates around what is politically viable rage on in the art world, thinking about the question of how artists can make significant statements and how best to fight against the prevailing ideology often seems simplistic, as if these debates had not already occurred and been recorded by the literary world—Brecht, Lukács, Adorno, Marcuse and others. If in the 1980s it became fashionable to embrace pastiche and appropriation, to make work that referenced the art world or art history, the most visible pressure in the early 1990s has been to make political art. But there has been surprisingly little discussion about what constitutes politically engaged work. The art world often applies this definition only to art whose content is overtly and clearly about political concerns and whose form is readily accessible or clearly confrontational. Marcuse, however, takes issue with the often-hidden assumptions built into these concepts when he writes

> The political potential of art lies only in its own aesthetic dimensions. Its relation to praxis is inexorably indirect, mediated and frustrating. The more immediately political the work of art, the more it reduces the power of estrangement and the radical, transcendent goals of change. In this sense, there may be more subversive potential in the poetry of Baudelaire and Rimbaud than in the didactic plays of Brecht. [11]

Marcuse is talking about something very specific here, articulating the effect of work that does not necessarily move the intellect to a direct perception of injustice, but that can move the spirit and thus indirectly effect social change. His is a difficult position to explicate because the relationship between the emotional life of individuals and the collective political reality has not sufficiently been explored. It is to the credit of the Frankfurt School of critical theory that it attempted this kind of investigation. But no matter how subtle these distinctions are, this passage from Marcuse's book would constitute fighting words were they written today because, for the most part, the art world would not easily tolerate such juxtapositions. It has often employed definitions of the political that privilege certain content, but this also has meant that it has denied the possibility that work too easily designated as "bourgeois" might actually serve a significant political purpose.

The North American Left, too, has often restricted its understanding of form. The same audience that desires art that contains revolutionary messages cannot grasp the degree to which innovations in form can also be radical, since such innovations change the scope, order, and content of what people are able to see. If the content does not overtly and directly articulate social concerns and the work is not easily accessible in a formal sense, then it is often not deemed political. This encourages the judgment that political art must be anti-art—art that refuses to take pleasure in its own formal properties or denies conventional forms or complexity of form and defies traditional expectations. Within Marcuse's particular understanding, though, art that becomes anti-art by refusing the conventions of art making may be too closely aligned with the reality of day-to-day life. Such art only recreates fragmentation in its simulation of reality and runs the risk of losing its subversive potential. We have seen such anti-art in the 60s, 70s, and 80s, work where the statement became more significant than its execution or where complexity in dealing with issues was sacrificed to easy comprehension—a distillation meant to foreground issues. Often it was work lacking in metaphor or work that, in an attempt to be acceptable to a mass audience, attempted to adapt familiar, popular forms. In the 90s such art appears in conjunction with political statements. Of this complex issue Marcuse writes

> While the abandonment of the aesthetic form may well provide the most immediate, most direct mirror of a society in which subjects and objects are shattered, atomized, robbed of their words and images, the rejection of the aesthetic sublimation turns such work into bits and pieces of the very society whose anti-art they want to be. Anti-art is self-defeating from the outset.[12]

Marcuse clearly rejects the notion that art can effectively comment on the degeneration of society by too simply recreating and mirroring that degeneration. Nor does he believe that one can successfully attack the one-dimensionality of society by reproducing that one-dimensionality. In reproducing the "miserable reality," such art reflects that which already exists and is, in a sense, too familiar. It does not allow for estrangement. We see this in video, performance, installation art, as well as in painting and sculpture. The key to this particular failure, Marcuse might say, is not content but rather a refusal to embody that content in an aesthetically challenging form that would further the question, push

the viewer or the reader to a more complex, more emotional, or revelatory understanding of the problems posed by the work.

This particular aspect of Marcuse's analysis would prove the most controversial for some who see his refusal to accept what he calls anti-art as an attempt to contain art and artists within conventional modernist boundaries. But it would appear that Marcuse is not so much interested in restricting formal possibilities as he is in fostering work that, in its refusal to simulate the present reality, encourages people to imagine what might transport them beyond this reality. His argument is also founded on the idea that, however radical it may seem to smash traditional forms, the shock effect will ultimately be dissipated if the artwork reproduces the experience of daily life. The need to make formally effective work is more than an abstract idea within Marcuse's system. For him it is *the* idea, crucial to the meaning of art itself. He writes, "In this sense, renunciation of the aesthetic form is abdication of responsibility. It deprives art of the very form in which it can create that other reality within the established one—the cosmos of hope.[13]

Within Marcuse's concept of the aesthetic dimension there are two necessary conditions. The first is that the artist has a responsibility to help society deal with its hidden conflicts and contradictions. And the second is that the work must embody hope in whatever way possible. Marcuse does not legislate how these prerequisites should be achieved, however. Nor does he project a simple optimism. Rather, these ideas represent his notion that a much-needed psychic space is created when contradictions are confronted within the aesthetic dimension. For Marcuse, hope lies in the particularly human ability to envision what does not exist and give that imaginary dimension shape. He believes that this shape, this original organization—whether in painting, literature, or music—is precisely what is necessary to transcend the limitations of the reality principle and that it is the job of all serious writers, artists, and intellectuals to attempt this feat. He does not merely want to elevate art above everyday life. Marcuse's vision tolerates an embrace of the contemporary issues of daily life, as long as these are presented in a form that embodies their ability to transform themselves—revealing their contradictions and emotional, political resonance. Even "death and destruction" should invoke the need for hope—"a need rooted in the new consciousness, embodied in the work of art."[14] In Marcuse's dialectical scheme, the "new consciousness" is the ability to address the complexity of one's situation and to find within it that which might lead to its transformation.

The Accusation of Romanticization

It is easy to understand why Marcuse has been called a romantic and why his work on aesthetics has received so little notice from the contemporary art world. There is no doubt that after all the collective, theoretical work that attempts to situate and explain postmodernism, certain aspects of Marcuse's thesis need qualification. During Marcuse's lifetime he continued to believe that there is a part of the human psyche that remains invulnerable to social repression. If this psychic aspect is tapped, which he believed art is capable of doing, then it could be given shape, articulated, its wholeness explored, no matter how fragmented the reality surrounding it may be. But Marcuse's concept of the psyche assumes a unified subject and a coherent sense of identity that ultimately escapes alienation. It also assumes the existence of a universal subject: all humans participate in this fundamental, common experience. In the same vein, he does not make distinctions between Western and non-Western art. Instead, art is treated as a monolith. And he implies that art can transcend racial, gender, sexual, and other cultural differences through certain aesthetic forms. These forms are undoubtedly Eurocentric, grounded exclusively within the Western tradition— the world out of which Marcuse's thought evolved.

At the core of Marcuse's theory, for example, is the issue of "the Beautiful," another locus of controversy that appears time and again in progressive movements "as an aspect of the reconstruction of nature and society."[15] Even when social upheaval is on the agenda, beauty often has been defined in a limited, benign way as "plastic purity and loveliness" and as "an extension of exchange values to the aesthetic-erotic dimension."[16] He is not content with the idea that beauty can only be manipulated for commercial ends. Marcuse's philosophical understanding of Beauty lends it a more profound relationship to questions of revolutionary change.

The Beautiful, for Marcuse, is sensuous and is preserved in "aesthetic sublimation" and the autonomy of art and its political potential reside in this sensuousness. He rails against a crude form of Marxist aesthetics that rejects the idea of the Beautiful as the central category of bourgeois aesthetics and fails to grasp its subversive element. Marcuse contends that what is deeply satisfying and aesthetic *is* political and art with political aspirations should utilize the subversive power of beauty when appropriate. But the Left has not always understood these subtleties. This leaves those artists anxious to make a strong statement about

society without the possibility of making work that is both political and beautiful. Perhaps this is why many artists resist involvement in political movements: they fear that such associations will deny them the right to engage in the sensuous, aesthetic fulfillment of the art-making process—the love of materials, principles of structure, pleasures of translating abstract concepts into form. For most artists, these are the reasons they were drawn to art making in the first place.

Such artists fear they will be forced to replace this love with a more intellectual grasp of "issues" and that pleasure will be transformed into a gnawing guilt derived from the enjoyment they take in line, color, and/ or texture. In fact, the work considered by political people to be the most subversive is often filled with unpleasure, deliberately negating the Beautiful and reflecting the unhappiness one would want to change. It is not a vision of what is possible or what might seduce others into endorsing the more progressive philosophical understandings it represents—or the future world it portends. In this sense, Marcuse's understanding of the sensuousness of art *can* be subversive, especially if it is understood that mass culture, as it exists in the United States, cannot comfortably tolerate what is truly beautiful in his terms—art that resonates with originality and strong formal properties and allows complex meaning to evolve.

Work matching this definition of the Beautiful could also require people to consider what no longer exists, what resides in dreams, memories of a time (whether real or imagined) when life was fulfilling and people's relationship to it seemed less estranged. It is not necessary to prove or disprove the historical existence of such a time. Rather, it is important to note that, in the context of many social movements, the seemingly retroactive emotion of *longing* has propelled people forward. This can be elicited through an appeal to the senses as well as the emotional and psychological life of an individual. There is little in mass culture that attempts to touch people at all these levels. When longing is evoked, it appears as melodrama and/or nostalgia. Such manifestations usually homogenize differences by settling for a mundane version of human experience. The result is a form of sublimation we tend to think of as entertainment and diversion, not the complex interaction of form and content we call art or the enjoyment one derives from art that is humorous, playful, seductive, well executed, and helps to move ideas and emotions to a new plane.

Most artwork is too layered and at times doesn't lend itself easily to mass appeal. Nevertheless, art that deeply affects the senses, the intel-

lect, the unconscious is essential to the well being of the collective imagination. Yet in North American society such art usually receives mainstream attention only when it has come under attack "in the name of morality and religion."[17] It is to art's credit that it can generate such an extreme response. Whether they know it or not, moralists are fearful that such work will arouse people, not in an overtly sexual way, but in a sensual, provocative manner. They fear it might touch people's profound desires and challenge the banality, conformity, repressiveness, the dissatisfaction they actually feel in their daily lives—work, environment, relationships. Therefore, there have always been those who have tried to impose silence on what they consider dangerous art.

Artists know the power of creating work that is directly sensual and erotic. They often do it precisely because it battles with the tyranny of delayed gratification and unfulfilled needs—a repression at the heart of capitalist society. But within the art world, work often becomes explicitly and provocatively sexual because artists assume their audience to be composed of moralists who will always be offended by sexuality and thus need to be confronted. Artists rarely imagine an audience hungry for real sensuality and receptive to all its possibilities—an audience with whom it would be a challenge to communicate. Were they to make work with such an audience in mind, art might be able to fulfill the types of demands Marcuse has presented.

"Art for the People"

The appropriation, pastiche, sometimes parodic cynicism characteristic of the postmodern period left a vacuum. Curiously, it now seems that the pendulum has swung fiercely in the opposite direction—toward sincere social concern and commitment. What results is an atmosphere in which artists are *expected* to serve a social function, moving in communities where they are unfamiliar and making work that talks to, has meaning for, people other than themselves. Certainly, this turn of events could be significant if the concept is carefully considered. But more often than not these ideas become demands placed on artists by other artists for whom making politically useful work has become a moral issue. Which is to say, if someone is not working in a political mode, their work is not considered responsive to the pressing issues of the society. This imperative is often directly connected to the issue of audience: For whom is the work created?

Surveying *The Aesthetic Dimension* it is clear that Marcuse has given a great deal of thought to this type of mandate. There is no doubt that he is dubious about anything that might sound like "art for the people." Marcuse fears a too-deliberate type of populism that diminishes and dilutes the potential impact of art. Art must help develop "a new morality and a new sensibility," he writes.[18] However, "the more the exploited classes, 'the people,' succumb to the powers that be, the more will art be estranged from them."[19] In other words, the more alienated people are from their own inner needs and desires, the more fragmented they will be in relation to the society in which they live and work; the more they need the experience of art that is powerful, but the more they may turn away from it because the deeper concerns such art engages seem too remote and obscure to touch their daily lives. Therefore, it often happens that the audience that would benefit most from such work will reject its content or find its form unattainable. Nonetheless, conscientious attempts to tailor the art to the audience can too readily assimilate the work and defeat the necessary tension that allows it to be subversive.

Marcuse's position on this issue demonstrates an understanding of the contradictions that artists frequently encounter. His willingness to analyze these ambiguities is lacking in much of the critical thinking of the art world today, which encourages artists to make work with a strong political orientation and then rewards that work—even though it has no impact on a larger arena. Similarly, work that is not overtly political but perhaps deeply subversive is too easily dismissed and criticized for not extending beyond traditional confines. Ironically, the success of artwork need not always be measured in terms of favorable reception but rather by how and by whom it is attacked or ignored—whether it appears Other when measured against predominant cultural values or, for that matter, the predominant subcultural values of the art world.

In a similar vein, Marcuse does not believe that the prevailing cultural values that make complex thought intolerable and fearsome to mass audiences should force artists to create art, writers to write texts to suit the tastes of an audience embedded in the one-dimensional society. If "art cannot change the world," it can help to change "the consciousness and drives of the men and women who would change the world."[20] It might appeal to those who see through the veil of Maya, who move beyond the myths of their own civilization. Artists can make a decision "to work for the radicalization of consciousness." In Marcuse's terms, this may mean "mak[ing] explicit and conscious the material and ideo-

logical discrepancy between the writer and 'the people' rather than to obscure and camouflage it. Revolutionary art may well become 'The Enemy of the People.'"[21] It may antagonize and confuse. Its ability to rupture continuity may be its strength. But it may be misunderstood, ahead of its time, beyond its audience, even when its message is intended precisely to liberate those who passively ignore or actively oppose it. The function of art is not to be politely absorbed but rather to challenge and disrupt. We have seen this concept played out fiercely in recent years. Art that was conceived as a vehicle to free its audience from repressive conventions was met with tremendous hostility by precisely those people who could have been moved to greater understanding had they welcomed the possibilities offered. But the work proved too unnerving to find acceptance among non-art-world audiences.

Actually, many artists and intellectuals themselves have trouble absorbing the difficult and controversial work of others or allowing multiple points of view to coexist. Artists who make such work can understand these negative responses if they accept and are prepared for a certain amount of rage when they challenge social norms that have been internalized as correct, moral, and legitimate. They need to understand the uproar their work has caused. But the dominant culture, or even the supposedly more sophisticated subculture of the art world, may not be able to absorb the most profound work produced, especially when it refuses to hew to a politically or aesthetically correct line and strikes out on its own.

To try to make work immediately tolerable to an audience for whom the work must inevitably be challenging is to attempt to homogenize the work and ultimately render it impotent. William Blake believed that his poetry had to be difficult to read, that it was in the act of struggling to understand the text that transformations of consciousness actually occurred. Simplifying the effect by translating the form thus dilutes the power of the work to reach into the psyche and challenge the values of society.

The notion of making politically useful work often leads to a desire to simplify not merely the form but the content as well, reducing it to a message that can be easily apprehended. This may result in a heavy-handed, almost insulting condescension that alienates the audience rather than engaging it. Viewers may "get" the message, but they may not like the message they are getting. This is also humiliating for the artist, whose function—unlike that of the TV scriptwriter, newscaster, journalist, cabaret dancer, or popular singer—is not to seduce only by

entertaining. As Susan Sontag says of her own work, a significant role of the artist of the future may be "to keep alive the idea of seriousness, to understand that in the late 20th Century, seriousness itself could be in question."[22]

Marcuse understood this aspect of art. Knowing the indigenous, anti-intellectual attitudes progressive North Americans have always faced, he was not sympathetic to any movement that forced art into oversimplification. He saw the limitation of this tendency, as well as the repressive consequences of pushing artists into a prescribed position. I think he also would have grasped the irony of any attempt on the part of the art world to determine what is legitimate, what work can and cannot be made, or how it should be made. It is not coincidental that the move toward self-regulation follows so quickly on the heals of postmodernism as the ascendant aesthetic and the concomitant tendency of many artists to isolate themselves from a broader audience. This reversal appears as a dramatic overcompensation, which, in the name of relevance and accessibility, may have the unwanted effect of destroying what is uniquely important about art—its commitment to play and freedom of expression. This crisis of purpose also provokes a crisis of vision. Artists and writers, insecure about what art should be and how to justify their activity, attempt to impose a meaning from the outside in the hope that a set of political criteria will make art more scientific, objective, moral, and therefore more legitimate. The anti-intellectual bias of North American society has relegated those engaged in such activities to its margins. It is no wonder, then, that what is now most valued in art is that which appears to engage directly with the issues of contemporary culture.

It is also no wonder that in the beginning of *The Aesthetic Dimension*, quoted earlier, Marcuse notes that only radical praxis can change the political situation and therefore his concern with aesthetics "demands justification." He prepares himself and his text for the inevitable accusations that his pursuit is a useless exercise in the face of more pressing, immediate concerns. If his final work retains nothing else useful for us today, however, it demonstrates the importance of aesthetics as an area of exploration and of art and artists as a crucial force of liberation within a repressive society. The debate Marcuse entered into almost twenty years ago remains relevant and continues. As the world artists live in becomes more complex, as the demands made on us all increase, his work on this subject could provide an endless source of inspiration, not necessarily for the answers it provides but rather for the

range of fearless questions it engages. Postmodernism may have changed the discourse and terms of the debate, with the introduction of issues of postcolonialism and the notion of the divided, decentered subject. But it has not helped artists understand how to position themselves. It has only made it clear that they *must* position themselves in relationship to their own identities, the social issues that surround them, and the world in which they live. In this post-postmodern moment, as the art world struggles to establish the conditions for its social identity and even its existence, *The Aesthetic Dimension* still remains one of the finest explications of the crucial place of art in Western society.

Notes

1. Barry, Katz, *Herbert Marcuse and the Art of Liberation* (New York: Schocken, 1969), 220.

2. Marcuse, Herbert, *The Aesthetic Dimension* (Boston: Beacon Press, 1978), l.

3. Ibid., 14.

4. Ibid., 6.

5. Ibid., 14.

6. Marcuse, Herbert, *Eros and Civilization* (New York: Vintage, 1961), 206.

7. Marcuse, *The Aesthetic Dimension*, 66.

8. Ibid., 68.

9. Ibid., 17.

10. Walter Benjamin, *Illuminations* (New York: Schocken, 1969), 237.

11. Marcuse, *The Aesthetic Dimension*, xii–xiii.

12. Ibid., 49.

13. Ibid., 52.

14. Ibid., 7.

15. Ibid., 62.

16. Ibid., 62

17. Ibid., 66.

18. Ibid., 28.

19. Ibid., 32.

20. Ibid., 32.

21. Ibid., 35.

22. Susan Sontag, "Susan Sontag Finds Romance," *New York Times Magazine*, August 2, 1992, 23–43.

PART II

THE EDUCATION OF ARTISTS

The Education of Young Artists and the Issue of Audience

Within the dominator system, art has been orga-nized around the primacy of objects rather than relationships, and has been set apart from recipro-cal or participative interactions.[1]

As an educator who has weathered the censorship battles of the last five years, I have been forced to rethink the repercussions of the art world's relative isolation from much of society. It is time for those involved in training the next generation of artists to consider how to incorporate into this educational process a fundamental concern for the particular-ities of audience and the placement of artwork within a societal context.

The relationship of the artist to society and the conflict between the artist's sense of art's function and that of the general public have not been adequately addressed by the art world or within art schools. The result: a cavernous rift has developed. Work that artists find unproblem-atic and barely controversial seems blasphemous, pornographic, or mean-spirited to those outside the art world. Art that artists hope will be an interesting and even welcome challenge to society is often met with little or no response. In such ill-fated interchanges, the audience has often believed that artists were being unnecessarily obscure or con-frontational at the same time that artists have felt misunderstood and unappreciated. The result has been mutual disappointment and hostil-ity. The serious debates about social or political issues that many artists are now engaged in, through their work, remain at least partially hidden to those who still adhere to conventional notions of what art will do,

what it will be, how far it can go, what subject matter it should address. By either confronting or avoiding such conflicting points of view, we, as art educators, directly influence the art-making practices of the next generation of artists and the place they will be able to assume within a democratic society. How we present the issue of audience to our students either encourages their engagement with a larger arena or perpetuates their isolation. And it is art's separateness from an expanded audience that has allowed it to become a vulnerable subject of narrow-minded attacks. Many contemporary artists want to connect to a larger audience; indeed, it is often part of their overall goal, a moral imperative to make significant work that has an impact on society. It is therefore particularly ironic that such work is often rejected by this very audience, the one outside the parameters of the art world.

To understand why most art that grapples with social or political issues generates hostility in non-art-world viewers, it is important to characterize the conventional Western expectation of what function art should serve and to measure how far this expectation is from the intentions of most contemporary artists. At the core of such a discussion must be conventions of beauty—that experience of pleasure so many associate with the phenomenon of art.

The often unconscious expectations of a non-art world, non-visually trained audience are that art will be somewhat familiar yet also transcendent, that it will be able to catapult its viewers outside their mundane lives, provide therapeutic resolution to emotional ills, and, most significantly, that it will end in wonder. In an article titled "The Repression of Beauty," psychologist/philosopher James Hillman writes that when you see something exquisite, so much so that it arrests motion,

> You draw in your breath and stop still. This quick intake of breath, this little hshshs as the Japanese draw between their teeth when they see something beautiful in a garden—this ahahah reaction is the aesthetic response just as certain, inevitable, objective and ubiquitous, as wincing in pain and moaning in pleasure. Moreover, this quick intake of breath is also the very root of the word aesthetic, *aisthesis* in Greek, meaning sense-perception. *Aisthesis* goes back to the Homeric *aiou* and *aisthou* which means both "I perceive" as well as "I gasp, struggle for breath . . . *aisthmoai, aisthanomai,*" I breathe in.[2]

Many still bring this traditional expectation to the art object—a hope that something will occur to jolt the viewer with an experience of

beauty or the shock of pain. In one sense (which some might qualify as escapist) this represents a desire to find a rarified place of abandonment that makes few crossovers with the real world and remains housed in the museum or in the pristine whiteness of the gallery, forever hidden from the course of history. In the best sense, this desire for the beautiful might pertain to the notion, not unlike that held by members of the Frankfurt School, that beauty is itself subversive, especially in a world suffering from narcolepsy. That what arouses desire, stimulates the senses, spurs the imagination—not in a simple, pretty, mindless way, but in a profound and therefore unsettling way—must inevitably challenge the normal course of life, which can never satisfy one's desires or one's longing for completeness.

Hillman also contends that "the work of art allows repressed districts of the world and the soul to leave the ugly and enter into beauty,"[3] to, like Goya's Black Paintings, transform the horrific into something that has shape, line, internal integrity—aesthetics. Many members of the art audience do not realize that what we call art, that which has aesthetics, can manifest itself in a wide range of incarnations and serve many functions. "Every well-constructed object and machine has form," says John Dewey, "but there is aesthetic form only when the object having this external form fits into a larger experience."[4] But what is the range of that expanded experience, which we have come to associate with art? The following is my attempt to categorize the many functions art might serve.

If it is successful in more than formalist terms, the art object resonates within its own history while also entering the ongoing debates in the art historical world. It speaks to a finely tuned intellect as well as to the collective unconscious. It can operate in images and at times in language or challenge the origin of language with its exploration of images. The work may address national identity as well as what is subversive to that identity. It may try to articulate the complexity of the past, the remembrance of what is lost, to uncover what is hidden, layer what is complex, speak the unspeakable, reveal collective fears, unseat personal anxieties, intersect the individual with the universal, challenge the collective dream. It can defy notions of progress and utility—the anchors of the reality principle—suspend linear time, immerse us in pleasure, irrelevance, irreverence, outrageousness. In Kant's sense it creates "purposiveness without purpose"—concentration for concentration's sake. It might play with, make fun of, denounce the prevailing ideology, mirror back the absurdities of commodification, push and torture the limits

of technology, invert what is known until it becomes strange, bombard us with what is strange until it becomes known, return us to a longed-for—if only imagined—childhood, propel us into a visionary future with the child self intact and equip us to function more healthily in the adult world. Artists re-present the culture from which their identity has been constructed—their race, class, ethnicity, sexuality, the complex combination of forces that have shaped the way they see the world. And they help us to understand, through images and language, the particularity of an individual psyche as it intersects with that of the collective.

There is something wonderful about art that can create joy in a direct way, but increasingly artists can only make reference to contentment and the sensuality of an idyllic life in their negation. This type of work, however, is most irritating to those with conventional expectations. They feel deprived of catharsis and the healing effect of beauty, yet such work has everything to do with beauty precisely because beauty, as a static, value-ridden entity, is so conspicuously absent. In its place is conflict, deconstruction—the taking apart and analysis of what there is and the mourning for a joyousness that no longer seems attainable.

As Hillman contends, the contemporary art world is concerned with lifting repression, but its sense of how you do that contradicts Hillman's proposal. It is seen as reactionary in most art world circles to make work that does not challenge conventional notions of beauty. In other words, when lushness and exquisiteness do exist it is often within the framework of postmodern appropriation and pastiche. There must be some irony in the presentation—the reminder, always, that we are not now seduced by what once seduced us and that we are able to stand outside the work with some critical distance and ask: From what ideological position was it formed? For whom was it made? Whose interests does it represent? What underlying questions does it ask? What implicit power relations frame it? The unintervened-with object is now rarely accepted on its own terms. A disruptive discourse enters into the experience and the work becomes a locus for serious debate. If this intervention is understood by the viewer, it can help clarify that art lives in the continuum of history, engages with contemporary issues, and can be transformed by their demands.

But although art and artists increasingly try to comment on the historical moment, seemingly inhabiting a space similar to that of their viewers, their discourse is still often hermetic and incomprehensible to those outside. But how clear does art need to be and who is responsible for that clarity? According to John Dewey, "The language of art has to

be acquired."[5] It is a learned discourse that may be accessed only through an immersion in art and the art world. But the existence of such a barrier is not acknowledged by those who present art to viewers. The mystification of contemporary art could be lifted in part if, when entering an exhibit, the general museum-going audience was cautioned that the work they were about to see might elude, confuse, and unnerve them, that its language must be decoded, and that the dislocation they may experience might be crucial to the work's intent. It is often not understood that a good deal of contemporary work is referenced to art history—the signified is the history of art itself—and is not, as many still believe it should be, the so-called life or emotional experience they expect art to address. Therefore, one cannot always "get" the work intuitively unless the allusions, spoofs, and comments about other contemporary work and intra-art-world debates are made apparent. Also, the environment of the gallery or the museum, designed to create a fake neutrality, does not always allow the work to establish an adequate context. Why should we expect that an isolated image can reconstruct an entire world around itself? Suzi Gablik quotes Sherry Levine on the "uneasy death of modernism." Levine says that the work in which artists are now often engaged "only has meaning in relation to everyone else's project. ... It has no meaning in isolation."[6] Its context, then, is the spectrum of contemporary artistic creation, yet it is often *presented* in isolation, left alone to generate its own meaning, even for those outside the art world who may not be able to recreate the absented part of the dialogue.

In practice what often occurs when a person walks into the sterile museum setting and tries to grapple with a difficult piece of contemporary work is that he or she is left with the question, "What does this work mean?" or "Why don't I understand it?" And then, if the work generates a bit of uneasiness or anger, the question becomes, "Is it art?" In Chicago's Museum of Contemporary Art I have heard similar queries directed at pieces by such artists as Joseph Beuys, Rebecca Horn, Anselm Kiefer, Christian Boltanski. Recently, I heard a man standing in front of a Rauchenberg painting say, "I could make something like that." Those expressing such often-heard statements likely feel a great deal of frustration. For them the work is not serving the function that they assume it should. Such audience members question the incorporation of found objects, the way the work is constructed; to them the craft is not precise enough, the materials too mundane, or the representation too minimal—in short, the work appears not to have demanded enough labor.

These viewers therefore suspect they have been duped and that they too could construct something of equal merit. Because they are able to step outside, to question its authenticity, it is clear that this work does not satisfy their need to be entranced, amazed, or swept away. They may or may not be sympathetic to the notion that the work might intentionally wish to transcend preciousness by negating the experience of its own rarification and that it is in fact successful in these terms. Not only might we say that the viewer has found the experience of the work wanting and in this sense has not "gotten" the artist's intention, but also that the viewer has not understood why this work has been called art at all. The hostility is directed to the artist but also to the entire art apparatus—the gallery owners, museum curators, collectors, and critics who sanction certain work, position it in the museum or gallery context, and, in so doing, raise a certain level of expectation.

When art has caused a public furor, both at the turn of the twentieth century and today, on the brink of the twenty-first, it has often been because the work conflated innovation in form with radicalness in content. A layperson may not easily understand the genres of installation or performance art, for example. These have evolved out of other forms—sculpture, theater, dance—and liberate artists from conceptual and physical constraints. But without having knowledge of the restrictions such traditional categories and conventions of form placed on the artist, a more general audience might have little access to, or sympathy for, the work. Once the parameters governing artistic activity have been lifted, the artist may be freer to create, but the audience is often lost.

When performance artist Karen Finley smears her naked body with chocolate and then covers it with sprouts to represent shit and sperm respectively, there is quite a bit to explain to those who can neither understand the humiliation she experiences as a woman or the form with which she chooses to express it. She uses monologues, she also uses her body, yet her work is categorized as neither theater nor dance. The simple devices she has found for communicating terribly complicated issues of power and submission are extremely effective. When described out of context, however, the work can easily sound banal and crude, an easy target for literalists of the imagination, those hung up on profanity and those unable or unwilling to acknowledge the depth of personal pain that this work attempts to convey. "Aesthetic experience is a manifestation, a record and celebration of the life of a civilization, a means of promoting its development, and is also the ultimate judgment upon the quality of a civilization."[7] Finley's work embodies a scathing critique

of society, yet few outside the art world are interested in exploring the value of such work. They cannot read her intention or identify with the anger implicit in her critique.

Right-wing politicians like Jesse Helms and Pat Buchanan, who supposedly focused their objections to some recent art on issues of pornography, in part have been punishing artists for the political content of their work, the inventiveness of its form, and the articulated indictments of society it contains. The work was often read literally, the metaphors lost, the irony too subtle for those who only saw it as an attack on revered icons. Had Andres Serrano chosen to present the contradictions of Catholicism in a less unconventional way, had he not submerged a plastic crucifix in a tank filled with urine to photograph it as romantically and mysteriously as he did, or had he chosen to communicate the corruption of the church and the denigration of the teachings of Christ without the use of imagery, perhaps no one would have paid attention. If Karen Finley had simply talked about abuses to the female body and had not attempted to recreate them symbolically, perhaps she would not have been as readily criticized. Had performance artist Tim Miller said the same things about being a gay man in American society during the last twenty years—from the joys of sensual discovery to the horrors of AIDS—without dramatizing the pain and without taking off his clothes, his National Endowment for the Arts grant might not have been revoked. Or if David Wojnarovich, in writing about the Artists Space exhibition inspired by the nightmares of AIDS, had kept his rage in check and hadn't alluded to those government officials whom he held responsible for apathy in the face of this epidemic, the NEA might not have noticed. These artists, and many others, have paid for their radicalness. They have been punished for the political content of their vision and the degree to which they have had to resort to extreme forms to communicate the passion of their positions. But such work has received little support from those outside the art world because its meaning is not understood and its significance as a pedagogical tool and as an analysis of contemporary society cannot be grasped by those who are only familiar with more traditional "high art" or mainstream mass culture.

However oblivious to its audience such work may seem, there is an important function served by difficult, innovative art that refuses to be assimilated. It jars the senses, challenges normal perception, and destroys the illusion that the world in which we live can be easily understood. "It can be argued," Terry Eagleton writes, "that the unreadability of literature is precisely its radicalism. . . . Literature entices only to

refuse, appears complicitous only to cold-shoulder. Literature is always somewhere else."[8] Art, in the same vein, can be utterly familiar and yet its opposite. It can baffle where one expects recognition, reject where one longs for acceptance, or be incomprehensible where one desperately seeks understanding. It can also be argued that the difficulty many encounter in trying to grasp the meaning of contemporary art demonstrates the unnecessary exclusivity of the art world—its isolation from most people's lives. But the inability of many "to read" the visual work that is in front of them is also a mark of how uneven the cultural life of American society has always been.

Undoubtedly the fact that art has been obliterated from the public school system is an important source of the problem. The situation of art education is perhaps worse than ever, and those who are attending or recently have attended public schools are, for the most part, visually illiterate. And even when art is taught within the school system, those who teach it rarely stretch beyond the traditional humanistic goals of art education, which focuses on genius, the masterpiece, divine inspiration, and predominantly white Western art that ends with Impressionism. Most who teach at the public-school level have not been trained to reflect upon the issues with which contemporary artists are engaged. Like literature, art now often presents itself as "threat, mystery, challenge, and insult."[9] "Literacy admits us to reading," Eagleton writes, "so that we can take the full measure of our exclusion."[10] Those able to read are actually unable to read. Those able to see are nonetheless unable to see. But to an audience that has not been taught the pedagogical value of such frustration (and even at times to those who have), this feeling of exclusion is a source of great hostility.

Artists and the art world seek to provoke in this way, but are then at times unwilling to deal with their audience's resultant anger. One could of course argue that the exclusivity of the art world is precisely the point and that art should indeed always adamantly refuse to blend into mass culture, where images and issues often are flattened to banality. But artists, for the most part, want their work to be understood and a stated goal for many is accessibility. Some artists talk about their desire to reach a larger audience, one outside the art world, and this has become a more significant issue as art in America is increasingly more charged with political concerns; some feel an almost moral obligation to reach out and extend to a larger, albeit unnamed, undifferentiated audience beyond that which is familiar.

Yet when one seeks models for a more accessible kind of work in the United States, few names come to mind. On everyone's list would probably be Barbara Kruger and Jenny Holzer, perhaps because their work is language-based and its messages seemingly explicit. What is interesting about their work in relationship to this discussion is that although it *seems* more accessible because everyone can read the words, in fact it is problematic in subtle ways. For example, who really is the audience for the work? How popular is it and how dependent on a certain art world cynicism and mistrust of American society? I watched Jenny Holzer's impressive digital electronic signboards revolving around the curved spaces of the Guggenheim Museum in splendid red, white, and amber and wondered, almost out loud, who is this artist and what does she really think about life, art, politics? Is she as paranoid as these aphorisms would have us believe or is this non-specified identity, manifested through these words, a creation, a persona—theater? At whom is this voice directed? And does her desired audience actually "get it"?

Holzer's aphorisms warn us about private property, sex, love, passion, crimes of the heart, an unnatural Big Brother about whom we should concern ourselves. But who or what constitutes this force we should fear and who is telling us to beware? What can be made of statements like these:

IT'S BETTER TO BE A GOOD PERSON THAN A FAMOUS PERSON.
IT'S BETTER TO BE NAIVE THAN JADED.
IT'S BETTER TO STUDY THE LIVING FACT THAN TO ANALYZE HISTORY.
IT'S CRUCIAL TO HAVE AN ACTIVE FANTASY LIFE.

Or

WHAT URGE WILL SAVE US NOW THAT SEX WON'T
PUT FOOD OUT IN THE SAME PLACE EVERY DAY AND TALK TO THE
PEOPLE WHO COME TO EAT AND ORGANIZE THEM.

These distillations, arguments, bits of conversation, political wisdom, and unsolicited advice fly by us. The power of the electronic billboards, the at-once arrogance and diffidence of the voice behind the text leave us breathless. We do not know how to think about what we have seen. We might ask ourselves: should we accept the confusion we experience as an essential component of the work? Or can we criticize the non-specificity of the subject and object of such discourse? What might an average viewer deduce? What is the actual effect? The issue becomes, where is the artist in relation to this work? Are we, as the audience, being

protected by her or patronized? It isn't always clear who the artist is talking to or why.

At a Barbara Kruger gallery exhibit in New York I experienced a similar confusion but for different reasons. Obviously Kruger's work has a much more clearly defined point of view—an explicitly feminist stance. In this particular installation her work was angry and that anger was focused around issues of power, domination, and gender-related inequities. The rage was palpable in red, black, and white, surrounding the viewer at every turn, even on the floor. But how are we supposed to understand these words? Were these messages directed to the hip art world? If so, then the art audience has already heard them. Are they for the average gallery goer? And, if so, should we assume that the gallery audience shares Kruger's analysis? Or are my questions irrelevant and should we simply be grateful for this forceful surrogate voice enraged for all who feel anger and have no voice of their own?

Both Jenny Holzer and Barbara Kruger speak as if they were the embodiment of reason in an unreasonable world, as truth in an untruthful world, and most assuredly as anger in a world that generates injustice and humiliation but offers few forms of expression for it. Jenny Holzer's aphoristic phrases have appeared on billboards, hat brims, T-shirts, placards. They have allowed the artist, here represented as disembodied voice, to find a site-specific way to rivet her discourse. She has successfully taken it out of the gallery context and has put it on the streets. All of this is significant. But its ambiguity could well be misunderstood by those who are not engaged in the debates around power, domination, and gender that this work reflects. It may not appeal at a mass level. But even were this work designed only to feed those in the intellectual vanguard it still would have a purpose. In a sense a great deal of what appears as political work and seems as if it should stretch beyond the normal art world context may have a more useful function as theory. It appeals to those able and willing to grapple with art as an expression of ideas and to understand it philosophically—beyond, in spite of, instead of the fixation with the object. How much or how little of this is grasped by those outside the ranks of the initiated, those exiled from the communication—the ex-communicated—can only be imagined.

The complexity of these issues poses a pedagogical challenge for those involved in the education of young art students. How might this next generation be taught to grapple with these concerns? Can they be encouraged to serve as a bridge between the cutting edge of art world ideas and an audience less sophisticated about how to read such work?

The issue of audience is rarely raised while looking at student work in the art-school pedagogical process, and by its omission it is usually assumed that work is being made to take its place within the art world context. This assumption usually becomes self-fulfilling. Yet among people with political consciousness, work which does not reach beyond the gallery world is often thought to have failed. Somehow it is hoped that there will be another venue, a larger arena, a new audience who will be interested in and affected by such work. But even the most political work is often unable to transcend its category as art. And work that is thought to cross over—move between the art world and a more mass audience—is often coopted by art world recognition. This fashionable assimilation is a contradiction for work whose goal is social criticism and a critique of the exclusivity and elitism of the art world from which it has emerged. But because most artists cannot sustain themselves economically, intellectually, or emotionally without the approval of the academic art world that provides grants, teaching positions, exhibitions, critical reviews, and ego survival, they set their sites within the art world and, however unsatisfying it may be, continue to make political statements about the hermeticism or corruption of that small arena. It would be ideal if work could break out of categorical boundaries and be simultaneously avant-garde and popular, but in practice this is difficult to achieve. Given these hurdles, educators must set out clear programmatic goals to help students think about their work within a larger societal context and to imagine who their audience might be.

In practice, these fundamental questions about audience only arise when students make work that has an overt political agenda or has some other deliberate message to communicate, work that is after some specific result. Often the reason politically oriented work is so didactic is that it is attempting to prove to viewers in a moral way that they should accept the artist's point of view, see the world or at least a particular aspect of it as the artist does. In its attempt to convince, the work often goes overboard, becomes heavy-handed. And what is designed to persuade, to demonstrate that art can educate and concern itself with the issues of the world succeeds instead in pushing its viewers away.

Mature artists like Jenny Holzer, Barbara Kruger, and Hans Haacke can bring a good deal of humor and irony to this challenge, but student artists grappling with the seriousness of the issues, perhaps for the first time, often lack this ability to step outside and to comment on the absurdity and even futility while nonetheless waging a strong battle against what disturbs, unnerves, or infuriates them. When students

make issue-oriented work they sometimes try to tell others what to think. They often assume that their audience knows very little about the question they are addressing and must therefore be educated, or they assume they are confronting a conservative audience that should be radicalized or a puritanical one that needs to be shocked. They rarely see, in an objective way, how confrontational and alienating the form of the work might be to those outside. At times this work projects their feelings about the world from which they come—their parents, the values presented to them that students now feel they need to combat. These touchstones become the object of their attack. The result, at its worst, may take the form of a generic rebellion: nudity for nudity's sake, anarchism for anarchism's sake. The ultimate effect of the work is not thought through. Students rarely step outside their own subjectivity long enough to measure the result. Even when they do study theory and develop strong philosophical principles, they are rarely taught strategy. And they are given little historical sense of how artists have functioned at other moments in American society or when they have successfully aligned with social movements committed to change.

In the same vein, because students need to be helped to understand not only the subject of their work but its objective, they must learn to ask themselves who would be their ideal viewer and who, most likely, will be their actual viewer? What might their audience need to know to understand the work? How much information should they offer? At a time when the issue of identity is being discussed in all areas of the art world, it is important to challenge the notion of a universal subject, to ask students about the particularities of audience and how much they actually know about the groups they have targeted. Such inquiries are truly confrontational within the art world because they smash the absoluteness of subjectivity that is so treasured and goes unchallenged in the traditional art school environment.

I am not arguing that artists should simplify their work, or take fewer risks. I believe strongly in the tension created by what cannot be easily absorbed and therefore engenders struggle. Rather, I am committed to the notion that the traditional expectations for the place of art in society must be challenged and that young artists must be taught to ask themselves how far they are willing to go to make certain vital connections apparent to a more diverse audience. Without such assistance, even postmodern work seems caught in a modernist paradigm—as it waits for its inherent genius and universal appeal to be discovered and trickle down to the masses. To assist a more direct and honest comprehension, artists

simply have to make some attempt to help the viewer through the work's complexity. This is what students in particular find difficult to actualize. Because they themselves do not always know how they arrived at their own images, they are at times not sure what information would be necessary to bring other people along with them. And yet, the amount of information disclosed by the piece itself becomes the measure for how much power one bestows on the audience. As we offer students our knowledge and experience, we extend to them the ability to communicate to as large an audience as they choose. Insofar as we show them that arrogance is unstrategic, however principled its intent, we give them the ability to assert control over the response their work might elicit. As we encourage or discourage the art school tendency toward hermeticism, we either free young artists from the confines of the art world's terminally hip subculture or circumscribe them within its discourse forever.

The obscurity and postmodern nihilism that characterized a great deal of the 80s art world in America has already begun to transform in the 90s. There is no doubt that my students are already pushing against the limits that have been handed down to them. They are increasingly committed to finding ways to represent their concerns about key issues in the United States, like homelessness, the degradation of the environment, AIDS, child abuse. And they are struggling to find new forms within which to present their work. In the face of the gallery system's monetary crisis and the serious degeneration of the urban infrastructure, many have already abandoned the desire for conventional careers as gallery artists and have instead focused on site-specific installation, performance, and work that is more community-based. They have started alternative spaces and cooperative venues. These young artists who have seen through the illusion of the marketplace are not easily seduced by its prestige. They have created larger goals that have a strong socially conscious component. They want their work to impact on society.

So much of what is wrong, so much of what accounts for the massive gap between American artists, writers, intellectuals, theorists, and the general public is historical. There has never been, and there is not now, a significant place for artists and intellectuals within American society. This is perhaps the biggest problem our artistic community faces. No matter how well we prepare our students, no matter how much we all attempt to reach beyond the narrow confines within which we have been trained, we nonetheless struggle against the fundamentally anti-intellectual nature of American society and the visual illiteracy the educational system perpetuates.

As I write this, it seems clear that we are probably watching the death of the National Endowment for the Arts as we have known it. But as the economy collapses around us perhaps artists will reach out to align themselves with other groups who also have been seriously disenfranchised. And one hopes the insights, perceptions, and brilliance of artists will be sought out in the 90s to solve, in unique ways, problems that appear to be frighteningly unsolvable. These solicitations could break down the artist's sense of isolation and help heal the censorship wounds of the last five years. They could transform the popular perception of art and the artist and help create compassion for those who attempt to articulate a personal vision even when these efforts are met with misunderstanding and opposition. Out of the urgency we are now experiencing, caused by the greed of those without imagination who have been allowed to rule for too long, will come the search for language and images rich and complex enough to represent the economic and spiritual pain many are now experiencing in America, and visionary enough to help encourage a sense of renewed passion and expectation for the future. We can only hope that the satisfaction artists might derive from constructing such images will be matched by the audience's engagement as they experience them.

Notes

1. Suzi Gablik, *The Reenchantment of Art* (London: Thames and Hudson, 1991), 62.

2. James Hillman, "The Repression of Beauty," *Tema Celeste* IV, No. 31, May 1991, International Edition, 63.

3. Ibid.

4. John Dewey, *Art as Experience* (New York: Putnam, 1934), 341.

5. Dewey, 355.

6. Sherri Levine, quoted by Suzi Gablik, *The Reenchantment of Art*, 18.

7. Dewey, 326.

8. Terry Eagleton, *Criticism and Ideology* (New York: Verso, 1975), 165.

9. Eagleton, 18.

10. Ibid.

Private Fantasies
Shape Public Events
and Public Events Invade and Shape
Our Dreams[1]

To the memory of Ericka Sherova-Marcuse

On May 11, 1988, the School of the Art Institute of Chicago was shaken to the core when a student painting in an exhibition at the school triggered a sequence of events that fiercely engaged the entire city of Chicago for three days. Rarely has a collision between the world of art and the world of politics exposed so many basic contradictions. Issues such as First Amendment rights, the limits of artistic freedom, the sanctity of the private domain, and the relationship between the artist and the world at large became topics of public concern. Over the ensuing months the repercussions of this incident spread throughout Chicago and throughout the national and international art community.

As chair of the graduate division of the school at that time, I was involved in this incident from the beginning. After much consideration of the event's complexities, it has become clear that there is no simple right or wrong here, no one truth to be found through Cartesian analysis, no heart of the problem to be dissected—except perhaps the broken heart of the body politic. Because the painting in question was conceived at a particular historical moment, it is necessary to recreate that moment and all its contingencies before an analysis can be achieved.

The Chronology of Events

Day One

May 11: David Nelson, a graduating senior, arrived at the school at 8:00 A.M. to hang a series of paintings, his entries in the traveling fellowship competition (an exhibition open only to the school community). At this time every year the school is transformed into a gallery for one week, while graduating students presenting work in all media compete for cash prizes.[2] Students draw lots for location and personally select what they will exhibit; there is no pre-screening.

David Nelson was lucky. He drew a prime location—a wall adjacent to the main entrance, a space no one entering the school could avoid seeing. Nelson hung five paintings. One was a self-portrait, a confident, young, blond-haired artist embracing small, doll-like figures representing various racial and ethnic groups. It was titled *I'm Sensitive and I Love All Humanity.* Close by he hung another work, which was to become known as "the painting"—a crudely executed portrait of an overweight former Mayor Harold Washington dressed only in white, lacy women's underwear—bra, panties, garter belt, and stockings—holding a pencil in his right hand, staring dejectedly from the canvas. The title was *Mirth and Girth.*

Before he had even completed installing these paintings, someone had notifed a Chicago alderman about *Mirth and Girth,* and the media had also been called. By 9:30 A.M. the painting was being talked about on one of the city's major black radio stations, and the staff of the *Chicago Defender* (a newspaper circulated primarily in the black community) was already in the office of the school's president, Tony Jones.

The painting was causing a furor. By mid-afternoon, every local newspaper, TV station, and radio show was somehow involved in the ruckus. Black Chicagoans who must have heard about the painting on the radio began to gather outside the school's entrance. The school's security force was busy prohibiting non-students from entering the building. A shouting match had already ensued between predominantly white art students and predominantly black members of the community. These student artists were yelling, "Civil liberties!" and "First Amendment rights!" while those from the community at large, angry that anyone would dare defame the memory of Harold Washington, were shouting "Racists!" at the students.

As tensions were mounting, Tony Jones convened a small group of school faculty, administration, and staff as an ad-hoc advisory group to help him determine what actions, if any, should be taken. This group crammed into the provost's office. As they deliberated, phones in the school's administrative offices rang off the hook with angry callers condemning the painting, and the press continued to gather, demanding a statement from the president. Then suddenly the opportunity to make an academic decision was preempted as the nine black aldermen, who had just marched over from City Hall, stormed the school. They were followed by Alderwoman Dorothy Tillman, Alderman Alan Streeter, and Alderman Bobby Rush,[3] who paraded into the school, ripped the painting from the wall with bravado and theatrics, and stormed into the president's office, *Mirth and Girth* in tow. (At this time the painting had already been damaged—a five-inch gash in one corner.)

That afternoon a resolution had been introduced in the City Council, which began: "Whereas, the artist, David Nelson, obviously exhibits some type of demented and pathological capacities ..." The aldermen interpreted this resolution as a justification for their actions: it requested that school officials remove the painting and that the city withhold public funds from the school until *Mirth and Girth* was taken down. The resolution was not, however, in any way intended as a mandate for the forcible removal of the painting.

The aldermen, as they confronted Jones in his office, threatened to burn the painting right there. Fortunately, someone suggested that perhaps such an act might be hazardous and that it would be smarter to set fire to it outside, on the school lawn. By this time Chicago police officers, also inside the president's office, had decided that the painting was "too inflammatory" to remain on the premises. Upon receiving a directive from Police Superintendent LeRoy Martin, they "arrested" the painting for having the "potential to incite a riot."

The seizure of the painting did little to abate the controversy. Crowds continued to build throughout the day. Many students who were still at the school (between the end of the spring semester and graduation) seemed initially concerned only with the issue of civil liberties. But soon they began to understand the complexity of the problem. Many of them found it a revelation to hear that Nelson's image of Harold Washington deeply upset black students at the school, as well as members of the black community in the city at large. They were amazed that one student's work could generate such an extreme response. Black students were torn. They were caught between their allegiance to the

school, their identity as artists, and their sense that the primary contradiction of this event for them was not civil liberties but racism.

Students continued to debate among themselves and by evening, under pressure from the media to comment on the events, they drafted a simple group statement, which declared that the painting represented "the sole view of one artist" and "did not represent the collective view." The statement continued: "Whether or not the content of the painting was offensive, it should have been allowed to stand in public view under protection of the First Amendment rights," because such an "infringement" of "basic constitutional rights was threatening to the freedom of artists everywhere."

Day Two

Late in the evening of the first day, the school had been informed that, as a result of the painting controversy, it was likely that a caucus of black state legislators would introduce a bill on the floor of the legislature in Springfield, demanding that all state funding be withdrawn from the entire corporation, the museum and school. (The school and the museum together comprise the Art Institute of Chicago—a corporate entity, each component of which has its own president.) The school was advised to act quickly. The Art Institute chartered a plane and sent a contingent of school and museum administrators, a lawyer, and a student-union representative to meet with the legislature's Black Caucus to see what could be done to stop the measure, which also called for the resignation of the school's president. While this group was in Springfield, Marshall Field V, the president of the museum's board of trustees at the time, accompanied by the president and vice president of the school, legal counsel, and three other administrators, met with Chicago Mayor Eugene Sawyer, his corporation counsel, chief of staff, and eleven aldermen at City Hall. After many hours of grueling debate, the school promised to apologize to the city and its residents for the distress the painting had caused and agreed not to display the painting in the future. It also promised that the school would continue its efforts to improve minority representation at all levels with renewed dedication.

The meeting in Springfield, unlike that at City Hall, appeared to achieve a greater level of understanding on both sides. First, many rumors and misconceptions were dispelled. For example, some members of the Black Caucus believed the painting had been hung in the Art Institute among the Renoirs. Others thought it had been up on the walls

for weeks and that faculty and students had seen it but had offered no criticism. Second, the discussion clarified for those outside the art world some aspects of the educational process of an art school. It was assumed, for example, that the school would have taken the painting down in a minute had it been of former Governor Richard Ogilvie (who had just died) or then-Governor James Thompson. The school's representatives assured the caucus that they had never taken a painting off the wall, no matter who was represented and no matter how compromising it might have been to any public official. The school had run into controversy before in dealing with student exhibits: live rats as part of a sculptural piece had been prohibited by the city's Board of Health, as had dead rats in a refrigerator, part of another installation. Former Mayor Richard J. Daley had been portrayed as an aborted fetus. Another former mayor, Jane Byrne, and Ronald Reagan had been seen in an array of compromising postures. President Jones, painted by none other than David Nelson, was depicted in one piece as a suckling infant in the arms of a bare-breasted Madonna. The school and museum contingent was able to convince the legislators that the school had never removed a painting or piece of artwork from the wall or from a gallery, no matter how controversial its content.

Many School of the Art Institute faculty, students, and staff had worked in Washington's mayoral campaigns and had been great supporters of the late mayor. I had co-chaired an intercity campaign committee called Artists for Washington. For those who had revered the late mayor it was particularly painful to realize how the credibility of both the school and the museum had been implicated in this incident. In the hope of changing this perception, school officials joined with the Black Caucus to issue a joint statement agreeing to work together, when possible. One issue both groups could readily agree upon was the need to increase minority representation among school students, staff, and faculty. School officials promised to work harder to improve the numbers of minority employees at all levels and also to improve external community relations.

The school and museum representatives returned from Springfield with a sense that some understanding had been reached and that something of the day-to-day life and purpose of an art school had been communicated. The City Hall meeting had unfortunately not felt as encouraging. A good deal of shouting and irrational pronouncements on the part of the aldermen had left top school administrators upset and anxious about events to come.

By late afternoon of Day Two, May 12, Reverend Willie Barrow of Operation PUSH appeared on national television, flanked by ten black ministers, to denounce unspecified "racist practices" at the school and to demand greater black enrollment and representation. Barrow condemned the painting incident as "the latest in a series of escalating attacks and insults against the black community." This group called for sanctions against the Art Institute unless it implemented a "review policy" to prevent offensive paintings from being exhibited in the future.[4]

Days Three and Four

Days of reckoning. By now the press had had time to take various stances. Syndicated Chicago newspaper columnist Mike Royko had called those who removed the painting "Alderboobs." One journalist had labeled the entire event a "panty raid." Another had called it an "Art Raid" by an "Alderposse." For some it was a great source of humor. For most it mirrored the chilling split between whites and blacks in the city, which seemed to be intensifying each day.

The story was front-page news nationally and internationally. Locally it was the *only* story. Faculty and staff had practically moved into the school to deal with the events minute by minute. Individuals from around the city called to condemn the school's publication of the full-page explanatory statements in local newspapers, which had been part of the agreement reached with the City Council. These callers chastised the administration for being too weak in their unwillingness to stand up to the aldermen. Others accused the school of somehow having encouraged the creation of such a painting.

For those in the administration, May 13 was a difficult day. A decision had to be reached whether or not to proceed with graduation as planned for the next day, in spite of bomb threats and the fact that PUSH's Reverend Barrow had called for a demonstration one-thousand strong to march on the Art Institute. The school was also anticipating at least a thousand people in attendance for graduation ceremonies, many of whom would arrive just when the PUSH demonstrators were scheduled to reach the Art Institute. The students had also called for an "Artists' Be-In" to convene at Daley Plaza, in the center of downtown Chicago. It was feared that all of these groups would collide and heated interchanges occur. To assuage some of the anxiety, the school increased security and asked for more city protection. Graduation was to go on as scheduled. Fortunately, this turned out to be the correct decision.

The next day, May 14, the school and museum were secured like fortresses: police cars, plain-clothes officers, and backup forces were everywhere. Everyone was on edge, but the administration knew that once graduation was over students would disperse and tensions would subside. Although the issues raised by the incident had not been resolved, it would be easier to focus on them in the summer without fear of a possible student-community confrontation.

There was almost palpable relief once graduation was over, but there was also a deep sadness, a sense that things could never be quite the same again. The community of the school had been torn apart. It seemed there was no collective agreement as to why these events had occurred, or how they should have been negotiated. Relations between black faculty, staff, and students and their white counterparts were extremely strained and self-conscious. Many Latinos, Asians, and other minorities felt alienated from all sides of the issue and met independently to discuss their positions. The school's place in the overall city community had been seriously challenged, and the inherent contradictions of a private art school located in the center of a racially diverse urban center had been exposed.

The challenge at this point was to step back, try to understand what had occurred, allow grievances to be articulated (however long that process might take), and ultimately work to heal the damage that had been done. It is only now, after some time has passed, that the complexity of the event reveals itself in all its dimensions. To understand its many aspects it is necessary to contextualize the incident.

The Social Context

An artwork is not an isolated physical phenomenon. It is a manifestation of a moment in the historical process of living.
—South African artist Andries Botha[5]

Harold Washington, Chicago's first black mayor, died on November 23, 1987. Those who worked for him still refer to him lovingly as "the mayor." He was the first person to truly crack the machine stranglehold on city politics. To elect him, twice, required the combined forces of progressive people from every community and from every ethnic and

racial group. This was a unity never before achieved in Chicago politics. It was an historic victory. But this coalition really had not had enough time to solidify. The allegiances were still precarious. Unresolved contradictions, paranoias, and ancient rivalries continued to exist and then began to resurface in Chicago immediately after the mayor died unexpectedly at the age of sixty-five.

Although considerable time has passed since his death, there are many who are still in shock and mourning. Those who loved the mayor, those who worked hard for his election, have not forgotten him or overcome their grief. Hundreds of thousands of people walked past his open casket as he lay in state (David Nelson among them). They are still saddened by the sense of loss, which is only exacerbated by the lack of a suitable successor. Much of what Harold Washington stood for has been destroyed by divisiveness, corruption, and a jockeying for power. Many politicians used their former closeness to him to try to win the black community to their side, while others, who were never really supportive of Washington, misrepresented their relationship with him in order to win political power.

When the incident of the painting occurred, there were many who were deeply upset by Nelson's work, but there were some who used the incident for their own ends. They saw in it an opportunity for grandstanding, for proving themselves the true guardians of Washington's memory. It was easy to rally loyal Washington supporters around such an issue. But had these aldermen sincerely wanted to protect the mayor's memory, they could have done so in a much more useful manner.

The incident could have been hidden from the media, dealt with quietly among leaders of the community and of the school. But instead, the media was actually solicited, used to record certain figures as they marched dramatically from the school, spoils in hand. Art critic Harold Haydon said of the aldermen's behavior, "They overreacted. Harold Washington would have ignored this. He was too smart. This was a dumb thing to do."[6] The aldermen acted inappropriately, taking the law into their own hands, creating even further racial tension and almost inciting a riot.

This incident, however, was only one among many that have caused dramatic splits between blacks and whites and between blacks and other minorities in Chicago. Prior to the conflicts around the Nelson painting, there was another incident which received national attention. Seemingly unrelated, the Steve Cokely affair was in fact a crucial moti-

vating force propelling members of the black community to respond to Nelson's painting as aggressively as they did.

Steve Cokely, an aide to then Acting Mayor Eugene Sawyer, made certain anti-Semitic remarks in lectures delivered at the Black Nation of Islam from August 1985 to November 1987. The gravity of these accusations shocked Jews and non-Jews alike. Among other things, he alleged that Jewish doctors on the South Side of Chicago were injecting black babies with the AIDS virus, and he later alluded to a Jewish conspiracy to "rule the world."[7] These remarks caused many to demand that Cokely be fired. It took Sawyer a week to make this decision. When he did, certain factions in the black community were enraged. They felt that Cokely's First Amendment rights had been violated. Any unity that had once existed between blacks and Jews had come undone.

Such unfortunate polarizations are not new to Chicago, but they now seem to occur more frequently on the national level as well. As Salim Muwakkil wrote in *In These Times*: "The *Zeitgeist* of racial intolerance has trickled down from the ruling Reaganauts to Hayden Lake, Idaho, to the college campuses, to the inner cities."[8] Eight years of a Reagan-led government has done nothing but increase tension and frustration among people who have had little, if any, outlet for political expression. It has also helped to cause a certain scapegoating of Jews, the most vulnerable representatives of the white power base.

The Cokely incident was only one of many indications of how tense race relations had become nationally and of how chaotic Chicago politics had become since Mayor Washington's death. But there is no doubt that this event, which occurred only one week before the painting incident, was equated with it in the minds of some in the black community. As Alderman Streeter said when asked why he thought David Nelson painted the painting: "It's all related. I don't feel it's a coincidence. I feel the fellow is a Jewish person who is defaming the mayor I love."[9] (Nelson is not Jewish.)

During this time, there were those who reasoned that if Cokely was not protected under the First Amendment, if he was not permitted the right to make anti-Semitic remarks with impunity, then David Nelson should not be allowed to display a racist painting. The Black Caucus in Springfield even asked for the resignation of school President Jones, using the logic that if Cokely was fired, then Jones should also be fired. But the analogy simply did not hold up. There was a great difference between a young student exhibiting a tasteless painting in a private school competition, however racist his intent, and a mayoral aide, sup-

posedly responsible to the Chicago community, making serious public accusations against the Jewish community over a two-year period. Unfortunately, all logical thinking had fallen by the wayside. The irrational tenor of events was captured by Alderman Streeter's assertion, "I don't care what the law, what the Supreme Court says, that painting will never go back up on the wall. If it does I'll tear it down myself."[10] This surprising denunciation of First Amendment rights sounds ironically like statements made by irate white racists during the civil rights campaign. History had come full circle.

The Issue of Iconoclasm

No one, especially the artist, has a right to be indifferent to the social order.
—From the manifesto of "Los Interioristas"[11]

The aldermen were not the only ones suffering from a myopic view of reality. David Nelson had his own subjective and less-than-lucid understanding of what was going on. He had been unnerved by a poster, on sale in Chicago at the time, called "Worry ye not." It was an image of Jesus Christ and Harold Washington, side by side, hovering over Chicago as angels and protectors of the city. Nelson interpreted this image as a sacrilege. Harold Washington was mortal, not an angel or savior, thought Nelson. He wanted to pull him from the sky. For Nelson this image was particularly offensive because not only did it deify Washington but it defamed Jesus. If Washington had become an icon, Nelson was quite literally going to smash him and bring him down to earth. In an interview with the *New Art Examiner*, Nelson said, "I guess in this city there are certain deities. Washington is a deity and you can't touch him. It wasn't Washington I wanted to poke a hole in—like a balloon. It was the deity aspect.... I'm an iconoclast, I guess I mean a person who doesn't believe in icons."[12]

A follower of Jesus Christ, Nelson admits to finding certain portraits of Christ within the Art Institute's collection offensive, even though he is quick to state that he would never consider having them removed. In discussions he also indicated a definite uneasiness with images of gay male eroticism that had been displayed in the school's fellowship competition the previous year. It is not coincidental that he chose to disempower the

image of Harold Washington by emasculating it. In a stereotypically homophobic manner, he insinuated that the illusion of virility people equated with Washington only concealed some type of sexual deviance.

To add to the sting, and to eliminate any question as to whether or not he was making an anti-gay statement, Nelson titled the painting *Mirth and Girth,* the name of a Chicago club for overweight gay men. Nelson's provocative and tasteless attempt to defame a beloved black leader prompted the *New York Times* to call the painting "savage." Michael Brenson wrote: "It is utterly unsentimental, with something of the no-holds-barred satire of 'Saturday Night Live.' Largely because of its indifference to the offense it could give, it has touched raw nerves and unleashed a storm of vindictiveness and anger."[13] It is important to note that Nelson's image does not so much depict the behavior of gay men, who do not usually dress in women's underwear, as it does transvestites or cross-dressers. It seems to be transgression that interested Nelson, but for the black community its primary negative power undoubtedly resided in its allusions to femaleness and gayness.

Nelson's decision to dress Harold Washington in women's underwear created a provocative image that is both racist and anti-gay. White men have for centuries tried to undermine black male virility while also attempting to negate the importance and power of black leaders— another form of emasculation. Given that the overall culture is anti-gay, it is not surprising that black men have come to equate one form of emasculation with gayness. It is therefore somewhat understandable that many members of the black community have become homophobic. Had this not been the case, the painting would never have received the response it did. Were Nelson not homophobic himself, he might not have painted the painting at all. Add to this complexly layered signification Nelson's portrayal of the mayor with splayed feet, an overweight body (which doctors surmised was a contributing factor in the mayor's death, from heart disease), and a pencil in hand, which his press secretary thought he had bent down to retrieve when he was actually doubled over in pain, and you can understand why Brenson called the painting "savage."

Many journalists writing about the painting, unwilling to think through the complex issues it raises, have too readily accepted Nelson's sense of this work as iconoclasm. But this is a misnomer. Iconoclasts traditionally attempt to disempower those whose entrenched position has been oppressive to others, those whose rigidly fixed and venerated image leaves no room for interpretation. There is usually a goal in mind, a need to discredit the sacredness of the image in order to liberate that which

has been repressed or unspoken. In Nelson's mind Washington might have had this kind of power, but in reality he did not. Harold Washington was dead when the painting was completed. He had already been removed from the arena of earthly power. A man who had been attacked and slandered his entire life, Washington only really garnered enough support to implement his reform platform at the very end of his life. As mayor, Washington doubtless had a great deal of political clout. But he had fought long and hard to win this influence, and in truth his base was always fragile at best. Although he had reached a position of personal strength, he represented a group of people—blacks, Latinos, Asians, gays, progressives— whose position in society continues to be fraught with insecurity. In the face of this fragility, it is impossible not to ask: What power was Nelson attempting to challenge? What did he think he would achieve?

There have been several other incidents which raise questions about the nature of iconoclasm and help clarify the use or misuse of the term in relationship to *Mirth and Girth*. There was, for example, the exaggerated response to Martin Scorcese's film *The Last Temptation of Christ*. Fundamentalists tried to buy up all the prints from Universal Studios before its release. Picket lines, protestations, and even stone throwing turned the opening night of what might have been a small art-house premiere into a sold-out circus event. Scorcese, like Kazantzakis, from whose novel the story was adapted, was not interested in iconoclasm, although this is what he was accused of. Rather, he was concerned with a demystification of the Jesus figure and an intense grappling with his trials and temptations, not as an outsider attacking the figure of Christ but as a Catholic, analyzing him from within. Goddard's *Hail Mary*, in which the mother of God is presented as a beautiful gas station attendant, also received a good deal of knee-jerk criticism from those who felt Goddard's retelling of the story in a contemporary setting was sacrilege. But in both instances these filmmakers were trying creatively to rethink the traditional narrative, to add a modern, human dimension to it.

An episode in Mexico City in 1988 bore certain similarities to the Nelson painting incident. At the Museum of Modern Art in Mexico City Roland de la Rosa, a Mexican artist, displayed a montage that superimposed the face and bare breasts of Marilyn Monroe over the revered image of the Virgin of Guadalupe, who is also known as the "National Mother," the "Mestiza Virgin," *la Guadalupana*. In so doing, de la Rosa set off four months of controversy about the limits of artistic freedom. Enraged civic groups stormed the museum, demanding the artist's

home address so they could "lynch him." De la Rosa became *persona non grata* and the museum's director was forced to resign.

Scorcese, Goddard, and de la Rosa were all working from personal visions that attempted to intersect with the collective imagination. But this effort is often misunderstood. In a July 1988 *Time* magazine interview about *The Last Temptation of Christ*, Father Morris, a Catholic priest, said, "You can't be working out your private problems to the degree that it causes people to riot in the streets."[14] The Scorcese film almost caused such a response; De la Rosa's images actually did. But the concerns of these artists cannot be reduced to a discussion of their "private problems." De la Rosa, for example, was attempting to mirror the hypocrisy of Mexican culture in which pictures of *la Guadalupana* can be found on the walls of gas stations, side by side with glossy nudes of Marilyn Monroe and other sexual icons. Images cross over both in the imagination and in reality to become cultural oxymorons. In the confusion, mother/saint/Virgin/whore are often conflated. It is difficult to fathom what all this hysteria has been about, when in fact nothing can really damage the image of the Virgin of Guadalupe, Mary, or Jesus. Their power in the collective conscious and unconscious is, for many, sacred and unshakable.

Harold Washington did not live long enough, nor had he accrued enough power, to have solidified one consistent image for people to remember him by. The black community really did believe Nelson's portrait to be slanderous and potentially damaging to his memory. And the lack of a clear sense of purpose behind the painting made it seem that much more frivolous and degrading. Needless to say, Nelson is neither Scorcese nor Goddard. His immature efforts were closer to lampooning than anything else. The painting therefore seems provocative only for provocation's sake.

Art World Narcissism

It's not a matter of right and wrong. It's freedom of expression.

—Student body treasurer,
School of the Art Institute of Chicago

It is one thing to defend an artist's right to produce any work he or she desires; it is quite different actually to approve of the subject matter of

the work, or feel one must remain silent about the content even if it is offensive to many. Artists have to question other artists who appear to engage in volatile situations for no reason other than their own narcissism.

A number of years ago a New York artist displayed abstract black-and-white paintings that he called "The Nigger Paintings." Even though there was no discernable racist image in these paintings, the title of the exhibit was enough to enrage members of the art community. Protestors marching in front of Artist's Space questioned the exhibiting artist's judgment in choosing a racist title for his work. No one involved was overtly advocating censorship, but there was a push to force the artist to rethink his intention. It is not contradictory to defend the artist's right to make whatever work he or she sees fit, while at the same time encouraging the artist to be aware of the social implications of that work. If the time comes to do battle in its defense, there should be the sense that the intention behind the work makes it worthy of this effort.

The art world thrives on freedom of expression and an attitude of "live and let live." Artists rarely ask each other to be accountable to any form of good taste or political correctness, because they themselves do not want to be asked to answer for their own work in this way. The permissiveness of this world, from students with pink hair and rings in their noses, to work that is radical and innovative in form, is not easily understandable to the world outside.

Many artists themselves are often isolated from the larger human community and the issues which affect people's daily lives. Yet they like to think of their creations and their place in the order of things as progressive. They will defend, on principle, any painting, sculpture, or film deemed too radical, avant-garde, or innovative in form or content for the prevailing consciousness to readily digest. This is understandable and essential to the maintenance of artistic freedom. But in the case of David Nelson's painting, this a priori acceptance becomes problematic. The work under attack in this instance is in no way progressive; it is politically reactionary, homophobic, tasteless, and misguided. Yet white middle-class artists, in particular, have not seen fit to analyze the content of this painting or to speak out against it. Perhaps they fear that were they truly critical of Nelson, they might sound too much like the aldermen. Perhaps they are more comfortable hiding behind the assumed unconditional right of any artist to iconoclasm, satire, and buffoonery. Or perhaps they find it unnerving even to consider that this work could be analogous to the kind of campus racial harassment which

occurred at the University of Michigan or the University of Wisconsin. And yet no matter how outrageous students' appearances may be, or how innovative in form their work might become, they are still capable of producing art whose content is reactionary. Often those who understand innovation in form are not necessarily radical in their political views, while those capable of radical analyses of content are often conservative in their acceptance of true innovation in form.

Beyond Polarization

Thinking is, indeed, essentially the negation of that which is immediately before us.

—Hegel[15]

The real barrier to understanding the complexity of this incident is that each side feels it must choose to interpret the problem as fundamentally one of censorship or of racism. In fact one can make a case for either position. But it is only when the issue is seen as simultaneously a question of censorship *and* of racism that a plan of concrete action leading to resolution can be imagined.

First, it must be understood that the actions of the aldermen were in direct violation of First Amendment rights. They are legally indefensible. There is little doubt that the ACLU suit on behalf of David Nelson will be settled in Nelson's favor, in or out of court.[16] As David Polsby, Northwestern University law professor, said on a local public-affairs TV program,

> I count no fewer than five Illinois statutes, three of them felony statutes, that were violated in this case. I think Aldermen Streeter puts the case exactly. The First Amendment was indeed transcended. There seems to be no argument whatsoever that the First Amendment was trampled underfoot like so much ticker tape by this vigilante action.[17]

The aldermen had no legal right to remove the painting. It is protected under the First Amendment as "visual speech." This protection is not contingent on the content of this speech. The painting could be picketed, protested, discussed in forums to exorcise public criticism, but it could not be forcibly removed. Yet no matter how clearly these legal

parameters are set, there are those who still believe that, given the content of the painting, such tactics were justified. Even if Nelson's actions could be seen as analogous to crying fire in a crowded theater, it would still be the responsibility of those in office to do everything they could to prevent a riot. In this case, these public officials used their official capacity to provoke one.

Although the aldermen's actions were undoubtedly illegal, their motivations must be understood. The aldermen justified their actions by calling upon a "higher moral order," which they felt themselves entrusted to enforce. Alderman Streeter and others have insisted that the First Amendment does not necessarily apply to African Americans because they were not included in the decision-making process when the U.S. Constitution was originally drafted. Members of the black community have said that the First Amendment has not protected them from racism, inequality, economic or psychological oppression. Given these feelings, as well as the aldermen's self-prescribed commitment to upholding the image of the late Harold Washington, the thinking behind their actions becomes somewhat understandable. The aldermen were torn in their identities and felt they had to choose which loyalty to uphold. This supposed conflict of interests is itself a consequence of racism.

Nonetheless, these leaders seriously violated their status as public officials. As long as the aldermen continue to focus on the racial slur inflicted by the painting, they needn't challenge their own actions or recognize their responsibility as elected officials to uphold the law. They also do not have to question the danger to civil liberties implicit in their attitude.

Second, like the aldermen, many white artists have also been guilty of using this incident to reinforce their personal fears. They have focused on censorship, a crucial issue, but they have polarized the problem until it has become a white-black conflict, forcing black, Latino, Asian, and Native-American artists in the city to choose between the importance of the issue of censorship and the concomitant issue of racism. These white artists have been unable to move intellectually and emotionally beyond their outrage that anyone would dare intrude on the sanctity of the school and make demands on artists' work. To the art world, understandably, the act of forcibly removing and consequently damaging a painting is frightening. Such actions, if allowed to continue, would ultimately result in a situation in which work of any nature, except the most neutral, would be subject to review.

At the same time that the tendencies which led to actions of the aldermen must be actively opposed, it should be recognized that the painting was extremely provocative at a time when racial tensions in the city were quite high. In this sense, exhibiting the painting was an extremely irresponsible act. As long as the art world continues to focus solely on the civil liberties issue, it avoids the vital question of the responsibility of the artist to the community in which he or she lives. But why does the predominantly white, middle-class art world choose to avoid this question of responsibility to a larger community outside its own parameters?

The Isolation of the Artist

To be modern is to know that which is not possible any more.

—Roland Barthes[18]

There is a fundamental split between the internal world of the artist and the greater world outside—which makes the art world's rare encounters with the political arena that much more difficult. One strain of this problem can be traced to the nineteenth-century myth of the "romantic artist." Locked in an isolated consciousness, alienated from society, the romantic resolved to make the inner self known. Initially romanticism was progressive, liberating, representing the struggle to break with the past and to attain an ideal embodiment of a subjective emotional truth. It glorified and idealized the autonomy of the self. But a century later this tendency now manifests itself as a hopeless break between the artist and the body politic. This separation has fostered anxiety, paranoia, and work that has become that much more cut off from its sociopolitical environment. Artists increasingly locate themselves not within a general historical context but within a privileged dialogue with their own history. Work is made about art which came before, and the art world has become increasingly hermetic, its discourse often incomprehensible to those outside its closed system.

In the postmodern era the polarizations have become even more extreme. The artist often seems no longer to have an intelligible purpose within the culture, except to articulate the final stages of its decline. There is little dialogue with the outside, at times no longer even a con-

flicting tension with the inner self to spur on the dialectic. Many artists have become comfortably uncomfortable in their alienation from the larger society and their work mirrors this resignation, blending into the existent landscape without anxiety. One cannot tell whether a work is commenting on its own exploitation, furthering that exploitation, or both. There is at times no frame of reference within which to place the image, unless one is well versed in all that is now, or once was, fashionable. The signifier has split from the signified. Meaning, which is no longer derived from a discernible context, seems hopelessly set adrift. The "aura," which Walter Benjamin refers to as the spirituality of a work, is now too often only an afterglow of glamour—trendiness, money, and success.[19]

Young artists are increasingly well aware of the depleted condition of the art world but are unable to imagine how they might connect with a larger context. Not only are they isolated in the physical and philosophical milieu in which they exist, but they also suffer from agoraphobia, the fear of stepping outside this world. Ideally, as Robert Storr has written, "An artist is measured, in the first instance, by the difficulty of the problem [he/she] chooses to confront."[20] But this is unfortunately rarely the case. Work is often measured instead by how successfully fashionable it is, or might become, in New York—how saleable and collectible. When work does take a political or social stance and does reflect the temper of the times, it is either attacked, ignored or, when accepted, then absorbed—transformed into a commodity, its power diluted.

Art schools must struggle to maintain their separateness from all of this and to uphold the integrity of the creative process. They have a great responsibility to their young artists to create some island, some refuge—not isolated from the world, but from the art scene, a place where real art issues are still confronted. But however much a school may try to exist outside the art world framework, students often leave confused about how to make a name for themselves. Both excellence and notoriety are too often seen as interchangeable paths to this same desired end. David Nelson is an example of a student seemingly unable to make these necessary distinctions.

An art school is a minisociety, a buffer between the art world and the wider culture, a place where young artists are socialized into their chosen identities. If it is successful, students learn how to think visually as well as how to execute ideas with the greatest degree of professional expertise. Schools of art should also try to train their students to think clearly, to ask themselves if their work is communicating their intention.

And faculty must try to teach students to be socially responsible for these intentions.

President Tony Jones has called the School of the Art Institute a "laboratory." It is a good analogy. In this environment, some experiments are successful and others fail miserably, but all are tested. Because of the nature of visual work, success or failure often takes place in a public forum. On May 11, black faculty, students, and staff, in particular, were outraged by Nelson's painting. Had the outside world left the school to its own processes, it would have challenged this work and opened it to in-house discussion. But there was no time for this private process. The painting was immediately transformed into a public issue.

Administrators of the school did finally meet with David Nelson, amid the early chaos around the painting, to discuss whether or not the response to his work was what he had intended. They hoped Nelson would recognize that the painting had gone way beyond any repercussions he might have imagined or desired and was now actually endangering people's welfare. They hoped he would consider removing it, not because he didn't have a right to display it but because, as the artist, he had the right to control its effect. From this conversation it was clear that Nelson was unnerved and worried about his own safety. He felt that had he removed the piece himself he would have looked like a coward to many of his peers. He could not do it. But had he the courage and wisdom to take hold of the painting's effect, he would have been the sanest person in the building at that moment.

Were the art world more rigorous and more willing to hold its own to a measure of social responsibility, were it more racially and ethnically diverse, Nelson might have understood the sociopolitical situation in Chicago. He might have cared enough to think twice about his relationship to it as an art maker. The community around him might have spurred his conscience. Had the other non-minority students understood the implications of Nelson's actions in a larger context, they might not have defended him so unequivocally. Although remaining protective of Nelson's First Amendment rights, they too might have been upset at the subject of the painting and critical of Nelson's obliviousness to the historical moment. Had all these possibilities become actualities, Nelson himself might have realized what a provocative act it would be to display such a work. He might have questioned his own motivation early on, recognizing that individuality is determined, not in isolated particularity, but in relationship to one's membership within the human community and within history. Had he thought it valuable to

take these considerations into account at that moment, he might have understood that his place within the larger collective was ultimately more important than either self-expression or self-aggrandizement. But Nelson, like many others at this moment, was incapable of this level of thinking. And, like many other student artists, he believed there was no value higher than self-expression.

A Rupture in the Continuity

The negativity everything possesses . . . is a state of privation that forces the subject to seek remedy, as such it has a positive character.

—Herbert Marcuse[21]

Consciousness and dialectical thinking can only evolve in an environment willing to tackle complexity head-on. They are best cultivated where multicultural and global issues hit up against the prevailing ideology, forcing resolution. But this ideal situation does not exist within the art world at present. Because it is not a truly multicultural society it has become inbred and philosophically impoverished. Until the demographics of the art world are transformed, instances of faulty thinking, like the painting *Mirth and Girth*, will continue, although perhaps not on such a grand scale.

The situation of the School of the Art Institute of Chicago, a primarily progressive institution, is a good example of the complexity of this problem. Like many other art schools, it is a private institution but receives some state and federal funding and part of it is built on publicly owned land. The school sits in the middle of a city that is racially and ethnically mixed, with blacks, Latinos, Asians, and Native Americans accounting for 57 percent of the population. At eighteen percent, the school's minority population is larger than most learning institutions of comparable size, cost, and status. And there have been some concerted efforts to increase numbers of minority students, faculty, and staff over the past years, but the effect has been less than dramatic.

The relatively small minority representation at all levels of the school is not the result of bad faith or racist intentions on the part of the institution; rather, it is primarily due to harsh economic and social realities. Fundamentally, it is very difficult to recruit minority applicants to

a private art school. Even when the high tuition can be subsidized, as is often the case, students still need to work to pay for food, clothing, shelter, and supplies. And because they cannot work forty hours a week and attend school at the same time, they become dependent on student loans. After four years at the B.F.A. level, or after six, when the B.F.A. and M.F.A. degrees are combined, students usually face substantial debts. And this situation has become much worse under the Reagan administration. "The intention of the Reagan administration to reduce many student-aid programs and its efforts to shift more of the burden of payment to students and their families has seriously affected low-income students and hit minority students especially hard."[22] At graduation, a student must begin to pay back these loans. But unlike doctors or lawyers, artists have no guaranteed high-paying job possibilities awaiting them. There is no secure career path to follow with clear professional rewards at the other end. This is perhaps the most discouraging reality facing minority candidates. A private institution cannot alone completely repair the damage caused by a federal policy that makes it almost impossible for minorities to attend college at all.

It is even more difficult to try to compensate for the cutbacks in education funding that have reduced the mandatory sixty minutes of music and art per week to zero in many elementary and high-school curricula. There simply is not enough money to hire the necessary experts in these areas. The result is that students are not exposed to the visual arts early on and are therefore unable to recognize their own inclination to this vocation. If they do want to attend art school, they are then at a disadvantage when they must compete for admission or struggle to keep up with those who have already had some training in these areas.

Art schools can try to compensate for these inequities with outreach programs, but these problems have become too large to be solved with small, inadequately funded projects. There needs to be an even greater commitment to these efforts for them to be at all effective. If serious changes do not happen in the schools there will continue to be a dearth of minority faculty among visual-arts educators. This lack will continue to be reflected in the general art world's racial profile.

For these and other reasons, the School of the Art Institute has often seemed unreachable and "other." There is no doubt that the school must work to change this perception of elitism through concrete efforts. But it operates at a disadvantage in this dynamic because it is often confused with its corporate partner, the Art Institute of Chicago, a world-

renowned museum, which, like many major museums, has mounted few exhibitions reflecting the ethnic and racial composition of the city that supports it. As a result, James A. Brame, president of the Illinois Alliance of Black Student Organizations, has called the museum "a closed bastion of white male Western cultural supremacy."[23] The efforts the museum has made to transform this image had simply not been sufficient.[24]

Had the museum and the school established stronger ties with other communities sooner, these feelings might not exist and this event might not have been played out as divisively as it was. There would have been built-in avenues of trust and negotiation between the Art Institute Corporation and the community, which could have been employed to deescalate the event. The anger unleashed by the aldermen was a glimpse of the return of the repressed. It had been under the surface for some time. It is therefore not in the least surprising that the school and the museum apologized for "the painting," a gesture which many thought was unnecessary or inappropriate. This conciliatory response may well have been motivated by cumulative guilt for not having bridged these polarizations earlier.

This incident has no doubt further separated the school, the museum, and the predominantly white art world from the city at large. It has exacerbated the already existent paranoia of many artists and has increased their alienation. And it is not yet over. In spite of community organizers who try to encourage open debate on the issues involved and "unity" efforts to create multicultural events, groups predominantly white or predominantly black do continue to meet, separately, to discuss the incident. But most people involved still seem unable to exorcise their own particular anger. Both sides remain myopic, retelling the narrative in terms of "us" and "them," unaware of the narrowness of their focus, unwilling to recognize their contribution to escalating racial tension. As long as these groups are comfortable in their moral superiority, they do nothing to heal an already polarized Chicago, a city that "needs no more excuses to hate."[25]

There has been unending confusion as to the meaning of events surrounding the painting episode and a deep dissension locally and nationally as to the proper response to these events. But there *has* been consensus among many groups that the school must seize this opportunity to make some serious leaps in reaching its affirmative-action goals. Internal and external task forces are at present working to build a more racially integrated art environment that attempts to reflect the demographics of the city and is more integrally connected to it. If the school

can succeed in increasing the minority population, improving its over-all sensitivity to racial issues, as well as opening itself philosophically to include the various multicultural perspectives these efforts will bring, it may truly be one of the only art schools in the country actively committed to such values.

One can hope that these gestures will encourage a national move-ment committed to creating a more culturally diverse art-educational environment. Over time, such efforts will invariably affect the larger art world, which is dependent on these institutions to train the next gener-ation of artists. If the art world does become more accessible, artists from various ethnic and racial groups, who often retain ties to their communities as well as commitment to their own ethnic history, can help bridge the unnatural split between the art world and the larger sociopolitical framework. Their collective vision, and the imagery they create, may also help develop a less individualistic, less narcissistic sense of the place of the artist in society. Such optimistic goals can only be achieved on a larger scale, however, in concurrence with a transforma-tion of economic and political conditions in this country.

As the immediate impact of the painting incident recedes, perhaps those involved will discover that the event has served to create a rupture in the continuity, one dramatic enough to expose hidden contradictions and decisive enough to force an irrevocable awareness of the need for synthesis and change.

Notes

1. A quote from Charles L. Mee, Jr., from a piece about the playwright by Eileen Blumenthal, "Blitzed-out Lovers Tell a Tale for Our Time," *New York Times*, 3 July 1988.

2. Since this event in 1988, the fellowship competition has been moved ouside the school's main buildings and is now part of the BFA/MFA graduat-ing shows, which are held in a warehouse space in Chicago owned by the cor-poration.

3. Former Alderman Bobby Rush is now a Democtratic member of the U.S. House, representing Illinois' First Congressional District.

4. *Chicago Sun-Times*, 14 May 1988.

5. Andries Botha, from an unpublished talk given at the African Studies Conference in Washington, D.C., 1988.

6. *Chicago Sun-Times,* 15 May 1988.

7. *Chicago Sun-Times,* 14 May 1988.

8. Salim Muwakkil, "Harold Washington's Fractured Legacy," *In These Times,* 25 May–7 June 1988.

9. *Chicago Tribune,* 15 May 1988.

10. *Washington Post,* 13 May 1988.

11. From the manifesto of the twentieth-century Mexican painters called "Los Interioristas," written by Arnold Belkin and Francisco Icaza, quoted in the Introduction to Shifra Goldman's *Contemporary Mexican Painting in a Time of Change* (Austin: University of Texas Press: 1977).

12. Quoted in Bill Stamets' article "Theater of Power, Theater of the Absurd," *New Art Examiner,* Summer 1988, 30.

13. Michael Brenson, "A Savage Painting Raises Troubling Questions," *New York Times,* 29 May 1988.

14. *Time,* 15 August 1988.

15. Hegel's definition of "thinking," as quoted in Herbert Marcuse, *Reason and Revolution* (Boston: Beacon Press: 1960), vii.

16. As I revised this chapter for publication here, David Nelson's civil-rights lawsuit over the seizure of *Mirth and Girth* was finally settled. On 21 September 1994 a federal judge in Chicago approved a $95,000 settlement to be paid by the city of Chicago to end the litigation. The monies are to be used to pay a portion of the fees for American Civil Liberties Union attorneys who had served as Nelson's counsel in the case. (See chapter 1, note 1, "Art Thrust into the Public Sphere," for additional information about the settlement.)

17. *Chicago Sun-Times,* 22 May 1988.

18. Roland Barthes, "Requichot et son corps," in *L'obvie et l'obtus, Essais Critiques III* (Paris: Seuil, 1982), 211.

19. This is a reference to Walter Benjamin's best-known essay, "The Work of Art in the Age of Mechanical Reproduction," to be found in *Illuminations: Essays and Reflections,* ed. Hannah Arendt (New York: Schocken, 1969), 217–251.

20. Robert Storr, "Nancy Spero: Central Issues—Peripheral Visions" in *Nancy Spero: Works Since 1950* (Syracuse, N.Y.: Everson Museum of Art, 1987).

21. Herbert Marcuse, *Reason and Revolution,* from the chapter "Science of Logic," 121–168.

22. Reginald Wilson and Manuel J. Justiz, "Minorities in Higher Education: Confronting a Time Bomb." *Educational Record*, Fall 1987–Winter 1988, 11.

23. *Chicago Sun-Times,* 26 May 1988.

24. The museum has since struggled with these contradictions and has become increasingly more deliberate in its efforts to diversify its exhibitions and educational programing.

25. *Chicago Tribune,* Editorial, 13 May 1988.

Reimagining Art Schools

There is much talk today about the twenty-first century. Will it be the era of hybridity, post-postmodernism; will it take place in cyberspace or in virtuality? Can we anticipate any progress on the economic front? Are we watching the total obliteration of public education as we have known it—and therefore the end of democracy? Can the inner cities be saved from increasing degeneration? And the natural world from ecological disaster? Can we stop the AIDS epidemic?

I begin with these global questions because art educators sometimes lose sight of these concerns. There is a tendency to focus on internal art-world and design debates, local or regional issues, the lack of government funding, or conflicts within art institutions without imagining their repercussions in a larger context—and without acknowledging that the students also live within a larger context. I therefore ask myself—routinely—about my own institution, which graduates hundreds of young artists a year: What kind of world are we sending them into? How well suited will they be to make their mark in that world?

It is a particularly good time to raise these questions, to note the social and cultural upheavals as well as the technological advances which have affected and will continue to affect the place of art in society, and to ask ourselves how our institutions might adapt to a new generation of students who will become the next generation of artists. In the 80s there was a great interest in social and cultural theory—ideas focusing on feminism, gender, multiculturalism, race, identity, and postcolonialism. Students became interested, from a philosophical standpoint, in how the world was constructed. Aware that the framework structuring their education was Eurocentric, they learned that the values placed on certain works of art were not absolute but rather were constructed within a certain paradigm. They learned to analyze that

paradigm and the notion of diversity and to experience how much larger the world became when its complexity was revealed. Art schools began scrambling to consolidate these ideas into course offerings that would bring students quickly into a sophisticated debate for which many students and faculty had previously not been prepared.

The salient aims of postmodernism—to decenter the subject, to deemphasize the object, to mix forms and disciplines for the sake of disruption at times and to liberate form itself at others—have dramatically changed the ways in which students see the world and how they approach their work. They have become more conscious of the need for ideas and for an ability to verbalize and intellectualize their intent. They demand a critical discourse. This has posed problems for art-school faculty, some of whom are comfortable working with such constructs and with difficult theoretical texts, some of whom are not. The demands of students to *talk* more, to debate more philosophical concerns—including some not immediately related to the art world—have in some institutions polarized the faculty, as students gravitate to one group over another, their alliances and allegiances changing from year to year. It has created a sense of a new and old guard, not so much marked by age as by orientation.

Postmodernism has also transformed how students choose to study and what they choose to study. At the School of the Art Institute of Chicago, which has nineteen departments, the bulk of our students have usually gravitated to the more traditional disciplines—painting, drawing, sculpture, photography. Although the applicant pool at the graduate level is still very strong in these areas, there now are an equal number of students wanting to enter time arts—video, performance, filmmaking, art and technology, sound, robotics, and holography.

Not only has the attraction to certain disciplines grown, but the concept of the work has changed as well. Students cross disciplines, moving in and out of forms. Often the medium is not as significant to them as the ideas they are struggling to actualize through that medium. Even the notion of making a specific piece of art oneself has evolved. Appropriation, collaboration, and technological advances have transformed the romantic hands-on/lone-artist model of art production. The object, or the relationship to the making of the object, is now at times intangible—removed from the physical plane. How this mode of working affects the final product in design, architecture, and art is still to be determined. While the computer, for example, has revolutionized

so many disciplines, the effects of this technology on the creative process are yet to be sufficiently explored and articulated.

Our students live in an electronic world. Brought up using the computer, it has become their main vehicle of communication. A graduate student at the School of the Art Institute of Chicago who did his undergraduate work at the University of California, Irvine, told me that his main collaborative partner is someone he met through Internet. They had never encountered each other in person and it took them a year of talking through "the Net" to realize that probably they had passed each other in the halls every day because, although they did not know this at first, they were actually both students at Irvine. The computer is simultaneously an intimate and anonymous vehicle. What does it mean to meet and work with one's art-making partner without ever having *seen* him or her? How do we prepare students for these types of interactions? How then do we measure their success?

In art production the computer often lends itself to the non-object object—the written word, the questionnaire, the electronic gallery, synthesized sound, computer-generated design, animation, virtual reality. The new technologies are not simply innovations to allow us to work in old forms more effectively; they actually create new forms of their own, such as fax art and computer-generated holography, and in the process generate new ways of thinking about the world. This work may require different aesthetic criteria that have not yet been articulated.

Students raised on these technologies, who are at home in cyberspace, construct the world differently from those of us who have come to these technologies after our vision of the world as a physical planet was already formed. Theory addressing such issues has been termed "post-modem theory"—a bit tongue in cheek. But we do know that the relationship with the computer as a tool is a significant—perhaps *the* significant—technological innovation of our lifetime. Its use will lead to possibilities we cannot envision. It will change us individually and as a society. It already has—raising ethical quandaries still to be studied.

At the same time that these more four-dimensional, or even five-dimensional, media are evolving (if four-D is time based, then five-D might be said to exist in non-physical space), there is an ongoing struggle concerning the legitimacy of more traditional forms. For example, debates still rage around painting: Is it an unredeemably bourgeois medium? Can it be saved, made relevant? Should we care? Yet no matter how much the art world denounces painting, the desire to paint remains indomitable and every year thousands of students around the world

enter art schools in the hope of making lives for themselves as artists working in the medium of paint on canvas. The 1993 Corcoran Biennial in painting was very well received and lines formed in 1994 to view Lucien Freud's retrospective at the Metropolitan Museum of Art in New York. However powerful the postmodern critique of it all has been, and however many artists work in the less-tangible world of installations, performance, and projection, the love of painting as process and object continues.

Even as the ancient practice of painting continues, the value of the artist as artisan, as crafter of the work, has proven itself to be an historical construct that can evolve. With the development of laser and Iris printing for both photography and computer-generated imagery, the person who fashions the programs, whose art is the manipulation of the computer itself, may need to be acknowledged alongside the artist as co-creator. As Jeff Koons sells his limited-edition cast porcelains for a fortune and appropriated imagery continues to hold art-status acceptance, the meaning of making one's *own* work in a physical sense, or inventing original images, has become increasingly less significant. Where is the art in art? Where is the craft? Who is the artist? Who is the craftsperson? When is the artist the technician? When is the technician the artist? These terms, which might have communicated recognizable distinctions in the past, are no longer useful in the present.

At the heart of the art-craft-design dilemma has always been the issue of utilitarianism. The functionality of a piece of work often determines which category is used to describe it and therefore its worth. In our society, artistic value has been placed on objects that are seemingly useless. Their purpose has been to enhance, not to serve any directly necessary function. Those that do—useful vessels, architectural plans—take on different and, in the romantic hierarchy of values, lesser meaning. They can be artful but they are not "art." They intersect too directly with daily existence. But some questions must be asked. Are great designers, potters, and architects not artists because their work has a functional application? Is the criteria really in the object? When talented architects and artists choose to make a functional product, is it not art? How do we categorize Frank Lloyd Wright's chairs, Dali's stage sets, Barbara Kruger's T-shirts?

Hierarchical notions assume that art must be separated from life, made of other stuff, placed in a rarified environment, judged by other standards. These somewhat obsolete dichotomies are very Eurocentric and are too often presented as absolute. While visiting South Africa I

noted that many of the art objects made by artists within that country's indigenous cultures were either useful as objects—necessary to daily life—or as part of ceremony—to aid fertility, to help the dead cross over, to protect children, to entrance or appease the spirits. There, the usefulness of an object does not create a different or lesser status as craft. Artists are understood as social agents important on many planes. This is a concept that has profoundly affected all art making in South Africa—for museums as well as for rituals, by whites as well as blacks. It is only when art is taken out of this context and brought within a European framework that these separations arise to haunt and confuse us.

Where Western culture has gone astray is that it has so rigidly separated the sacred from the profane, the spiritual from the mundane, that we cannot talk about the importance of art except in art-world terms. We are unable to discuss beauty, design, or even psychic disruption as essential to the development and care of the species. Therefore, how can we measure the inexplicable desire and need people have for aesthetics in even our most functional objects? The hand, mind, and eye of the artist, designer, fashioner of space, so prized and evident in the daily life of other cultures, is usually buried or mystified in our own. If it *is* noticed in American society, it is either scorned or falsely worshipped. Through expensive acquisition, pieces of art that may have no intrinsic psychic-social value are made valuable. And in the same vein, artwork that is truly extra-ordinary is made ordinary when transformed into an object whose value is determined by its monetary worth. All art is thus mystified by its commodification—its real social or anti-social value is obscured.

In the last five years there has been a reaction against this cultural construct. There has been a greater emphasis on art in the communities, in the public sphere, outside the commercial gallery setting, perhaps a response to the materialism of the 80s. As the bottom fell out of the art/gallery economy, young artists became aware that the likelihood of such success would be slim—a liberating, if sobering, realization. Coupled with the theoretical foundations that helped formulate an analysis of contemporary culture, it has led to the creation of a great deal of artwork that is more about connecting with a larger audience, engaging with communities and the society in general, than making an impact on the art scene. It is ironic that some of this art has actually received art-world sanction, approval, and reward.

This work that attempts to engage directly with the world is also a response to the sense that global society has become increasingly

depleted. Dire political situations around the world—in Bosnia/Herze-govina, Cuba, Haiti—the continued violence and uncertainty of South Africa, the recessive world economy, the astronomical numbers lost to AIDS in the art world alone, and whole nations like Thailand or Uganda that might simply be erased by the virus, have created a climate in which artists have taken their role as participants in the world more seriously. Many artists have become activators—active in making people aware of these issues. In addition, as the art world has become more diverse, increasing numbers of artists take their identity from their racial, eth-nic, class, or gender positions and often make work based on the con-tradictions within which they live.

At the same time that students have become more conscious of their possible usefulness and have expanded their horizons to live as artists within a larger world, we as institutions have not been as quick to adapt to the contradictions they must face. We have not necessarily helped them to cope with the reality principle. In most instances we have often chosen to ignore it. For example, we are well aware that many of our stu-dents will not actually earn a living as practicing artists, and only a small percentage will continue to be artists when they leave us. Many will find a place for themselves in art-related professions. They will work in gal-leries and museums accomplishing a whole range of tasks. They will become small-business entrepeneurs—opening restaurants, coffee shops, boutiques; fabricating items; doing art installations. They will start rock bands and sound studios. They may get rich in related profes-sions. Wherever they go they will take the training we have given them. But how realistically have we prepared them to handle the art world that they must master in order to survive as artists? How well have we pre-pared them to write grants so that they might get fellowships and buy themselves time to be artists? How well do they understand the market-place they are entering? And the political climate they will live in? We often fear focusing on these realities because to do so might compro-mise our way of educating them. But to do so might precisely shake the foundations of our institutions in ways they need to be shaken.

One element of such a refusal to incorporate this reality into our thinking is the traditional stigma against art education as a discipline. We do not encourage our students to learn to be teachers, except at the college level. And when we do have arts-education programs in our cur-riculum, we rarely think highly enough of them to insist that they have the resources and rigor they need to attract our best students. We legit-imize and hierarchize college-level teaching as a more noble profession

when we know how few jobs are out there and how few there are likely to be. We do this also when we are aware that the country is suffering, even dying, for lack of vision in the public-education system. America needs its creative people. It needs their sophistication, daring, and vision in every arena. We need to educate these people with enough confidence so that they will want to assume their adult role as full participants in society.

I learned something very important in my recent trips to South Africa: Artists were not labelled "political," or relevant to a political struggle, based solely on the content of their work—which is what happens in the American art world. Rather, they were evaluated, like everyone else, on the quality of their life's commitments. The site of the canvas, the sculpture, the installation, or the photograph is viewed as only one arena of struggle. In South Africa I met artists considered very important to the National Artists' Coalition—a major political force in South Africa—who painted landscapes or abstractions. Yet their life's work had been committed to the dismantling of apartheid. It would also not have been enough to make "political art" if they then chose to live a life removed from the lives of others. It is the interaction of the entire person that is deemed important and the recognition that our lives and work are political simply because we activate them within society.

This must be the centerpiece of the education of artists. Joseph Beuys thought that the education of artists was important because, unlike other forms of education that were focused on channeling the student, art schools were about educating the entire person. "A total work of art," he said, "is only possible in the context of the whole of society."[1] We might say that an artist can be formed only when all of the self is considered and placed within the societal context. This type of education, which focuses on developing the person, allows for the possibility of a true democracy in which everyone is capable of being, in Beuys's terms, "co-creator of a social architecture." If we offer our students only one version of what art is, what design is, what architecture is, only one sense of how to measure their own success, then we limit not only their possibilities, their development, but those of the world we are living in as well. There are many ways that art in its largest sense can be useful and, when it needs to be, subversive. Young artists should be educated with enough vision that this multiplicity of possibilities begins to emerge.

For fun I have begun to speculate what it might look like were we to start an art school from scratch now, in 1994. We might not structure it

around disciplines or media at all, for example. We might not replicate the structures we now have in place. Rather, we might choose to configure an institution around ideas to create what Joseph Beuys called a "meeting point" along the path of an artist's development—a place where artists intersect with each other, where ideas collide. Instead of having departments serve as the main module, we might create committees—on abstraction, gender, design, art and politics, narrative, identity, community-based work, theory. There might be a committee related to text and image for those who write and/or use language in their visual work. And perhaps every five years the committees would change or their emphases would change. Students could focus on different committees during their schooling, learning to work in whatever forms they needed to actualize their ideas while studying the central problem of their work—and the problem may not revolve around the medium.

Perhaps in this new model, experts in each medium would be on hand to facilitate the process of working in particular forms, but faculty might be free to move between various committees themselves. They might find they can have a more exciting exchange with someone working in another medium who shares their particular goals in art making than with a fellow painter, sculptor, designer, or video maker. Perhaps, for example, a performance artist interested in the use of space in relation to the figure would have more in common with a painter or an architect. Perhaps performers concerned with monologue would be closer in sensibility to poets and fiction writers than to more movement-based artists. But within present structures they might never meet. These types of unorthodox pairings, which seem so logical, occur too rarely within our present institutions, which are so bound to media-based departments and specific space allocations that they inhibit rather than encourage creative intersections.

Even my own institution, which prides itself on its interdisciplinary orientation, is bound by its own physicality—the equipment, the designations of space, and the maintenance of space—which makes the environment considerably less fluid than it might be. Although it may be difficult to radically restructure the space of our own institutions, it is important to imagine the ways in which such creative exchanges might occur.

Space limitations notwithstanding, traditional divisions and categories are now in flux. This upheaval is part of a major paradigm shift that must be taken into account as art schools plan curricula, teaching

objectives, and institutional goals. Today's art schools were, for the most part, conceptualized decades ago. They are on the verge of becoming obsolete, if they fail to address the needs or temperaments of a new generation of artists who make fewer allegiances to any one form, who are living in the computer age, and who want to integrate social and political concerns with the making of art.

Our job now is to offer these students a version of their options and possibilities which is as large, as diverse, as passionate as the sum total of our own experience, to give them the courage to challenge themselves, the structures of our institutions within which they study, and the larger society in which they live. How we do that, what we do to achieve it, is the subject of debate. That we do it is essential and a worthwhile mission for the last half of the last decade of the twentieth century.

Notes

1. All Joseph Beuys quotes are from his essay "Not Just a Few Are Called, But Everyone," as exerpted from *Art in Theory: 1900–1990, An Anthology of Changing Ideas*, ed. Charles Harrison and Paul Wood (Oxford: Blackwell, 1992), 889–892.

WRITING ON ART

CHAPTER 8 ❧

Imaginative Geography

To be rooted is perhaps the most important and least recognized need of the human soul.

—Simone Weill

It is part of morality not to be at home in one's home.

—Theodor Adorno²

There are times when disillusionment becomes so great that one can no longer believe in the world in which one lives, in the country, the politics, the ideology, the lies, or even the dreams. They all seem compromised, bloodstained. At such moments I have always turned to art, books, and critical theory—space outside of space, time outside of time. I have found there the momentum to continue the struggle of my own life—to intersect desire with the necessities of history.

Embodied in the work I have been drawn to are strong voices that have defied the absoluteness of what is, with the possibility of what might be. Such work has helped me to rethink the concept of home, to understand it not as the place where one is from, nor where one might be at present, but rather as the place to which one might be going. This imagined space can serve to agitate and, in contrast, to illuminate that which is no longer homelike—heimlich. No matter how engaged in the moment such work might be, it also allows for the ahistoricity of longing.

In an attempt to discuss the meaning and importance of art which is metaphorical and dialectical and to establish a broad context for the extraordinary sculpture of South African artist Andries Botha, I find it

essential first to place myself on a space/time continuum, to give my own voice specificity and a point of historical/geographical location.

I am writing this from what has been called postwar America. Outside my window yellow ribbons still encircle trees, lampposts, banisters, doorknobs. Often they are displayed with American flags. They have been there since January 15, 1991, marking the vigil—the wait for the return of troops from the Persian Gulf. These yellow bows, in fabric or plastic, appear innocent enough, remembrances of those who have gone off to fight. But they are ideologically charged—representative of the controversy between those who have believed in this war and those who have not; those who support American foreign policy and those who do not; those who have sent family members to fight in this war and those who have not.

Many in this country are jubilant, vindicated by the quick "victory" in the Middle East, their faith in America's prowess restored. But there are others—an often invisible mass of writers, artists, intellectuals, activists, thoughtful Americans of many professions—for whom this supposed triumph feels more like defeat. For those of us who mourn the loss of 100,000 Iraqi lives (a figure that grows every day), the events of the past months have provoked an inquiry into the meaning of our work, its intention, its impact on the world, and the position we must now assume within American society. There is an urgency to restore a sense of purpose to our lives, to counteract what often feels like despair.

The generation of the 1960s, which contributed to ending the war in Vietnam and to the development of consciousness about race, class, and gender, believed in our power to transform the world. Because the fact of the war in Vietnam has never stopped haunting us, we were assured that America, as a nation, also has lived in the shadow of its own nightmare, plagued by guilt, self-recrimination, and remorse for its war crimes: the killing of innocent Vietnamese citizens, destruction of an ancient civilization, portrayal of an entire population as non-human, and acceptance of the fundamental lie that the Vietnam War was rational and just. But the startling truth, now become manifest, is that what many Americans most regretted about Vietnam was not the immorality of the war itself but rather the massive U.S. defeat and the loss of honor that accompanied it. The resultant need to reestablish military supremacy in fact enabled the American people to believe in the justification to decimate Iraq.

And thus, as the war in the gulf geared up, people who already had seen the immorality America was capable of began to speak out, to pro-

test and challenge all aspects of the war, even the particular discourse and images used to represent it. Eighteen-year-olds who had never known war before took to the streets along with veteran protestors. And after the January 15 deadline came and went, we prayed that an end would come quickly. When hundreds of thousands of Spaniards, Germans, and French protested their governments' involvement in the war, we looked to Europe with expectation that the opposition there would bring sanity here. When it was clear that in spite of the impact of these efforts the war would go on, we hoped the mass of American people would come to understand its absurdity by looking at the great economic toll it was taking on already depressed resources. But although there were discussions at this time about the degeneration of American schools, massive homelessness, and serious drug problems, the United States still managed to triumph by defining success as military strength while refusing to acknowledge the breakdown of infrastructures at home.

Although we who are Americans should ostensibly be at home in the United States, in fact, many of us live as strangers in a strange land, alone, lonely, burdened by the weight of our nation's history; it is a sentiment I am certain many South Africans can well understand.

This is in fact a barbaric moment for the United States, a time that represents a return to values many thought certainly would be left behind. But instead of moving to a more global, less racially divided, more ecologically concerned world, where national boundaries become increasingly less meaningful and talk of multiculturalism and gender equality become grounded in attempts to respect difference, the "new world order" has actually come to mean a regression to nineteenth-century practices of colonialism, racism, nationalism, and the exploitation of resources. Is it any wonder that we should look with hope to the transformative power of images and the analytic potential of language?

When I travel in Europe and see the increasingly rapid and uncritical adoption of American culture into daily life, whether it be the need to consume, or the assimilation of American-style democracy, I want to say: I have seen the future. I have witnessed the degeneration that accompanies fast food, slick Hollywood movies, the dictates of advertising, flattened, cliche-ridden, watered-down values and a false sense of individual freedom based on the choice of which product to consume, a society that has never had the capability to deal with complexity, seeks homogenization of its ethnicity, speaks in platitudes that from its founding days have blatantly obliterated class and racial concerns. Beware of this society which so effectively exports itself around the

world. All these elements which seem benign in themselves together represent an insidious taking over of culture and history that will ultimately reduce the quality of life. But these might seem the too predictable wild rantings of an ungrateful American.

Given these concerns, is it any wonder I am drawn to Adorno's assertion that, "It is part of morality not to be at home in one's home"? This statement seems so timely and appropriate, not just to Americans or South Africans, but to the condition of many thoughtful people around the world. Adorno was writing about another lost home, another society gone mad. Like all intellectuals from the Frankfurt School of Critical Theory, he too was forced to flee Nazi Germany and destined to become the dialectical negation, a culture critic wherever he landed, bringing with him lessons from one of the most extreme and irrational horrors ever experienced. German intellectuals who left prewar Germany have taught us that such questions of culture and politics must be asked seriously, that creative people must function as intelligent opposition to the prevailing ideology.

But how do you know when your home is no longer your home? When you have thought and dreamed yourself beyond it? When the task that seems given to you is to challenge the foundations upon which it is built? Can artists, writers, intellectuals, those who have found a vehicle for expression, accomplish this task while also being true to their own needs, desires, personal journeys, so that their work is not simply morally, politically correct, but also representative of their emotional reality, however complex it might be?

In his essays "Reflections on Exile" and "Yeats and Decolonialization," Edward Said describes what happens when creative people, distraught with the politics of a society in which they live, try to negotiate their daily existence amid hostile forces with which they must take issue—morally, philosophically, aesthetically.[3] He describes the place where the political and the psychological conflate, where the colonized becomes the disenfranchised, the refugee, the alienated, the exile, the estranged. It is the creative person who finds a way to fight back, to reclaim, for all who live in a state of deterritorialization, an imagined space in which to live. Said writes:

> To follow Adorno is to stand away from home in order to look at it with the exile's detachment. For there is considerable merit in the practice of noting the discrepancies between various concepts and ideas and what they actually produce. We take home and language for

granted; they become nature and their underlying assumptions recede into dogma and orthodoxy. The exile knows that in a secular and contingent world, homes are always provisional. Borders and barriers, which enclose us within the safety of familiar territory can also become prisons, and are often defended beyond reason or necessity. Exiles cross borders, break barriers of thought and experience.[4]

Artists, writers, and scholars allow for the possibility that this alienated condition might lead to creative ends. They, in fact, have often become international figures because their concerns have traversed individual boundaries; their efforts to grasp the world in images and language have become translatable across societies; their dilemmas, although rooted in history, also often transcend it. They speak to the interstices, the spaces between the personal/collective, the conscious/unconscious, the historical/mythic.

When exiles create for themselves a new world in which to live and then construct that world in language, a poet, writer, or intellectual may emerge. When the imagined world takes physical form and comes to exist in two, three, or four dimensions, it may be represented as the work of a performer or as that of a visual artist. This work creates a new land, a demilitarized zone, a place of safety which defies old-world colonialization and presents a distillation of all the complexities within which one lives. Or, it may present a world beyond complexity that has imagined itself into synthesis. The work of visual art thus becomes an actual invented space that adheres to the laws of the imagination and the necessities of gravity—that which is conceivable on the conceptual and physical planes.

Artists who work in such dimensions at times cross over into alien territory, to ask difficult questions of themselves and of society, questions not usually asked by those who have enough power to ignore them. They dare to walk the liminal line where air meets land and land meets water, where the physical meets the psychical, the reality principle/the pleasure principle, the male/the female, Eros/Thanatos. Living on this line is no simple task. It involves constructing a home, not just for oneself, but for those who live outside their own society, aware they are a composite of its values yet conscious of the degree to which they stand apart. For all who insist on complexity in a world bent on homogenization, demand synthesis in the face of polarization, and long for peace in a time of war, the work of art becomes a point of focused contestation as well as refuge.

The artist, writer, and intellectual—like the exile—must learn to live with ontological insecurity. Fear and trembling might better describe the nature of the risks that must be taken, than the glamour and pleasure often associated with the creative process. Whoever thinks that this life is romantic has never tried to unseat the language of the oppressor while still oppressed, or to remain in touch with the deepest part of the self while attempting to live in the immediacy of history. Such a person has not tried to create a world *ex nihilo,* faced the dread of the blank canvas, the white page, the empty screen, or the resistance of unarticulated matter demanding to be given shape and intention.

The exile and the exile in residence are always caught comparing what exists in the present with what has existed in memory—the original home, the country of origin, which might only be the remembrance of a dream, experienced while awake. This straddling of many realities is described by Said as "contrapuntal," a term taken from music to signify the simultaneous existence of multiple dimensions.

My interest in contrapuntal endeavors has led me to the work of Andries Botha. I have found in his questions a mirror for my own, in his willingness to live within contradictions no matter how painful they may be, an antidote to bipolar thought and segregated feeling. Although it would appear that our cultural predicament—America and South Africa respectively—are light years apart, in fact his efforts create a timeless historicity that conflates distance. His work is rooted in the specificity of his homeland yet is transcendent of it. He is an artist steeped in a multiplicity of traditions who is unwilling to allow any one strain to dominate his intent.

In a sense Andries Botha is a paradigmatic transgressor: an Afrikaner profoundly concerned with the obliteration of race distinctions; a male artist focused on issues of gender and androgyny; a spiritual artist committed to the social/political/collective and public arenas; an intellectual driven by intuition; a maker of beautiful objects outraged by preciousness and commodification; a South African engaged in the daily struggles of his country, trying to live as a citizen of the world.

In such complex times when the spirit is endangered, it is precisely to these masters of impossible intersections that one needs to turn to counteract the pull of gravity with a bit of grace. It is no wonder that those of us wandering on the frontiers of many lands, desperate for a place to meet, discuss, and rest for a time, would look to artists like Andries Botha who have both facility and desire to give structured dimension to boundariless thought.

If there is a moral imperative associated with the art objective or the place of the creative thinker/artist in society, an issue hotly debated in South Africa, then it comes out of this urgency we all feel for a new home, one which encompasses the need of thoughtful people to match the complex experience of their inner condition with a location of equal integrity in the outer world. It is within the parameters of such political and "imaginative geography" that I position the work of Andries Botha.

Notes

1. This Weil quote is cited in Edward W. Said's essay "Reflections on Exile," which appeared in *Out There: Marginalization and Contemporary Cultures,* ed. Russell Ferguson, Martha Gever, Trinh T. Minh-ha, Cornel West (New York: New Museum of Contemporary Art and MIT Press, 1990), 357–366.

2. Ibid. Said takes this quote from Theodor Adorno's *Minima Moralia: Reflections From a Damaged Life* (London: Verso, 1974).

3. "Yeats and Decolonization" appears in the small collection *Nationalism, Colonialism, and Literature* (Minneapolis: University of Minnesota Press, 1990). Other essayists include Terry Eagleton and Frederic Jameson.

4. Edward W. Said, "Reflections on Exile," 365.

Andries Botha, *Sondebokke, Slvipmoordenaars, Secres En Slagoffers,* 1991, mild steel, lead, wood, wax, wire mesh, wattle. Courtesy of King Georg VI Gallery, Port Elizabeth, South Africa.

Andries Botha, fragment from *What is a Home...?*, 1995, aluminum, mild steel, expanded mettle, wax, lead, galvanized sheet metal, cane. Courtesy of the artist.

Goat Island's *We Got a Date*

I

For it is utterly decadent, in a world gone out of joint, to behave as though everything were in perfect order.[1]

Goat Island works collectively, collaboratively—slowly over time, paring down the essence of the piece "like salt in a crucible" (as D. H. Lawrence said of the stories of Edgar Allen Poe).[2] In their recent work the text is modest, the music haunting. The movement is original, excruciatingly painful, purposefully repetitive, and the narrative is rich in psychological and social complexity.

I took eight friends to the Chicago premiere of *We Got a Date*— three painters, a classicist, a psychiatrist, a labor organizer, an insurance representative, and a sculptor. The painters and the sculptor loved the choreography, which they saw, respectively, as painting and sculpting in space. However, they thought perhaps there should have been little or no use of text. The classicist, moved by the "darkness" of the piece, nonetheless bemoaned the absence of eros and longed for pleasure and some sense of catharsis. The psychiatrist, disturbed by the performers' robotlike movements, reminiscent of "the rigidity of catatonia," feared for the mental stability of the director. Trained as a literary critic, I exulted in the overdetermined, metaphoric, cipherlike quality of the work—which begged for explication.

Performance art, which operates in four dimensions, does not reconstitute itself easily into the two dimensions of words on the page. *We Got a Date* is no exception. It is a difficult piece to unravel, dependent

as it is on music, dance, movement, and narrative to fulfill its intention. The result is that there is no one vantage point from which to illuminate its complexity. Also, there is no clear way to avoid the inevitable extracting of a part from the whole. Only in the alchemical process of performance itself do all the layers and levels come together. To even approximate this experience, it is necessary to rely on many discourses: the literary/critical, the psychoanalytic, the sociological, the anthropological. Stealing from them all, one can begin to tackle its cumulative effect.

Apart from the metaphysical need of the viewer to position himself or herself critically in relationship to the piece, there is also Goat Island's deliberate attempt to physically position the piece in relationship to its audience. We Got a Date was created for a gymnasium—or some equivalent long, corridorlike space. The width then is narrowed further by the placement of the chairs, one deep in a row along each side. The audience faces directly onto the basketball court, at times so close that a stray foot might trip the performers.

But here, unlike in a game of sport, the players run behind the audience, do laps that circle around them, constantly forcing them to swivel in their chairs, to observe the discomfort of their fellow viewers, to turn 180 degrees or to risk missing the action. This physical positioning puts the audience in place to experience each excruciating movement. We see them sweat, their muscles twitch. We watch them dress and undress. We come to function like a Greek chorus both inside and outside the action. Later, as the events unravel and the atmosphere becomes sinister, like that of a witch hunt or an inquisition, we then become the jury—an impassive, silent mass, witnesses to the testimony and isolation of the players.

II

> . . . the body is the prisonhouse of the soul; . . . the
> unpleasant consequences of sin, both in this world
> and the next, can be washed away by ritual means.[3]

There are three stories told within the unravelment of the piece. The first, performed by Joan Dickinson, breaks the silence of the hypnotic movement that begins the performance. It is a tale of childhood ostracism. A young girl (Katie Bach) forces her little brother Chuck to stick his finger up the pet dachshund. "The next day," she tells us, "Martha let Chuck do the same thing to her." The result: "When Chuck told the class

about it, no one talked to Martha again until high school when she made alternate on the cheerleading squad."

How did Martha suffer the ostracism and public humiliation caused by the event? What did she feel all those years when no one would talk to her? We can only imagine the subsequent time spent on the analyst's couch as she attempted to recover from this slander. The simple story recreates the humiliation of childhood—all the ways in which we torture each other, all the ways boys abuse girls. And in so doing, it begins to raise central questions of power and domination. Why wasn't Chuck ostracized? Why wasn't he scorned? What level of trust had he betrayed in telling everyone . . . everything? Why does the body so readily become the focus of shame? How can we deconstruct power relations? Why are some in positions to be shamed and others to do the shaming?

The second story, told by Greg McCain, reveals the situation of an adult man (McCain himself?), who begins: "The last time I had sex was 1986." This takes the audience aback. 1986! We unwittingly calculate just how many years it has been. This narrative is somewhat startling. Rarely does a man in this culture admit that he has lived without sex for so long. He then describes this "last time" for us in detail. It is the prototypical one-night stand. No frills, no fluff, just all the weirdness that can occur when two strangers who feel no love decide to have sex. It is startlingly without glamor, without eroticism: "We kiss, we fondle each other. I slobber into her ear. We fuck. The whole thing takes about three minutes." Functional sex. Minimal seduction. No romance. Told hesitatingly, by someone who, although obviously pained to hear his own words, has resolved just to spill it out. We are positioned as witnesses to these confessions, which seem designed to wrench truth from the performers. But the starkness offers no guidelines to help us understand the nature of these confessions and how we might respond to them. Why are these people telling us their stories? Why are we listening? How should we be listening? As therapists? Analysts? Friends?

The third story is another episode of childhood humiliation, although this time the gender is reversed. Through an interrogation by Matthew Goulish, performer Timothy McCain reveals the story of a twelve-year-old boy (McCain?) who is seduced (raped?) by his high school math teacher, Mrs. Compton. This woman rubs up against him at lunch, finally corners him, and pulls down his underwear in the coatroom, where she has intercourse with him. An actual pair of boy's jockey shorts—an allusion to this story—becomes the object of symbolic struggle throughout.

These stories operate on an individual as well as a societal level. We, as audience, can generalize, theorize from these tales because we know such incidents to be true to our own experience. We know that when so much is thought deviant, it makes it difficult to move the body through the world and to take pleasure in it. The relationships between childhood sexuality and desire, for example, are so little understood. The subtleties of adolescence can be even more unnerving as teenagers try to come to terms with their physical needs and erotic natures. And in adulthood it can all get even worse as the longing for companionship brings such desperate loneliness that people are forced to try to satisfy the personal complexities of desire with virtual strangers. This is the human condition as told through the socio/historical matrix of American society.

The three stories are filled with past humiliations and disappointments. The present, as represented by the process of the piece itself, is a type of ritual—a ceremonial attempt to release the pain and to reveal secrets of the sacred and profane. These secrets are predominantly about sex and are therefore the most prized by this society. We like what is seamy, hidden. The telling of repression and desire is part of the talking cure of psychoanalysis. But why does it seem that this public display of personal and hidden secrets (which have been essential to the development of the individual psyche) in fact provides no real release? We feel these stories could be told ad infinitum without resolution, without absolution. The tellers cannot free themselves from the burden of the past. Like the Ancient Mariner in Coleridge's tale, who must return again and again to "stop the wedding guest" and make him or her listen to the same story, they also are enslaved by their narratives. The process of telling is, in effect, a failed attempt at exorcism or absolution, but it is met with silence and at times with disgust.

III

A man [or woman] is shamed either by being openly ridiculed and rejected or by fantasying to himself [or herself] that he [she] has been made ridiculous. In either case it is a potent sanction. But it requires an audience or at least a man's [or woman's] fantasy of an audience. Guilt does not.[4]

In a shame society, "people are chagrined about acts which we expect people to feel guilty about."[5] Such a society offers the possibility that the

responsibility for certain crimes and "deviant" desires can be absorbed by the collective. There is the sense that a person can publicly present a shameful act and that the society has the power to absolve it.

We, on the contrary, live in a guilt society, where complex emotions associated with misdeeds are privatized, personalized, hidden from the culture as a whole. In such a situation, a person may suffer guilt, although no one else may even know of "the crime," unless it is revealed to them. Perhaps this is why American society is the most psychoanalyzed and psychoanalyzable. People need some external forum where they can be relieved of past or inherited guilts (sins). Because no responsibility is taken for the individual psyche by the collective, emotions that are often culturally determined become unjustly personalized. We are therefore left with guilt. Within such a configuration, the act of telling, although an attempt to collectivize the experience and in so doing perhaps to achieve some acknowledged acceptance of it, in fact leaves the teller even more desolate.

One could say that *We Got a Date* attempts to perform a shame ritual in a guilt society. Such an impossibility accounts, in part, for the strangeness, even uncanniness (a re-membering from the collective unconscious) of viewing such an effort. The performers tell us their tales, perhaps to relive and relieve the memory. All we can offer, however, is detached observation. The isolation of these individuals is revealed as they squirm, crawl, drag themselves through elaborate, ritualized motions, while we, the audience, literally on the sidelines, seem to represent a cold, heartless, narcissistic civilization. Even though most people in the room probably can relate to the experiences directly and can remember a time when the body suffered in connection with sexuality, or sexual desire, they cannot, do not, know how to intervene in the exposition of the pain. The tone of the piece recreates this sense of cold abandonment.

This silent, hidden recognition is all that is possible in a society that does not offer agreed-upon rituals through which one can come into one's own as an adult, sexual being. Individuals are alone with this process of inculturating themselves to the prescribed roles and taboos presented by the society. There can be no catharsis, no release, no healing in a society that assumes no responsibility for the feelings or actions of the individual. *Therefore* there can be no shame rituals. Confession becomes a hollow act. No benevolent confessor waits to perform absolution. Instead there is the interrogator, the accuser, whose severe judgment and lack of generosity we all must face, if not objectively in the world, then subjectively, in our tormented moments with ourselves.

The patriarch who represents the law of the father, somehow associated with repression, death, and dis-ease, is here embodied in the sleazy character of Roy Cohn—a lawyer, an active force during the McCarthy anti-Communist trials, a witch hunter, searching to rout out all "truth." This is a strange, yet poetic choice. "Did you like the smell?" he asks Joan Dickinson (in reference to the story of Chuck, Martha, and the dachshund). "You never told anyone about Mrs. Compton?" he taunts Tim McCain. Cohn is presented as a sinister, seedy character crouched like a succubus on a tabletop. Where has he garnered the authority of what William Blake calls "The Accuser"? Why is anyone answering his questions? Will he find these three guilty of their sins? Can his judgment free them from the psychic weight of their own personal histories? "Once I decided that a man should die," says Cohn, "and do you know what happened? He did." This is an interrogator who seems above the letter of the law. In fact, Cohn is the embodiment of the law—licensed to interpret its meaning—which in all its multifarious forms is undoubtedly male, heterosexual, concerned with the perpetuation of partriarchy and the family unit as we have known it. But he is also the voice of suspicion. "Are you now or have you ever been . . . ?"— fill in the word—Communist, homosexual, lesbian, deviant.

Yet, true to the dialectical nature of *We Got a Date*, Cohn also has a story and it is also about shame, specifically related to the body. "I was shaving one morning," he says, "and I felt a lump. . . . They did a biopsy—and found I had liver cancer." But there is some innuendo here, something else going on. Is it that Cohn actually had another disease, a less acceptable disease? "You can ask my doctors," Cohn adds defensively. The role of the interrogator has shifted to Dickinson, who asks Cohn, "Why have you never married?" A strange question, but we can guess its implication:

> You are suspicious to us, Mr. Cohn. Perhaps you are not interested in women? Perhaps this is not now and has never been liver cancer. Perhaps it is something worse.

As Susan Sontag has taught us, there is always some "worse disease," some more stigmatized disease—which can be understood as a social-historical construction.

Those who know Roy Cohn's story are aware that in fact he did die of AIDS. This anti-Communist, anti-homosexual upholder of the law was gay. He lived a life of perfect duplicity. His own obsessive search for

deviance—dare I say the obvious—some displacement of the internal persecutor—the voice of guilt, transformed into his public shaming of all others who, like himself, dared to deviate from the law.

IV

> [T]he fact that the very word "pain" has its etymological home in "poena" or "punishment" reminds us that even the elementary act of naming this most interior of events entails an immediate mental somersault out of the body into the external social circumstances that can be pictured as having caused the hurt.[6]

Because there are really three variables through which the concept of the piece manifests itself, it is necessary to step back from the verbal text for a moment to read the discourse of the movement and the music as they intersect with the narrative. It is at these points of intersection that many of the ideas of the piece actually manifest themselves. It is also within the use of both eccentric and familiar movement that the personalized, ritualized gestures, routines, and patterns take on a recognizable significance as replacements for a public, collective ritual of absolution.

The fundamental metaphor and hidden premise of the piece develops around the concept that the physical body can represent the psychic body and that the two are, in fact, one. The psychic body (the unconscious, the emotions, the intangible, the soul) of a person can be damaged, wounded, distorted, tortured. It can feel pain, but as Freud understood, because we only have one word for pain, our description of this experience is imprecise. Psychic pain is made known to us in this piece through the physical body as it is stressed, distressed, pushed to its limits by the excruciating gymnastic exercise (exorcism) of the movement. This movement also seeks to reveal that we are socialized into patterns of psychic behavior through the precise regimentation and training of the physical body.

To evoke the dimensions of this metaphor, the performers must in some way both represent the individual body as well as the body politic. This is achieved through various directorial choices. Fundamentally,

these are not your usual dancers/actors/performers selected for their perfectly formed bodies or the predictable/correct ways in which they move. Lin Hixson is after something more quirky, odd, off-center, and therefore, inevitably more human.

Within the group we have two rather large, bulky, thick men who could almost be football players—brothers Greg and Tim McCain. We have an average-size woman, Joan Dickinson.[7] And we have one rather small, intensely wiry third man—Matthew Goulish. The result is a strange mixture, guaranteed to minimize the possibility of coupling within the piece in any way we might construe as conventional. Nonetheless, it is impossible to stop ourselves from speculating and attempting to make some familiar arrangement out of this configuration, which leads to such questioning as: Is this some type of symbolic family: mother, father, and two oversized sons? Or three brothers and a sister? Or two gay men and a heterosexual couple? We try to orient ourselves by arranging these performers along the conventional lines of gender and sexuality. In anticipation of our unconscious desire to make these performers fit our expectations, the group reconfigures constantly during the course of the action.

In the early sequences they appear as four large children innocent in their movements and their dress. At the first performances of this piece, they were wearing long, navy blue bermuda shorts, white T-shirts, thick-soled black shoes—awkwardly hip in their clunkiness. But these four look too big, too grown-up, and too strange to be dressed this way. Is this recess? Summer camp or boot camp? They do odd kangaroo jumps, not like hopscotch, not like dance, not gymnastics, nothing quite so recognizable, but some sort of ritualized don't-step-on-the-cracks game that they all seem to know. They jump, run, tussle. They roll. Then they do the sequence again, backwards. But there is no comfort in the repetition, no sure sense of what these movements are about.

In the next sequence, the Indian music (which could sound Latin) leads to a type of social dancing—routines like the cha-cha, the meringue, the illusion of ballroom dancing as learned in gym class—sterile, sexless—form the uncomfortable, all-too-familiar beginnings of socialization. Boys who have trouble learning the dance steps are being taught to lead. Girls who pick these steps up easily are being taught not to. Sometimes the big guys wrestle as if they were in the schoolyard, then pull back, compose themselves, remembering their commitments to the more adult routines. We are witnesses to the taming of natural energy—the reluctant transition from male bonding to the prescribed union

with the female, from libidinally non-directed play to the socialized public display of sublimated sexuality.

The first spoken narrative breaks the movement's hypnotic silence like pebbles ripple the surface of a lake. Those of us trained to deal with language are relieved, grateful for the rupture in the strange ritualized code which, like abstract painting, offers few clues for us to decipher its intent with confidence. One can speculate as to the meaning of these movements; there is a tendency to want to make sense of them and to decode them. Such deconstructing demands referents. These the audience must bring to the piece, which puts us all on the same equally shaky ground.

The innocence of the movement, like the innocence of childhood itself, is broken by the memory of humiliation. Dickinson tells the Chuck/Martha/dachshund story, sings a song from early memory in a distracted childlike voice. This is followed by movements that reflect an intimation of death. Greg McCain pulls himself across the floor, elbows bent, using the strength of his upper body, as if he has been wounded in battle and has lost all use of his legs—a strange kind of castration. He drags his limp body across the floor as if he were a slug, and then collapses in exhaustion. But just when you think all has been spent, he stands up and walks away, casually, as if nothing has occurred. There are also sleeping bodies, curled in fetal-like positions. These remind us of the ancient Greeks, who believed that

> It is in sleep that the soul (psyche) best shows its divine nature; it is in sleep that it enjoys a certain insight into the future; and this is apparently because it is freest in sleep . . . for sleep is the nearest approach to death in living experience.[8]

Although the content of the narratives refer to Eros, the movement is actually closer to Thanatos. Goulish and Dickinson are carried like corpses, frozen in the arms of the McCains, who appear colossal as they hold these smaller bodies out in front of them, the way people in inconsolable grief might carry the sacrificial dead off a battlefield. Throughout, there are reminders of repression in the stiff movements—bodies frozen in time. There are also tableaus, stills, allusions to Goya, to the *Discus Thrower,* to Bosch's *Cure for Madness,* to the *Dying Gaul,* to Caravaggio's *Martyre de St. Matthew.* Memories, historical references, cultural clues, history embedded visually in the individual and collective psyche.

It would seem that the prototype for this strange non-movement movement, non-dance dance, is the mechanism of repression itself, which, in Freud's terms, functions somewhat like this: There is great energy gathered, cathected around an event that is too horrible for the psyche to simply absorb, too difficult for it to comprehend and still survive. The imprint of the event must be hidden, so that life (as the individual has known it) can go on. Over time layers upon layers of experience bury the trauma, but it does not disappear. The memory tries to reassert itself. The psyche tries to keep it hidden. Great amounts of energy are expended to keep it from making itself known to the conscious self. The unconscious, in conflict, seeks both to release this repressed entity, and thus to free itself from it, and also to keep it hidden within its domain. The memory struggles to be released, to release itself, to heal and cure the psyche, but it is now glutted with its own power and frightened to leave its place of comfortable discomfort within the psyche from which it can control behavior. Its specificity of meaning, the source of these contortions, long ago has been obscured. Not even the unconscious can recall its definitive original shape. This is where psychoanalysis can be useful. It functions as a retrieval system for information the self has tried to hide from itself, in fear of what recognition might bring.

The range of this strange ambivalence is represented in the action of the performers and in the choice of music. In sequence, there is the rigidity that Wilhelm Reich so rightly associated with repression and hysteria, followed by rapid spurts, bursts of energy, catharsis. When, for example, the Ronnettes sing, "The night we met I knew I needed you so and if I had the chance I'd never let you go," the music offers a much-needed comic relief. There is the exuberance of decathexis—a frantic rush into action, a respite from the depressing bind of language and the tragic story of the one-night stand. The second half of the piece is dominated by the Hasil Adkins' "We Got a Date"—a piece of music so raspy, slimy, sinister, grating, and dramatic that it covers everything in a grimy darkness and sets the tone for all that is to come.

As the piece progresses, these gawky children begin to grow up. But, it seems, they will never enjoy the dream of romantic, domestic bliss. This group refuses to get their socially prescribed roles straight. They do the same movements—forwards, backwards, upside down. They return to them, perhaps for solace. We've seen them at it before—that strange pointing off in the distance. The tableaus again. They know the routines. And we are beginning to speak their language. The movements have

become familiar—that little pivoting of the kneecap, those jumps and rolls, like circus families who build human pyramids, then jump through rings of fire. There is even a parody wedding. The bride changes into her funky wedding dress in front of the audience. This moment of disrobing might be a bit of eroticism in an otherwise almost anti-erotic piece about sexuality, but it is defrayed by her white cotton girl's underpants and 50s-style cotton bra. She is made to look too schoolgirlish here to be really provocative. And the groom's suit is too small. He looks awkward, gawky. They barely touch. Goulish wears a spaghetti-strap dress over his Bermuda shorts. He looks shorn, a Falconetti-like woman impersonator, cross-dresser. This strange androgynous figure tries to intervene in the marriage, but like a Marx Brothers routine, whenever he comes close he gets tossed off to the side. The bride leaves the groom to try to recover him, reconnect with him. The boy's underwear continues to be pulled and pushed, fought over like some obscure object of exchange.

When they get tired of all this, the bride is dumped on the prostrate figure of Greg McCain, who tries to drag himself across the gym floor with her weight on top. What can we make of this? In such a context of symbolic movement, the wedding should bring happiness and joy but instead it brings numbness, death, some type of torturous repetitive routine. What have they done to deserve such a fate? Is there to be no joy in their lives, as they try to adopt adult roles, as they try to channel their energy into conventional forms? Could this be a balletic history of the social evolution of the species—a veritable rearticulation of *Civilization and Its Discontents,* in movement?

V

Even the virtually inexpressible experience of one man [or woman] is still a human experience and therefore, even at the highest degree of subjectivity, a social one.[9]

We have moved from innocence to experience, from the wild energy of youth to the perverse socialization that accompanies adolescence to the tired rituals of adulthood and, finally, the end of life. Now we have arrived at the intersection of the individual and the mass through the persona of Roy Cohn. He has come to embody the weird contradictions and fears

that result from a system that restricts the entire range of human thought, emotion, vision, and desire. His stance as a known anti-Communist and baiter of homosexuals has been made ludicrous by the disclosure of his own homosexuality. Does he not in himself represent the range of possible contradictions that have emerged through this piece? And, as such, is it not fitting that he, as interrogator, is now interrogated? The humiliator, the humiliated? He who shames, now shamed?

As bizarre as it may seem, Roy Cohn has become a metaphor for all that has gone wrong, for all that is not as it appears to be. He is the devil, Beelzebub, Satan, the fallen angel, who sits on the left hand of God. He is the concentration camp guard, the sadistic autocrat: "Count," he commands Greg McCain in reference to the one-night stand. "How many bodily fluids were exchanged?" "Let's see," says McCain hesitantly, "there was saliva, semen, the woman's fluid. . . ." "No," shouts Cohn, "Count: one saliva, two semen . . . I love to count," says Cohn in a crazed and wicked tone. He loves to extract from experience only what can be quantified and contained.

But how can one quantify sexuality? Why would one want to? Why should it become an object of controversy at all? Why do people end up in one-night stands? Why does marriage become a parody of itself? Where does it go wrong? Is the source of all these problems to be found, as Foucault would have us believe, in the idealization of the bourgeois family?[10] Or is it in the designation of gender? Or are they one and the same—all the result of the societal regulations that administer socialization and, in so doing, patriarchy?

In the absence of a public forum at which to confess how far most of us deviate from the image of perfection, beauty, glamour imposed on us from outside, how can we shake off false needs to come to a deeper, truer, freer desire? Is psychoanalysis such a forum or is it not itself the place where sexuality is most problematized? And finally, what have these issues to do with the experience of theater and/or performance?

In an attempt to address these problems as they relate to *We Got a Date*, it is useful to return to the ancient Greeks, for whom theater served a complex, curative, psychoanalytic relationship to society. It concerned itself with issues of the law, the family, repression, the will of the state. Tragedy addressed the problem of the individual's attempt to operate with autonomous desire in the face of immutable law. There was a shared iconography of meaning. Everyone knew the complexity of this law and everyone knew the price that had to be paid for the deep, unconscious imaginings of such crimes as incest, patricide, matricide.

Here clear social boundaries were placed on desire and the human psyche struggled to tailor itself to suit them.

Because the Greeks were aware that these restrictions were difficult for the individual to adhere to, they acted out these deep desires onstage, to give shape to them, to exorcise them, and ultimately to show the consequences of those who could not control their need to act upon them. In this way, through art itself, individual deviance was collectivized and transcended. The theater served as a circumscribed space for the return of the repressed. It allowed what was most feared to manifest itself while still protecting the law. There was temporary resolution and the experience served as a collective psychoanalysis. But how can the pain, loneliness, and isolation of the modern condition or the suffering caused by such sophisticated repression and repressive desublimation find release when there is no shared discourse nor any agreed-upon need for a collective, therapeutic experience?

Performance, in its refusal to adhere to theatrical conventions, affords an opportunity to tackle these questions with a rawness long gone from most traditional theater. It allows for the speaking of the unspeakable in forms that can still unnerve, upset, confront, and, at times, release. The language and movement is often privatized, as we have seen here, yet, through ritualized repetition of an internally coherent symbology, the shared cultural touchstones soon become apparent as the individual psyche collides with that of the collective.

At the end of *We Got a Date,* Roy Cohn, in a 50s Las Vegas lamé jacket, sits alone at the table using a dropper to drip stage blood from his eyes. While this red substance runs down his face he blindfolds himself with a shiny bandage and gropes his way to the center of the floor. Dickinson finds him there, leads and positions him as her partner. He is now the hanged man—a degenerate, sleazy, lounge-act Oedipus[11]— a pariah who has sinned against the state. Like his predecessor, he also has taken his own sight. We can only speculate as to the meaning of this act. Perhaps he is like Gloucester in *King Lear,* who only found the truth once blinded and then could say, "I stumbled when I saw."

As partners, Goulish and Dickinson begin to dance—a slow dance. The spotlight is on them. It might be romantic had we not been through the pain of the past hour and a half; were this not Roy Cohn/Oedipus blindfolded, as if about to be hung or to pin the tail on the donkey. They do the now familiar little knee twist and point. The lights go out. It's almost a prom, a bar mitzvah, a wedding—some ritualized rite of passage. Yet one senses that it is only the end and in no way a new beginning.

In this darkened room, without knowing what we can expect (and no sense of how this piece could end), we begin to hear something known, but at first it seems too unlikely to be true: The Four Seasons doing their version of "I'm Dreaming of a White Christmas." From where did this come? Why this song? Why now? It should seem completely inappropriate and yet miraculously, it works—a perfect release. Finally you can cry.

Although nothing is resolved, we are offered an uncanny moment of nostalgia and longing that recreates the strangeness/straightness of the 50s with its dream of the perfect family and the fantasied white Christmas, which was usually reduced to slush. The familiar/familial soppiness of this song, and the images it evokes, unite us.

And while these two dance, the others cut in, to have their turn with Cohn. Finally Greg McCain and Cohn curl up, immobile, on the floor in the darkness. "To sleep perchance to dream." However, like pods from *The Invasion of the Body Snatchers*, or latent bundles of cathected energy waiting to be released, they might steal your psyche or your soul. What is this strange non-resolution/resolution? These final pairings? Certainly they are not there to mirror a happy ending, or a reassertion of heterosexual or homosexual bliss. No one ideological/philosophical/sexual preference has won, not in this modern/postmodern world. The drama has simply, successfully come to a close.

As a result, we are reminded that the alchemy of well-made art rests in its ability to argue the problem through analogy and metaphor, to make unpredictable juxtapositions work, and when their rightness becomes manifest, to end. Such is the process of *We Got a Date*. The lights fade. There is no more. If hope is to be found within the parameters of this worldview, it is in its exquisite, uncompromised revelation of pain, and in the possibility that a poetically structured, collaborative work, based on individual, isolated moments of humiliation, can cross over to capture the history of repression and collective despair.

Notes

1. Ernst Fischer, *The Necessity of Art* (New York: Penguin, 1959), 72.

2. D. H. Lawrence, "Edgar Allan Poe," in *Studies in Classic American Literature* (New York: Doubleday Anchor, 1951).

3. E. R. Dodds, *The Greeks and the Irrational* (Berkeley: University of California Press, 1951), 149.

4. Ruth Benedict, *The Chrysanthemum and the Sword* (New York: Houghton Mufflin, 1946), 223.

5. Benedict, 222.

6. Elaine Scarry, *The Body in Pain: The Making and Unmaking of the World* (Oxford: Oxford University Press, 1985), 16.

7. Joan Dickinson left the group soon after this piece and Karen Christopher subsequently replaced her. Bryan Saner and Antonio Poppe have since replaced the McCain brothers.

8. Dodds, 135.

9. Fischer, 168.

10. Reference to Michel Foucault's theory as developed in *The History of Sexuality* (New York: Vintage, 1980).

11. Lin Hixson used this expression when we discussed the piece in Chicago.

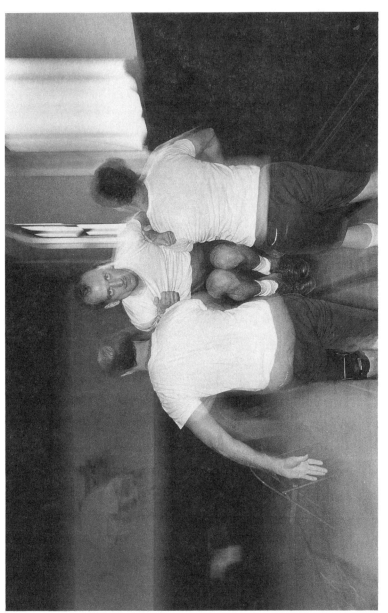

From Goat Island's *We Got A Date*, 1990. Courtesy of Robert C. V. Lieberman.

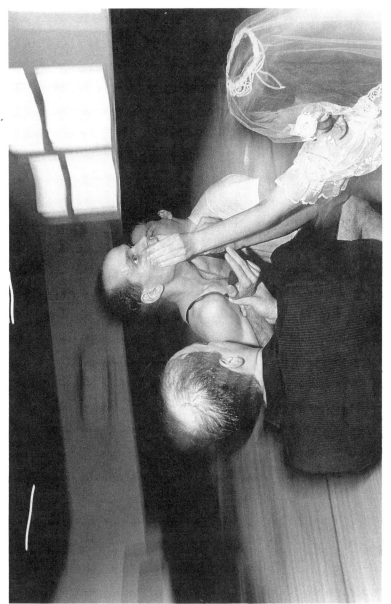

From Goat Island's *We Got A Date*, 1990. Courtesy of Robert C. V. Lieberman.

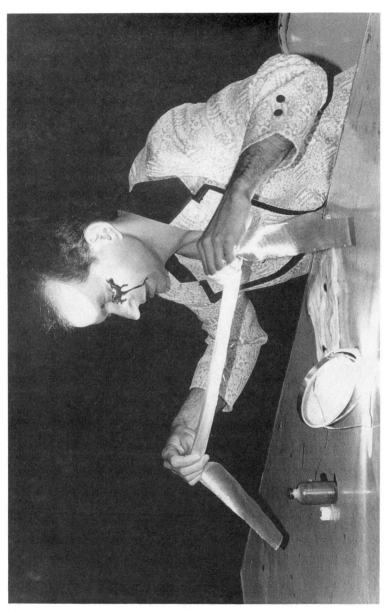

From Goat Island's *We Got A Date*, 1990. Courtesy of Robert C. V. Lieberman.

CHAPTER 10 ❧

From Tantrums to Prayer

Psychotherapy stops short. It invites confession but omits prayer.

—James Hillman[1]

Although it is not billed as such, Goat Island's *Can't Take Johnny to the Funeral,*[2] appears to be the completion of a trilogy that began with *Soldier, Child, Tortured Man* (1988). It deals not only with the humiliations, fears, longings—the dark side of childhood, adolescence, and adulthood—but with the extreme vulnerability of infancy. This earliest condition, over which we have no control, profoundly shapes the individual psyche. It also is mirrored in the external societal structures that are often an unconscious response to unresolved fears and memories of abuse.

A squared circle forces the audience into a more intimate, more intense confrontation with the action than the basketball court arrangement of the earlier work. The synchronized movements are back, presenting us once again with an initially mystifying and indecipherable code. There is the same commitment to gesture, action, the same hyperactivity of movement, but here the tension and strenuousness are augmented by a microphone used sparingly to capture the heavy breathing and the pounding of blood in the performers' heads. Because they are willing to work themselves to exhaustion to alleviate the anxious urgency that appears to motivate the work, we become committed to their excessive action. Once again we are willing to suspend analysis of its symbolic meaning while we give ourselves over to its unravelling.

This time the inspiration for the movement was derived in part from sports photos—rugby, la crosse, water polo—frozen motion,

reenlivened, translated into dance and gymnastics. At times the empha-
sis is directional, reminiscent of the *kata*, the patterned movement of
karate, or various Native American rituals that honor the north, south,
east, and west—an obeisance to direction, as if it were, as a concept, a
player in this drama. Here, as in other Goat Island works, we cannot
resist wondering what has set these performers into motion and what
hidden necessity motivates their actions.

When the performers do slow down enough for us to study them,
they appear as lost souls, wandering inside their own intent, a bit like
the inhabitants of Dante's hell, caught in a circle or *malebolge* of pain, a
bit like the figures of Bosch's *The Garden of Earthly Delights*. They
appear as part of some social interaction, yet inevitably apart. At times
they become ontologically regressed, adults reduced to infancy writhing
in convulsions. They also appear phylogenically regressed, wild dogs
gnawing on each others' legs, humans reduced to a lesser species. Or
they simply appear helpless, deranged inmates of a sanitorium, caught
in the privacy and isolation of their illness. They reenact obsessive pat-
terns and appear to obey silent directives whose meaning they alone can
understand.

Karen Christopher rotates her finger in the air and swivels her body
while looking sidelong off into space. Matthew Goulish spins and col-
lapses as if shot; with a circular movement of his hand he appears to
torque down his mouth. There are times when they do interact. Chris-
topher crawls into a fetal position on top of Greg McCain's prone body.
Tim McCain rubs his head against Goulish's leg like a cat. They each
cover their mouths with their hands, politely, almost with a slight gasp,
as if they are remembering some unspeakable event, as if they must
restrain the words they might otherwise utter. All motion is laboriously
synchronized, separate scenarios woven into one complex, perfectly
choreographed nightmare.

At intervals someone separates from the group to make a statement,
not unlike the shattering of silence in *We Got a Date*. Language once
again is a way out of the abstraction of movement. It breaks the repeti-
tion and allows us, as audience, to enter in. However, here the confes-
sional narrative has been reduced to fragments: "I'm not an American";
"I didn't come out of my mother's stomach like my sister"; "I have no
close folk. My parents died when I was a kid"; "A big family must be fun.
I imagine it makes you feel you belong to something"; "What do we do
with all our fears? Do we whisper them within a loved one's ear?" We

sense that these are internal monologues about insecurity, madness, glimmers of thoughts that have obsessed these characters for some time.

With this piece Goat Island crosses some serious boundaries. Four anatomically correct rubber dolls, gruesome, primitive, naked, are cradled in one instance and smashed, thrown, slammed against the floor in the next. Finally, the performers decapitate these strange babies, eat some white sticky substance from inside the hollow of their plastic heads and lick their fingers clean. They suck the matter out of the brain, perhaps robbing the infants of their faculties and then feeding on their strength. We are reminded of Goya's depiction of a voracious *Saturn Devouring His Son*. Cannibalism, infanticide, vampirism, a host of allusions are generated. Is the child really the metaphoric child inside the adult—fragile, forever underdeveloped and abused? Is it the child of our ahistorical/hysterical memories? Perhaps this dismembering is designed to facilitate a re-membering, a return to the pain of the past, a reenactment of physical abuse and psychological battering. These acts appear to be reminders of the capriciousness of a callous adult world that has attempted to deny its own vulnerability by disallowing helplessness in others.

Within this painful drama something unexpected, humorous, ironic, and deeply moving occurs. We watch the players swath Tim in bandages, his almost naked, unguarded body transformed into the object of an inexplicable surgical process that miraculously turns him into a saint. He becomes the crucified Christ carefully brought down from the cross—a reminder of the murder of the individual by the mass, the death of higher consciousness by that which is base, the assassination of love by fear. He becomes St. Sebastian, riddled with arrows. And then the generic soldier returned from Vietnam or the Gulf. It is a statement about maleness, martyrdom, and murder all in one.

Here the mythology of Catholicism is taken from Poussin and Caravaggio. Painterly poses are struck. The martyred figure is positioned center stage while the performers group themselves around him in exaggerated gestures. They create tableaux and then revolve in several directions, reconfiguring their frozen formations as they go. They appear to be angels, witnesses, looking heavenward to escape the irrational brutality of humans and the humiliations of earth.

As reviewers have noted, the work is disturbing, in part because it is designed to unseat the earliest traumas, those disturbances of the heart to which we are never resigned. Here Goat Island has reenacted the progression of individual consciousness as it moves from the

unformed, unarticulated, purposeless mass/mess of infancy, to the particular focused point of concentration—a state that is achieved only through pain and reflection. Although it does not seem that Goat Island has found God, it does appear that, with a bit of irony, they have discovered the need to acknowledge the spirit.

By the end the players have become elevated and silenced by the process undertaken. They have moved from regression to contemplation, from frenetic motion to stillness, and, finally, from tantrums to prayer.

Notes

1. James Hillman, *Thoughts of the Heart*, Eranos Lectures, no. 2 (Dallas: Spring Publications, 1981), 23.

2. *Can't Take Johnny to the Funeral* premiered on 29 May 1991 in Ghent, Belgium. I saw the piece in final rehearsals in May 1991 and then at its Chicago premiere in October 1991.

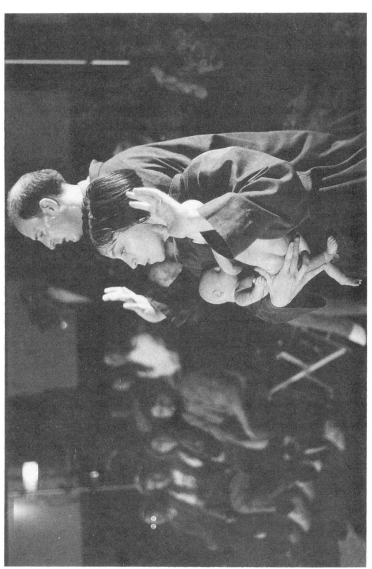

From Goat Island's *Can't Take Johnny to the Funeral*, 1993. Courtesy of Eileen Ryan.

From Goat Island's *Can't Take Johnny to the Funeral*, 1993. Courtesy of Alan Crumlish.

From Goat Island's *Can't Take Johnny to the Funeral*, 1993. Courtesy of Eileen Ryan.

Drawing from the Subtle Body

I

Of all the work produced by the rather diverse group known as the Chicago Imagists, that of Barbara Rossi has been perhaps the most consistently elusive. Words such as "hermetic," "mystical," and "meditative" reflect the enigma this work has presented for viewers and critics alike. Writers have made reference to the fact that her drawings and paintings have alluded to the spiritual and to the technique of making them that often has been laborious—refined to a state of flawlessness. Although there has always been the sense that the pastel colors, comic imagery, and flat, perfected surfaces were designed to direct the viewer to a world of grave seriousness, the specific concerns of this world have never been sufficiently explored. To grasp the extent of the works' complexity, it is best to view them assembled *en masse* and in an historical progression. It then becomes clear that Rossi has defined an elaborate visual language that refers to a symbolic order of her own creation. The more we can trace the evolution of this language, the more its particular grammar reveals itself to us. This decipherment of meaning requires an exploration of her work in relationship to both Christian and Indian iconography, to psychoanalytic discourse, and to those more philosophical questions that determine the work's sociological context. Such an approach might be called a "hermeneutic of the visible," an interpretation of the visual as text.[1]

To begin this process, it probably should be said that the work of all serious artists in some way marks the evolution of their own consciousness, and that the act of producing it, whether recognized as such or not, has a metaphysical component. But it is not true that such work necessarily charts the path of the artist's own spiritual development while also

reflecting in its central concern the concept of the evolution of the psyche as a universal construct. For an artist to give shape to this more encompassing process visually is not an easy task. It is particularly difficult when there is no adequate common iconography, no shared symbolic language. And it becomes risky and lonely to concentrate on such issues, particularly in a society that has no real interest in or commitment to them.

The one outlet allowed for such concerns is psychoanalysis and in this arena Americans, for the most part, have chosen Freud the scientist over Jung the spiritualist. Even in dealing with the irrational we tend to value the rational more. A symbolic language and mythology about the workings of the conscious and unconscious are articulated by the discipline of psychology, but this is a limited vocabulary, which has entered into mainstream society in a very diluted form. Constructs such as the Oedipus complex, neurosis, and dream interpretation take on an almost comically literal meaning when translated into the one-dimensionality of popular culture. Through their assimilation, these ideas have lost their mythic resonance.

In its American incarnation, the psychoanalytic process becomes available (in theory) to anyone willing to dredge up the complexities of his or her childhood. But the real goal is to come through the process better able to negotiate dealings on the physical plane. There is no collective understanding that different levels of psychic development do exist, or that such development is an ongoing process that people might pursue for its own more spiritual, less tangible results.

When one evaluates such poetic and intellectual limitations, Rossi's work can be understood as rare in American society in general and within the body of modern art in particular. Very early on Rossi's work stops being concerned with subjectivity. Although influenced by psychoanalytic theory, it is after something more Other, more outrageous, beyond the topography of the unconscious. The artist seems to want to defy the Heideggerean notion: "We moderns arrived too late for the gods and too soon for Being."[2] She appears to be interested in that which links the human intellect and spirit to a greater force. And she utilizes both Christian and Indian iconography to represent a reality more diverse and larger than either philosophical system alone could offer.

But how can a spiritual person, not necessarily belonging to a particular denomination, find a place for herself and her work in a society that is cool to such issues and in an art world that is even cooler? "Analysis rather than apotheosis is the name of modern art," writes critic

Donald Kuspit.[3] Nonetheless, in Rossi's work we experience the effort to build a connection with the metaphysical and beyond. To approach such difficult concerns it has been necessary to synthesize an iconography that is neither too abstract nor too literal, neither too accessible nor too obscure. Not an Andres Serrano representing familiar icons in an often glorious but at times sensational way, nor a Salman Rushdie caught between cultural expectations, Rossi appears to be an artist who desires subtlety and mystery. Personally hidden, she directs the scenes from behind, creating work that could be ponderous but in fact appears light and even playful.

This is an artist who seeks to seduce and to cajole. It is therefore understandable that she begins with the one shared symbolic system American society does provide—the world of popular culture, especially its flattened imagery that appears familiar and comiclike. She then manipulates its apparent banality to her own ends. There appears to be a premise operating here that the more fantasied the images, the more they will disarm, dislocate, and free both the viewer and the work from the reality principle. It would seem that she pushes color, shape, and form to resonate at a higher frequency, to bypass perhaps even the intellect and thus to affect the psyche and soul more directly.

How successfully Rossi can use the flat, *reductio ad absurdum* comic form to achieve such goals can be judged by the work itself. Certainly what is most difficult about Rossi's art—the abstractness and ultimately the privateness of the discourse—can in part be attributed to the challenge of this attempt. It would seem that she has had to look outside our society to find a new vocabulary, one with adequate resonance to address the complexity of her interests yet free from the weightiness of overt Christian iconography. It is not surprising that over time her early interest in Indian philosophy and painting has come to predominate.

II

From the beginning Rossi's work seems to be focused on specific concerns: how to represent the geography of the psyche in visual imagery; how to chart the development of the soul; how to give physical shape to the metaphysical; and how to develop a personal symbolic system through which to explain, examine, and represent the process through which individuals come to understand their lives in relationship to a cosmic order.

These issues are already present in the "Head and Shoulders" series, which contains more than 150 pieces in various media spanning the period between 1967 through 1975. This series, which is the one most often associated with Rossi, worked itself through as drawings in graphite and colored pencil, as quilts composed of etchings and acquatints, and as acrylic and oil paintings on Plexiglas, Masonite, and canvas. These images-built-upon-images, which always miraculously evolved into abstract heads and shoulders, became a "Self-Portrait" series, a "Man of Sorrows" series, a "Weeping Woman" series, and those named for various fantasied personages.

In practice Rossi would start work out from the center of these pieces, conscious that the images were evolving into heads and shoulders yet committed to a free and uncensored process that allowed the mind to wander. When she first began this series she was not yet familiar with the work of the Hairy Who. This stream of imagery just seemed to pour out of her own subjectivity to create little worlds, continuous but self-contained. The images often made allusions to sexuality, to distortions and objectifications of body parts. At times they were grotesque, each image appearing in a random order, yet each in some way suggestive of the next—a foot, bit of rope, shoe here; an iron, arm, vagina there—an endless compilation of shapes and figures. The repetition of this same process, at times even the same imagery, allowed a free fall of thoughts to pass before the mind. A release of often cacophonous psychic noise manifested itself visually, as in music when a wall of sound is constructed so densely that no one individual sound can at first be distinguished from the rest. Like *japa*, the repetition of the mantra in Indian meditative practice, the very act of drawing/painting served to clear the mind, thereby achieving a cessation of mental activity. The repetition ultimately led to a more one-pointed, focused, silent vision. But at this stage the emphasis was on permissiveness and a basic trust in the ability of the mind to present some order, even if the order, constructed like that of the Surrealists, was designed to disorder the established structures of normal perception.

These drawings in some way mirror how the mind works, what is juxtaposed to what, how patterns are ultimately constructed. The concept, although perhaps not intentional at the time, seems as closely related to the narrative techniques of stream of consciousness or automatic writing as to the game of the "exquisite corpse." The "conglomerates of psychical formations," as Freud calls them, are like the images of dreams.[4] They have a cohesion simply because they all come from the

same unconscious, but their relationship to each other cannot always easily be read. In yoga philosophy it is understood that:

> The life of the mind consists of an uninterrupted succession of thoughts, all linked to one another rather like the separate frames of a movie film that produces an impression of an unbroken movement when projected at a specific speed; or like the waters of a river whose very swirling melds them into one continuous flow.[5]

The world that unravels itself is often playful, comic, unpredictable, and unexpected. Yet there is a density to this work that could border on frightening. It is not surprising to learn that during this time Rossi was also looking to late Gothic engravers of Germany and the Netherlands, as well as to certifiably insane artists such as Adolph Wölfli, to those referred to by Ernst Kris in his *Psychoanalytic Explorations of Art*,[6] and to those represented in the Hans Prinzhorn collection. Because of the dark surreal dimension of Rossi's work, her world seems to share these artists' similarly claustrophobic and hermetic sensibility. At times there is the sense of being trapped in the density of the work. In *Yellow Fant* (1971–72), for example, a sardonic red fringe bordering the entire aspect of the face creates a macabre grotesque aspect. There is often a feeling that the work *had* to be made.

However, the works of this period are as deliberate as they are spontaneous, as trusting that some organic order will evolve as they are meticulously controlled. This early work also conveys the sense of the artist as a very refined educated eye attempting to discover a way to work that does not mire her in the weight of art history or the dictates of the contemporary art world. At this period it would seem she is attempting to work beyond traditional iconographic formats and to liberate her imagination.

The "Heads and Shoulders" series comes to represent both the personal world of the artist and also, in reflection, the mass of visual and cultural information that bombards us every day and that we must organize or go mad. The fun for the viewer is in trying to find recognizable images and connections between imagery, the larger face in the mass of individual images, the whole through its parts. Even the process of discovering individual images can be meditative for the viewer. In retrospect one might read *Black Rock Top* (1972), a painting whose woven surface contains mesh holes through which figurative parts of the body fall, as some type of early allusion to the veil of Maya—the mask of illu-

sion that separates humanity from a sense of reality uncluttered with worldly desires. Here something has cut through, pierced the illusion exposing the mind's unfocused clutter.

It is not surprising that Rossi moves easily among many forms. The quilts are also built piece by piece, unit by unit, until finally there is a whole. The process is literal, intense, tedious. Obsessive labor, a meditative quality, overt sensuality, and eroticism in form and content exist in these quilts, mirroring in their tactility the world of breasts, genitalia, and vaginal openings found in the earlier work. These are traditional American quilts in high relief—with satin and feathers, a bit of down-home, brothel, and bridal gown—all done with great bravado during a period when the New York art scene was focused on Minimalism. Objects of high kitsch, to be worshiped for their eccentricity, for their surreality, they dislocate the world around us—to what end, we are not sure.

<div style="text-align:center">III</div>

All the natural movements of the soul are controlled
by laws analogous to those of physical gravity.
Grace is the only exception.[7]

It would seem that the "Head and Shoulders" series could have continued to infinity, but at a certain point the work took a dramatic turn. After Rossi painted *Fishing Picture* (1975) and *Z-Zone* (1975), the meditation becomes more purposeful. A vocabulary develops that one is able to read with greater ease, and the images begin to take on new meanings in relationship to each other. The format shifts from vertical to horizontal. Here the figurative images are fashioned from designs for sailors' knots, Celtic knots, Girl Scout knots. Knots become a consistent way of representing the body and the human condition.

This next series, which I call the "Navigation" series, is completely dependent on the use of abstract figurative elements to tell its story. These drawings and paintings are quite sparse in form and are modeled on Siennese works with a strong narrative component. There are only a few characters or players in these dramas, a few lines used to designate the landscape and the distance that must be traveled. The artist functions as the director positioning the players, dictating their movements.

But the drama is almost silent. Unlike the noisy antics of the "Head and Shoulders" series, the ostensible purpose of the action here is to move the small, at times knotted figures across the canvas from the left to right. This passage may be with the assistance of a motorized car and pulley as in *A Ski Drawing* (1976) or with the help of a small boat as in *Sailing Stage* (1975); it may be on a jump rope as in *A Dance Drawing* (1975) or by catapult as in the painting *Beach Dancing* (1977). Through whatever means possible the figure struggles its way across the surface. The actual significance of this at times comical-looking process could not be more serious. It represents the journey of the soul from the world of the ego to the place of detachment, from an obsession with the self to an absorption of the self into that which is greater. It is the voyage from the earthly plane to a more spiritual one. This onerous drama, which has enormous resonance in much of Christian art and literature, is here represented with playful abstract simplicity.

The dynamic is frequently constructed as follows: A large figure, usually a thick, looming, knotted mass, watches from the left like a cloud blocking the light. It serves as an observer—or in yoga terms, "a witness"—to the movement of the more fragile figurative knot that struggles across the landscape to reach the receiver on the other side. The receiver is usually a grid or latticelike construction. It also is reminiscent of some type of knotted circuitry. The reference to an electronic receiver is a visual pun. The knotted figure, perhaps the ego-driven personality, is here the main character. It moves like a signal across the surface. If it reaches the receiver on the other side, the message or code is complete. If it does not, the signal will be short circuited and the journey aborted.

The crossing from left to right is fraught with perils. Its precariousness is made quite clear by the contortions the figures must make to reach the other side. The visual language of the crossing is often mechanical—with pulleys, levers, wheels. Perhaps there is some allusion to mystic writers who see the spiritual world as governed by certain familiar contingencies that we usually associate with material reality. Simone Weil, for example, writes: "There are necessity and laws in the realm of grace, likewise even hell has its laws. . . . So has heaven."[8]

This might be thought of as the physics of transcendence. While the figure moves from hell to heaven, from earth to non-earth, from the physical to the spiritual, we can see the various obstacles that determine how successfully the knotted ego is received and thus relieved of its trials. Certainly it requires great effort, especially if one is to ever reach the

far shore of *moksha*—which signifies release. The journey can be read as allegorical: *A Ski Drawing* plays with the notion of the cart pulling the soul—or, as Hindu mythology offers, the body as the chariot transports the soul as driver. A cart moved by a pulley—a soul pulled by the body, the body pulled by the soul. All of these associations are generated by the visual-linguistic play that forms a rebus, or dream puzzle. Such details of meaning are deliberate in this work. For example, the ladder, lattice, waves, or staircases we encounter often have seven steps that may allude to the seven *chakras*—the seven sacred points of the body. When we count eight steps it is likely, given Rossi's absorption in Indian philosophy, that these refer to the eight stages of yoga consciousness.

This is the landscape of the spiritual—of the imaginary and allegorical. The one who can best interpret such imagery, Freud tells us in *The Interpretation of Dreams*, is the one who "can detect the truth from the misshapen picture."[9] The one who can best read the image is the one who can see it as reflected and reversed in water—or the fluid substance of the unconscious.

Water, or the allusion to water, is indeed often encountered in the course of this visual-linguistic journey. In *Flower Returning to the H_2O* (1978) (the title is a reference to the painting of *St. John Returning to the Desert* by Giovanni di Paolo), a flower has dipped down into the water, perhaps to be baptized (perhaps to incarnate before leaving the planet altogether). "To dive into the water," Heinrich Zimmer tells us, means "to delve into the mystery of Maya, to quest after the ultimate secret of life."[10]

In *Swimmers Be* (1978–79) the figures are at various stages of immersion: one with its head out and body in; another with its legs out, almost walking on the surface. Although some figures are freer than others, all are involved in a ritual baptism. A certain joy appears in this work, a sense that the tedious process also can be fun, that there is color, design, and movement along the way.

In *A Lake in a Dream* (1976) the reference to water comes clearly from the symbolic dreamlife of the artist. There really is no lake. The rather bulbous-shaped figure at the center represents the body as a series of knots, nooses, a landscape of intersecting rivulets. It is almost a topographical map mirroring the contour of the land or the sea— scarred, streaked, marked by the passage of time. On the right is a small knotted figure—an unevolved version of the larger central figure. Here we can understand the yoga concept of *nadis*—the labyrinthine passages through which the more subtle elements of breath and fluids

travel throughout the subtle body as through a waterway. Yet as the figure becomes bulkier and more cumbersome, the likelihood of real movement seems almost impossible. And perhaps most significant, the noose is already around the neck, about to be tightened. The claustrophobia of the condition is acute. Or as Freud says of the terror of dreams: "One tries to move forward but finds oneself glued to the spot, or tries to reach something but is held up by a series of obstacles."[11]

In *A Bark Drawing* (1976) the condition becomes even worse. Here the figure moving across the landscape actually is a mousetrap. The knots become reminiscent of the metal wires that are set to snap the neck of the mouse in two. The mousetrap, like other visual puns, is a representation of the body as the ultimate trap whose catch needs to be released. Release, which is a crucial concept of Indian philosophy, means the end of the physical body as we know it.

The mousetrap can in fact be read as figure. The cross-hatching at the base is reminiscent of the lotus posture; the snap above looks once again like a noose around the neck. Here, too, a very mundane image is used to represent a sophisticated concept. The spirit is trapped on the physical plane, held down by the body and the law of gravity. Grace is finally the force that will allow the spirit to break from the thickness of the body as matter and to ascend. Or, "As a bird imprisoned by a net will fly up to heaven after the tails are cut, so the adept's soul, released from the bonds of desire by the knife of yoga escapes forever from the prison of Samsara."[12] *Samsara*, the cycle of death and rebirth, is directly related to the *chakras*. These are the Gordian knots a person must cut through with the tools of meditation in order to elevate the spirit and leave the cycle of reincarnation. Wherever we look in this series of drawings, the knots are struggling to move, to be released. Throughout, Rossi shows us that there *is* someplace to go and that in fact what is interesting is how that release might occur. There seems to be confidence that once we are able to leave the physical plane, the pain of the struggle will cease.

In *Final Rose* (1980), as in *De Risen* (1978), the figures have actually ascended from the horizon. The setting for *Final Rose* appears to be Chutes and Ladders, or Parchese, or some board game. Perhaps this is a pun for a bored game, the boring game of life and death, where a few throws of the dice can nail you down or get you off the board, out of the bored, finally rose or risen forever. Here a phallic lingam, still knotted, but altogether less restricted, takes central place. Almost freed from its moorings, it appears to represent transcendence. In *De Risen* the vulva-like shape has left the horizontal line altogether: ascendence is possible.

But in *O Infants Aired! O Plateaux Perdus!* (1980) there is sadness. Life as we know it exists on the horizontal line. Life as we wish it to be exists above. These embryonic figures are half-below. They have not even reached the mundane plane. They are submerged in the fetal state, overshadowed, about to be snatched by anonymous plastic-gloved hands. Perhaps these surgical hands that have come to steal them before birth, to keep them from life: "O Plateaux Perdus," the lost plateaus. Perhaps they have missed the opportunity to incarnate, to experience this plane and thus remain unevolved, undifferentiated, and subterranean.

Throughout all the work, and particularly in this series, Rossi takes on the difficult task of representing the yogic subtle body, sometimes known as the astral, or the psychical body—that which is impressed and acted upon by the physical body. She can only allude to it through the creation of metaphor and a lightness of being that the knotted figures seem able to achieve. Their non-corporeality enables them to levitate out of this dimension, to transcend it and to be released. In fact we actually can plot the axis of life, death, afterlife, and "beforelife." We can determine where these characters are in their own progression by paying close attention to the vertical and horizontal. In this work Rossi shares the traditional aim of Hindu image makers: both give visual shape to that which cannot be seen.

<div align="center">IV</div>

Though the outward symbolization in images is strikingly erotic, the connotations of almost all the forms are almost exclusively allegorical.[13]

By the time we come to *Sleepers* (1982), *Two Lights* (1982), and *Orange A.M.* (1983), Rossi has become immersed not only in the content of Indian painting but also in its form. Here we begin to see literal representations, even parodies, of *Nayika* paintings. These paintings from the late seventeenth and early eighteenth centuries in one of their many aspects depict the tortured lover (nayika/nayaka, female/male, heroine/hero, respectively) as she or he awaits the return of the absented lover. For the most part, the one who waits is a woman, often Radha, the one waited for is usually Krishna. Radha is portrayed as visibly suffering until his return. These paintings depict this love affair between a mortal

and a god as erotic, joyous, and often painful. But Rossi uses this form to allude to waiting—a concept she extends to take on even more complex significance.

Nayika paintings are usually set in a bedroom, a living room, or the Indian equivalent of a parlor. There is often a couch, a rug, a pitcher, a few precious symbolic objects. At times they are set outside, at the place of rendezvous. Excess is represented in a lush world, in an array of food presented as a banquet, or in the opulence of dress. The waiting comes to signify both the lover bereft, without the loved one, and also the soul of the individual longing for the sight and feel of the divine. The touch of Krishna, made physical and erotic, is a symbolic representation of the experience of god reaching out to the mortal being. Eroticism here is used to express the ineffable.

Sleepers seems almost modelled directly after the remarkable *Nayika* painting *Reaching Out Stealthily*—a painting that Rossi did not see until after she had completed her own. In her representation of the sleep state, as in the Indian version, balance is precarious. The perilous angle of the knotted figures in both is presented to best display their tortured, tightly wound condition. Rossi creates a two-tiered drama to allow for greater narrative possibilities, a technique used in several works completed during this period. We read from top to bottom and establish our relationship hierarchically. *Sleepers* is erotic. The figures are tangled in their own desire and/or psychic confusion.

In these paintings there are often pairings of male/female, yin/yang. In *Two Lights*, the moon representing the male and the sun representing the female are both out and full simultaneously. The sleeping figure, the writhing figure, is here even more delicately balanced. She waits on the edge of the couch, almost falling off, attempting to defy gravity.

In *Orange A.M.* the wiry-haired figure, who appears to be female looks rudely awakened; she is frazzled and frightened, confused about where she is. "She who waits for her lover," as they say of *Nayika* paintings, "with the couch of love prepared."[14] But there is irony here. This couch seems a bit more like an electric chair than a divan. The serenity and silence of the "Navigation" series is gone and there is an agitation to these images that creates a high-pitched disquietude.

Among this period of "waiting" paintings are those that represent more hell than heaven, more physical pain than erotic gratification. In *El Sombrero* (1982) and *Crucifixion by a Thread* (1983) the image is of a tortured figure, waiting in a state of agony. These figures, although quite strange and buglike, are more easily identified with and identifiable.

They seem corporeal, more overtly humanoid, more grounded by earthly constraints than any thus far. A successful tension exists between the viewer of the scene being enacted and the subject being tortured. We are somehow implicated, watching the torture but unable to assist the victim. As witnesses, *we* have replaced the looming mass on the left. And there is now no longer a journey to be made; in fact, these paintings are about the restriction of movement. The figures are hung by a thread, pierced by a sheet, pulled this way and that as they have some secret wrung from them. Or perhaps they are saints suffering a prescribed purgation. We have no way to understand the terms of the world in which we have found ourselves. And the ambiguity of our own position to these suffering creatures, our voyeuristic relationship to their pain, produces anxiety.

Rossi depicts two types of crucifixions—horizontal and vertical. In *Crucifixion by a Thread* we once again see the canvas divided into two tiers. In the upper panel, the figure is being pulled by some unknown source looming above, beyond the frame. The figure seems stuck between the tables, stretched by a sheet and thus kept from falling. Balance is again a serious issue, one over which the figure has little control. The body hangs down, but the arms stretch out, simulating a cross. Here the idea of being pulled in two directions simultaneously becomes literal. One is forced to resee the cross as a form that resembles the human figure—pointing down to earth and up to that which is beyond earth, to the horizontal landscape and to the possibility of a vertical ascension. The cross signifies the point of intersection.

The flattened surface, the contorted figures, the bold coloration, and the divided narrative canvas represents the use of Indian painterly conventions to express the Christian fixation with the crucifixion. In the top frame the figure lies on what might be an operating table. There is also a sense of waiting, just as one waits in a hospital room for the doctor to perform some medical ritual, or where one waits for the mad scientist to finish off the experiment or for the torturer to end a life.

In the bottom frame, a silent Kafkaesque setting reminiscent of "In the Penal Colony" replaces the howl of the upper panel. A strange, mechanical, gray, buglike figure, hung by its feet and arms, lies half-up/half-down on a blood-red table. Cool colors delineate the walls and there is the possibility of hope offered by the escape of a window and the soft, luminous pink light emanating from behind. The thread might be severed and the creature released, but the question remains: released to what and by whom?

This delicate yet absolute thread holds a symbolic meaning in Indian mythology. Hindu men wear a threadlike wrap under their garments to remind them always of the larger universe where they play such a small role. "The sacred thread is the outward and visible symbol of the sutra-man thread spirit on which all the individual existences in the universe are strung like gems, and by which all are inseparably linked to their source."[15] This use of the thread might also be a reference to the words of St. John of the Cross, who said that we could be held to this earth by "a thread or a ton of bricks."[16] What is fascinating in this painting is that Rossi is able to evoke a sense of suffering and sinister forces beyond the canvas, without betraying the coolness of her usual style. Perhaps the aloofness reflects her own recognition that suffering is inevitable.

El Sombrero was inspired by Hispanic folk art with its blood-splattered statues of the suffering Jesus. Here the seemingly crucified figure is covered with red dots. He is hoisted upon something like a gynecologist's chair, twisted on the rack and hung upside down, like an inverted ladder. Perhaps he is intended to reflect our own sense of spiritual misdirection. As Simone Weil writes: "May that which is low in us go downward so that which is high can go upward. For we are wrong side upward."[17] These paintings leave us in a state of agitation. Will these creatures be released? And if they continue to suffer will their suffering be redemptive? That is, will it ever end?

The waiting theme continues in the next series of colored pencil drawings (1984–1988), which show the figure caught in a more silent, less dramatic type of suffering. *Lady in a Cross Section of Her Enclosure* (1984) presents the body in a yoga stance simulating one of the various *asanas* (postures). The cross-sectioning of the body allows us to imagine the astral body, the subtle body, the planes of reality housed within the psychical body. One can see not only the child within the mother but the potential child within the potential mother as well. "Her Enclosure" refers to the physical body, to the fact that it encloses the spiritual. It also alludes to the understanding that both the physical and the psychic body are capable of suffering. Perhaps her destiny is to weep, to feel sadness, to be female and be crucified. The tears fall like blood from the stigmata. The whole room is a cross section—a section of the cross. Perhaps the square on the floor mirrors the quadrangularity of the room and thereby reflects the parameters of her space. How does one measure the dimensions of one's earthly condition? How does one represent the

convergence of the material and the metaphoric, of the body and the spirit?

In *Farmer and Furrow* (1984) the sacred points seem engraved into the body. The hand, farmed like the land with its lines and furrows, is reminiscent of palmistry. The rivulets appear as the landscape of one's own destiny etched into the palm. These lines reveal what we bring to this life, how we create our destiny while here, and the relationship between the two. The title invites us to ask: Who is the farmer? What is being furrowed? It would appear that once again a force has descended from beyond to do the torturing. We have missed the moment of castration or decapitation, the moment, as poet W. S. Merwin writes, "When the nails are kissing the fingers good-bye."[18] We see only the sadistic result—the bleeding, weeping hand, the gaping wounds. The fingers with their sheared edges remain around the frame to remind us of what has been lost. Perhaps it is another visual pun and we are supposed to remember that there are nails that are wedded to the hand as well as those that affix the body to the cross.

Mumtric (1987) also offers a cross section. The title alludes to another cross of sorts, that between mom or mum and tantric. Here we have the tantric mother, perhaps the sexualized mother, the figure within the figure who stands on the sacred stone, the lingam used to represent the phallus. We see male and female genitalia, the child within the female, the child within the child; we see the cycle of death and rebirth figured to infinity, overlapping the sacred as worshipped in the brahma-cow visage.

Balance as well as waiting seem central in all the drawings of this period. In *Graces Waiting for Transformation* (1985) the three figures all support each other quite literally. The central figure is balanced on a ball, the outer two on spindly points. In *Broken Ladder Figure and Her Supporters* (1984), which is taken from an early German engraving of the Holy Trinity, the central figure balances very precariously on a broken ladder, while two older maternal figures wait on the sidelines. "The Broken Ladder Figure," like Christ in the early engraving, is central. But there is a cynicism here. Will the ladder allow her to ascend to heaven or does the break signify that she has lost her chance? Can this female Christ continue to keep her balance on such a fragmented structure while spanning two worlds? In the upper background a couch appears as in a dream of earthly comfort. Will one ever be able to end the balancing act and rest, or will that only lead to material gratification and never satisfy the deeper layers of the human soul?

If there is purgatory in Rossi's work, these drawings are its represen-
tation. They reflect pain but perhaps possibility, neither descension nor
ascension. They are about the absence of movement, the absence of the
divine, time out of time. There seems to be nowhere to go. These figures
must simply hold their place, hold their stance, and wait for infinity.

V

*En sa moytie, ma moytie je recolle—to her half, I
rejoin my own half.*[19]

If there is a paradise to be found in this arduous journey it comes in the
most recent series, the Krishna/Radha paintings: *K. & R. D. & D.* (1988-
89), *Duo Do O!: Dancing Diptych* (1989), and *Coup* (1990). These
express *bhaki*—the relational love between god and the devotee. This
series, spanning 1988 to the present, concerns coupling—male/female,
sexual/spiritual, heaven/earth. These paintings are about the possibility
of reclaiming the body, the erotic, through the spiritual. In Indian
mythology, Radha occupies a very central place. She is portrayed as a
married woman like the famous *gopis*, or cowmaidens, and she also is
pulled out of a conjugal situation by her passionate love for Krishna.
This makes her *parakiya*—one who loves outside of marriage. In nor-
mal circumstances this would be a very shameful state to be in, yet when
the seduction is caused by love of god or Krishna, the meaning is
changed. Here this relationship represents the power of divine love to
transcend all domesticity. Radha becomes inextricably identified with
Krishna's *shakti*—his female cosmic energy, the underlying force that
empowers him. Their relationship represents Krishna's own need to be
loved by humanity and is a continuation of the *Nayika* theme. But here
the love is requited. No one waits. No one is abandoned. The coupling
is finally successful.

There is a coolness and flatness about the way these works are
painted, which is in startling juxtaposition to the hotness of the subject.
Nothing is static; everything is charged with *shakti*. Even the bowls of
fruit are active and denote passion. The figures seem weightless; their
steps defy gravity. They are transfixed by the dance, precisely involved
in the moment. There is no need for a future or a laborious passage. They
are already having a wild raucous time, in the body yet outside the body,

of the earth yet free from the weight of the earth. In *Coup*, for instance, the figures are so entwined that it becomes difficult to tell where Krishna's arms end and Radha's begin. This is the closest Rossi has come to Indian painting and the closest Krishna and Radha have come to being portrayed by Rossi as gendered sexualized beings. This play and lightness has not been in her work to this extent since the original spontaneity of the "Head and Shoulders" series. We cannot help but imagine that some aspect or phase of the journey has finally come to an end.

VI

In philosopher Boethius's plan for conversion he suggests that one must look inside oneself (*intra nos*), outside oneself (*extra nos*), and finally above oneself (*supra nos*). Only then can one find release. It would seem that we have followed this prescription and have passed through various synthetic iconographic worlds to arrive.

What is most interesting about Rossi's approach is that it does not exclude philosophical systems. Contradictions, multiplicities of meaning of both East and West are allowed to coexist. The erotic and material can represent the spiritual. In discussing this work we can talk as much about *rasa* (essentialized feeling) as about epiphany, as much about *shakti* (cosmic energy) as about grace. For a Western audience the significance of these concepts and images is still somewhat elusive and therefore problematic. But the code that was once so difficult because it was so personal is now linked to larger, more objectively accessible mythologies, enabling us to decipher her work.

Through mythic narratives, Rossi has tried to find a way to see the transcendent in the mundane, the spiritual in the material, strength in fragility, and fragility in strength. She has attempted to image heaven on earth, hell on earth, and the possibility of abandoning such metaphoric locations altogether. The process of coming to understand the work is a slow one. Yet such effort can lead to the realization that we are all crucified by a thread, trapped in a cross section of our enclosure, navigating from left to right across a desert of our own invention as we attempt to defy the laws of gravity to seek a bit of grace. What is reassuring about this work is that Rossi does offer a way out, a means of egress. And if at first this exit does not seem easy to access, at least it is available to all who are willing to learn the code and embark on the journey, however tenuous their vehicle of transport may be.

Notes

1. Diane L. Eck, *Darsan: Seeing the Divine Image in India* (Pennsylvania: Anima Books, 1981), 14.

2. J. G. Merquior, *From Prague to Paris: A Critique of Structuralist and Post-Structuralist Theory* (London: Verso, 1986), 225.

3. Donald Kuspit, *The Existential/Activist Painter* (New Brunswick: Rutgers University Press, 1986), 12.

4. Sigmund Freud, *The Interpretation of Dreams* (New York: Avon Books, 1965), 136.

5. Jean Varenne, *Yoga and the Hindu Tradition,* trans. Derek Coltman (Chicago: University of Chicago Press, 1976), 87.

6. For more information on this subject see Ernst Kris, *Psychoanalytic Explorations of Art* (New York: Schocken, 1952).

7. Simone Weil, *Gravity and Grace* (New York: Octagon Books, 1979), 45.

8. Ibid., 145.

9. Freud, 130.

10. Heinrich Zimmer, ed. Joseph Campbell, *Myths and Symbols in Indian Art and Civilization* (Princeton, N.J.: Princeton University Press, 1976), 34.

11. Freud, 371.

12. Varenne, 127.

13. Zimmer, 137.

14. B. N. Goswany, *The Essence of Indian Art* (San Francisco: Asian Art Museum, 1986), 61.

15. Zimmer, 183.

16. An aphorism the artist mentioned in discussion.

17. Weil, 81.

18. From W. S. Merwin's poem, "The Nails," in W. S. Merwin, *The Second Four Books of Poems* (Port Townsend: Copper Canyon Press, 1993), 22.

19. Roland Barthes, *A Lover's Discourse* (New York: Hill and Wang, 1978), 226.

Barbara Rossi, *Flower Returning to the H_2O*, 1978, acrylic on Masonite and wood frame, $25^1/_8$ x $31^1/_4$ x $1^3/_4$ inches. Courtesy of Phyllis Kind Gallery, Chicago; photo by William H. Bengtson.

Barbara Rossi, *El Sombrero*, 1982, acrylic on Masonite and wood frame, 45 x 35⁷/₈ x 1⁷/₈ inches. Courtesy of Phyllis Kind Gallery, Chicago; photo by William H. Bengtson.

Barbara Rossi, *Crucifixions by a Thread*, 1983, acrylic on Masonite and wood frame, 31⁵/₈ x 25⁵/₈ x 1³/₈ inches. Courtesy of Phyllis Kind Gallery, Chicago; photo by William H. Bengtson.

Barbara Rossi, *Coup*, 1990, acrylic on linen, 32 x 48 inches. Courtesy of Phyllis Kind Gallery, Chicago; photo by William H. Bengtson.

Lineaments of Desire

Seen in retrospect, Christina Ramberg's work provides its own context. These complex paintings reveal to us a progression through which the artist has addressed issues of gender definition, the objectification of the female, the movement toward androgyny, the interaction between historical and emotional time, as well as the more painterly issues of balance, symmetry, and synedoche, which mark the physiognomy of her work.

Throughout the paintings, which date from 1970–1982, the torso as urn has presented the pictorial plane upon which individual and cultural unrest has struggled for resolution.[1] The artist's attempts to understand complex relationships and contradictions, both conscious and unconscious, have led her to shape, reshape, annihilate, and regenerate the figure. Perhaps this is why there seems a natural correspondence between her work and that of the seventeenth-century metaphysical poets, who, through metaphor and conceit, sought to bring unity to a fallen world. These poets believed the human form to be a microcosm, "a little world made cunningly,"[2] which they envisioned as a small mirror in whose reflection the relationship between the physical and the metaphysical, the mundane and the spiritual could be revealed.

In "Church Porch," seventeenth-century poet George Herbert wrote:

25

. . . Salute thyself: see what thy soul doth wear.
Dare to look in thy chest, for 'tis thine own:
And tumble up and down what thou find'st there. . . .

76

Sum up at night, what thou hast done by day;
And in the morning, what thou hast to do.

Dresse and undress thy soul: mark the decay
And growth of it: if wish thy watch, that too
 Be down, then wind up both; since we shall be
 Most surely judged, make thy accounts agree.[3]

Clothes, on or off, the act of dressing or undressing, of grooming one's body and, by "divine analogy,"[4] one's psyche and soul to meet the world are metaphors that Christina Ramberg has developed in her work from the beginning. Even in the most recent paintings (1987–88), where the figure at first seems absent, we soon find that, in fact, it is still central, although more abstracted than in the earlier work. The meticulous surface that once successfully deflected the viewer from too readily understanding the import of the images—and the control that kept the anxious object securely in place—are now no longer necessary. In the new panels the artist has created a unity in which form and content are equally concerned with the same issues of equanimity and balance. This integration marks a dramatic shift. It inspires us to go back and study the artist's intention—where Christina Ramberg as painter wanted her work to lead us, as well as the more unconscious directions that she herself might, to this day, find inexplicable. Both aspects help us to understand the nature of the artist's journey—where she began and how she has reached the place of contemplation she now presents in her work.

> *Day after day I have sat in my chair turning a symbol over in my mind, exploring all its details . . .*
> *attempting to substitute particulars for an abstraction like that of algebra.*
>
> —W. B. Yeats[5]

The earliest paintings (1968–69) are about being observed as one prepares oneself to be seen; in these, a good-natured innocence combines with a sophisticated interest in gesture, style, fashion, and the accoutrements of femininity. *Hair* (1969), *Dull Quilt* (1968), and *Cabbage Head* (1968) are small, carefully executed, cropped in close, as if one were looking at the back of someone's head, or even one's own head, reflected in a small, dressing-table mirror. It is as if we have come upon an image in reflection, but when we turn to locate the actual body that has cast it there is none to be found. These heads, parts, and pieces remain unidentified. When we are given a face, as in *Rose's Woe* (1969), it is anon-

ymous, obscured by the handkerchief Rose uses to dry her tears. In *Sore Head* (1968) the hair stands on end, punk before its time, comic-book style, designating fright or pain. Hair, Christina Ramberg says, interested her, because it is "manipulatable." It can be sculpted, moved, arranged more readily than any other body part. Beautifully polished nails move through the strands, patting, matting, cupping its textured surface. The artist is representing the act of parting the hair, anatomizing the parts, isolating units of the female form, focusing on them, as women often do, trying to get them right.

In these paintings style seems rooted in a particular time and place, but we are not sure where or when. There is the illusion of retrospective specificity. It might be the 30s, 40s, or even 50s. But in fact the clothes from *Lola La Rue* (1969) or *Pearl Rainbow* (1969) are not from any one period. They are fantasy garments; platform shoes that no one could ever walk in; exaggerated hair styles that could never be achieved, layered, textured, magically coordinated to match the patterning of the shoes, the lace on the long-line girdle. Little bits of trim represent gesture, limbs, hands held up in prayer. We feel we are within the traditional American, feminine psyche, etched in rose appliqués corny and nostalgic. Fashion here already parodies itself, preparing women to go out into the world transformed by bits of artifice. This playfulness and bite reappears later in *Glamour Guide* (1973), where Ramberg presents us with the eyebrows of our choice—decals that fascinated her during lunch hours at Woolworth's. It was in such five-and-ten-cent stores, poring over the myriad possible beauty potions, that girls growing up in the 50s first became aware that perhaps they were too plain and needed some adjustment. But too plain for what? For whom? *Glamour Guide* allows us to rectify the situation. Choose the arch that suits you best—a curve like that of Marie Antoinette? A lilt like Hedy Lamar's? A choice that might change your life, make you glamorous and ultimately enviable.

The series of paintings that begin with *Corset Urn* (1970) manifest the same interest in pattern, shape, synecdoche that mark the earliest work, but in this group the artist pushes the issue of women's relationship to their bodies and to the dressing of their bodies a bit further. The corsetted bodice, no matter how elegantly painted, no matter how intimately or imaginatively rendered as disembodied form, as urn, will always, nonetheless, bring with it historical, political, and social implications. The cinched, wrapped, bandaged, bonded, constrained figure of woman, the hour-glass ideal has, over time, come to signify psychic

unfreedom. Defined by external forces, victims of fashion and style, few women have ever owned their own bodies, lived in them as if they were their own. Beauty has always been a thing apart, an attribute bestowed from outside—most often by men.

Shady Lacey (1971), Shadow Panel (1971), Black Widow (1971), Satin Hanky (1972), Istrian River Lady (1974), and Waiting Lady (1972) establish a complex relationship between the woman getting dressed and an unspecified voyeur watching, perhaps through a crack in the door or an unshaded window. The paintings themselves embody the tension between passive and active, seer and seen, surveyor and surveyed. In this work there is never nakedness. Even in Hand (1971) the elongated white fingers and the "pregnant palm"[6] are portrayed as dressed—constrained by a white cloth pulled taut. The female is always painted as the nude in John Berger's sense, always undressed but nonetheless clothed in an enveloping gaze coming from outside the canvas. "Nakedness reveals itself. Nudity is placed on display," writes Berger.[7] There are always just enough garments to entice, to call attention to those body parts that are revealed and those that are not.

In these paintings the body is always partially clothed, often in beautifully rendered undergarments of satin and lace. One just doesn't wear these items, however, no matter how luxurious they may seem; instead, one is transformed by them. The names for each embody their function—elasticized panties, push-up bra, cinch belt—all designed to adapt the reluctant female figure to the "lineaments of desire."[8] By focusing on these undergarments we come to understand how the free body of woman (which is never represented) is wrapped to perfection. Ramberg demonstrates how these garments segment the body into many parts and demarcations, each adding to the body's alienation and to the culture's ability to fetishize and eroticize its bondage.

To the panties, brassieres, and stockings, which break up lines of the figure, the artist adds yet another segmenting garment—the underarm shield, the perspiration guard, designed to protect the dress from the underarm, an indispensible addition to 50s female gear and perhaps a clue to what Ramberg might be up to.

There is no real naughtiness in these paintings. They do not represent the release of repressed fantasies that have become distorted as a result of being constrained. Nor does the implied voyeur in any way appear lascivious. The flat, comiclike portrayal, the gorgeousness of the garments present these half-dressed women as voluptuous and adored but not necessarily sexual. They are painted so lovingly, so tenderly, so

innocently that I begin to suspect that the implied voyeur of these strong and complex paintings might not be an adult at all but rather a young girl, perhaps sitting on the edge of the bed, watching her mother dress, focused in close on the breasts, the torso, the hips, thighs, and pelvis—those parts of the female body most significant to the child. To understand the importance of this interpretation for Ramberg's work it is necessary to step back for a moment, to analyze the profound and complex meaning of the mother's body and of the distortion of the mother's body for the daughter's psyche.

Young girls often watch their mothers dress as they prepare to go to the theater, to dinner, to parties. They admire the mother's body—soft, at times disproportionally large, overweight, or skinny, bony, rarely perfect by the world's standards but nonetheless perfect to the child. The mother is the archetype and prototype of femaleness. Girls watch as their mothers transform their most familiar bodies into unrecognizable forms, metamorphosed for an unknown observer whose gaze they suspect is male. They often catch their mothers with their dresses positioned over their heads in the act of becoming desirable, the object of someone else's fantasy. And while observing this act, the daughter recognizes that this body, which she adores, is lost to her. It is in the process of becoming a body for the world outside the dressing room, outside the domestic arena. As the mother's body is cinched, wrapped, a thing apart from her, it becomes alienated from the daughter as well. And it is not simply the body of the mother that is lost at this time; it is also the girl's own body that she comes to understand is lost to herself as well. At this time girls learn what maturity might mean. They imagine their first pair of stockings, high-heeled shoes, their first brassiere, garter belt, silk underpants—adult gear, artifacts of femininity that they both fear and are drawn to. They long for these items, cannot wait to have them, but they dread them as well. These garments appear like torture apparatus to restrain their untamed bodies and, in so doing, to constrict their psyches, to mold both into the proper shape.

Because Christina Ramberg catches these full-bodied female figures in the act of dressing, it would appear that it is this transformation that she is interested in: the process through which the female is transformed into something Other, something perhaps strange and unnatural. *Shadow Panel, Black Widow,* and *Satin Hankey* all show the figure, arms up, garment overhead. It is at that moment when the body is about to be hidden from view, when the torso is seen nude for the last time, that the loss of the body of the mother is complete and with this loss there is

also the loss of innocence, the time when girls begin to understand that the female body, their bodies, is not/are not perfect. They begin to understand that they will no longer sense their bodies as belonging to themselves. Part of growing up female is the recognition that the freedom of movement must be surrendered. Girls learn to imagine themselves as others might imagine them. They learn to measure themselves against an external standard, which may not be their own. "The surveyor of woman in herself is male: the surveyed female. Thus she turns herself into an object—and most particularly an object of vision: a sight."[9]

The culture is ultimately afraid of the female body. This is the reason women are encouraged to wrap, hide, objectify, and constrain it. Perhaps its meaning is far too mythic and powerful to allow us to see it naked, as it is, the place from which we have all come. It is a constant reminder of our vulnerability and mortality. A myth has therefore been created that justifies hiding it, transforming it: this is the myth of the inferiority of the female body. Girls growing up learn it well. They learn to accept their body's fundamental need for transformation. This is why they obsess about clothes, makeup, undergarments—vehicles to improve its/their condition. With this damning realization comes a further mystification that leads us to believe that the male body is inevitably more perfect and complete. How else could men have gained such a superior position? Why else would women go to such lengths to please them? It is not simply an oedipal desire to possess the mother's body that is ultimately at issue; it is more essential, primal. Once women come to perceive their bodies as inadequate, they lose the sense of themselves as whole, integrated, human beings. The link to this original desire for unity is the mother. When women are unable to accept their own bodies, they live in a serious state of self-abnegation, one from which few women ever completely recover. The lessons are learned in the body, whose freedom or absence of freedom, whose nakedness or fear of nakedness, reflects women's psychic liberation as well.

Ramberg has said that it was her intent to show the psychological binds women are caught in. Clothes and undergarments became her metaphoric vehicle to achieve this end. The perception of her own condition as a woman, and that of other women, led her to fixate on the physical constraints placed on the body that are as hidden from view as the psychic constraints women struggle to overcome. Ramberg's paintings raise all these complex issues. How consciously, how deliberately, how far she herself would go in her acceptance of the weightiness of

these ideas applied to her own work I can only speculate. However, it is clear after looking at two decades of her painting that she has been seriously grappling with these ideas for quite some time. In fact, early on, when their complexity was just beginning to be addressed, the artist was already immersed in them. As Judith Kirshner wrote, "her powerful paintings of female torsos encased in lace corsets or bandages . . . originate in an imagination that was female *avant la lettre,* Lacanian *avant la parole*."[10]

These early paintings were intended to comment on the problem—silently, cautiously, even humorously, to usurp the position of the voyeur by incorporating the voyeur into the paintings themselves, catching the dressing figure in the process of becoming an ideal. But while trying to address these complexities with varying degrees of consciousness, the artist encountered a fundamental irony. Although she herself was female, her own body and those of other women were not hers to interpret. The final authority did not rest in her as the painter, the creator of images. Rather, she learned that the symbolic meaning of women's appearance, gesture, posture, garments, and undergarments had been reified over centuries into codes of representation. Certain ways of depicting the female body will therefore always suggest enticement. Not even women themselves are free of the meaning of these images. They have internalized centuries of tradition, which also leads them to eroticize their bodies in prescribed ways. One can simply avoid creating such images or one can attempt to use the work to comment on them. These are the possibilities. But however conscious of these difficulties visual artists may become, it is very difficult for them to transcend the problem.

Will women ever be able to live freely without hyperconsciousness, ambivalence for their bodies, without nostalgia for an innocence, a girlishness that can no longer exist? Are there representations of the female torso that do not feed the culture's prurient interests? Can women painters find ways to represent the female figure that do not position women for the gaze of the other?

Having painted these paintings lovingly, carefully, to render the female body, to explore its meaning, Christina Ramberg was pained to realize that these paintings had been appropriated. There were those who read them as allusions to sexual bondage or perversion, those who did not understand that the images of constraint were metaphoric. This work was not about further exploiting women. Nonetheless, these

paintings actually were found enticing to those aroused by female vulnerability.

At this point the female figure, lost to the girl-child, was lost to the female painter as well. The unresolved issues raised by these paintings made it difficult for Christina Ramberg ever to reclaim, fully and with innocence or abandon, the female body as subject again. Perhaps *Wrapped Ticklers* (1974) and *Tall Tickler* (1974) were the artist's revenge/response to this dilemma. If the woman's body was to be bound, no longer free to move as desired or to generate its own meaning, perhaps the male body should also be restrained, constrained, fetishized, and appropriated.

> *Such thought, that in it bound*
> *I need no other thing,*
> *Wound in mind's wandering*
> *As mummies in the mummy-cloth are wound.*
>
> —W. B. Yeats[11]

In the next series of paintings, spanning the period from 1974–1981, the figure is metamorphosed into an object, no longer enticing, no longer discernable as to gender or even species. In *Untitled* (1974) and *Wired* (1975) only the barest traces of the human form remain and with them an inherent sadness. The figure is hung on a hanger, bound and gagged. It now appears more mechanical, at times androgynous, at times insect-like, never voluptuous, never erotic. In *Strung (For Bombois)* (1975) the figure is dissected with lines reminiscent of a dressmaker's pattern. It is hollow; only the barest outline tells us where hips and thighs might be. The fabric that breaks up the figure looks like bandages, strange ropelike pieces are overlaid where the genitals might be and seem more a deterrent to sexuality than an indication of it. The life force has been removed. The figures have become inanimate, broken up into origami-like shapes (*O.H. #2*, 1976) or made of driftwood (*Chair Backs*, 1976, or *10 Watt Coffee Table Lamp*, 1977). The body has undergone a crippling series of transformations.

In the period that begins with *Hermetic Indecision* (1977), Ramberg utilizes the wood, ropelike texture found in the earlier paintings of this series to create the sense of musculature. The figure could be male, female, or both. The elegance of the mylar wrappings seduces the viewer away from recognition that this body, however elegantly clad, is rapidly

coming undone. This ostentatious clothing and the flat, impenetrable surface only diverts us further from understanding the trauma that has occurred. The lacelike fabric that covers the stomach and legs is textured like skin that has been flayed down to the veins. There is neither blood, nor gore, to represent the suffering.

In this group of work the representation of the psychical body has transformed into the physical body. In *Hermetic Indecision* we are witness to Ramberg's depiction of the psychological state of ambivalence as it is given incarnation. Expressions such as "torn apart" and "pulled apart" are made literal. Blake would say they had become Literal, with a capital L, to denote the passage from the metaphoric to the concrete. In a psychological sense the libidinal energy appears so great that there can no longer be sublimation—a deflection of repressed energy—into other outlets. There is no chance that this release can come in moderation. The figure cannot stay bound any longer; yet when it comes undone, it is not liberation that is experienced, but fragmentation.

In *Muscular Alternative* (1979) this strained control has caused the body to become armored and rigidified. The striation marks designate stress, pain; the entire figure seems a combination of flesh, wood, broken up, harnessed, no longer lovingly girdled in black satin as in the earlier paintings. Here the artist holds the figure together by a brace on top of a brace. The shoulder is not simply disproportionate, it is painfully dislocated, pulled so taut that it is unable to move without cracking. This painting, like all the earlier ones, is cropped in tight. We are offered no context, no idea who, what, where, how this could have occurred. Even if the figure is a mannequin, or a dress form, what perverse owner of such an object would see fit to deform it to such a degree? If this is the physical body then it is in great torment, tortured by an unspecified torturer.

In *Layered Disorder* (1979), *Interior Monument* (1980), *Vertical Amnesia* (1980), and *Sedimentary Disturbance* (1980) the corset becomes a corselet made of leather, fabric, mail, and used, it would seem, as armoring. The figure is still disfigured, dismembered, crippled, but nonetheless capable of a kind of elegance and a posture that seems complicitous with whatever may be happening to it. Even though the guts seem to be spilling out of the figure in *Sedimentary Disturbance* the arm is positioned on the hip with a rakish bent, casually resting in the pocket as if standing on a street corner or leaning against a post. In *Interior Monument* the figure stands straight and proud, like a warrior, even though the broken, pointed edge of a crutch is precariously close to the genitals. (Or perhaps

the figure stands so fixed because it is immobilized by fear that if it moves it will castrate itself.) The exaggerated, thickly brocaded garments of a knight, a matador, or an Elizabethan actor confuse us again as to time and place.

Ramberg's use of pattern, texture, and color diverts us from absence of an arm or leg, the truncation of a limb. Layers upon layers of fabric account for the quiltlike effect. These appear to be the humorous, playful, and at times alarming creations of a seamstress gone a bit mad, dressing her mannequins in the most elaborate and unpredictable ways. What could these juxtapositions suggest? A crutch made of rope for a leg, a small pair of pants for a codpiece, an envelope propped upright (like a tap) on the shoulder, a furniture leg for an arm, a small canvas or mirror hung on a chain as a medallion, miniature jackets found hiding in the most unpredictable places. "Tis all in peeces, all cohaerence gone; All just supply, and all Relation."[12]

Sedimentary Disturbance, with its spewing forth of rocks and rivulets, suggests the inability of the figure to contain itself any longer. Here is the desperate image of the need to remember a unity, to recreate cohesion for the now-fragmented body. Bits and pieces from all contexts are woven together to form the whole. The process is as rich with overdetermined meaning, puns, and puzzles as the multidimensional symbolic world of the unconscious, where disjointed images appear layered on top of each other to form a pattern so intricate, so impenetrable, so complex that its sense appears as nonsense, its meaning at times indecipherable. The complex disordering of all expectation like that the surrealists hoped to achieve Ramberg accomplishes brilliantly, without self-consciousness.

In *Layered Disorder* what appears to be a dead fox, muzzled and leashed, is casually positioned on top of the head like hair or a hat. *Hearing* (1981) presents a small dressed torso half-way down the side of an elaborately dressed figure, positioned as if it were an ear, ready to listen. The logic resides in the iconography of dreams. The clever use of language in the titles helps pull conscious meaning up from the unconscious and gives us some clues to work with.

These depictions of figures are being beaten in *Black and Blue* (1981), burned at the stake, set on fire from within in *Freeze and Melt* (1981), possibly close to impalement in *Interior Monument* (1980). But we as viewers are initially seduced away from these horrors by the elaborateness, the excessiveness of the garments. We sense that the artist is purposely holding us back, keeping us on the surface, so that we will not

get too close and unmask the figure perhaps to find a hollow space beneath, to learn that the core is no longer there.

During this period there are two untitled paintings—little suits of clothes, perfectly rendered outfits that have in fact been left uninhabited. Only the mold or imprint of the figure remains. The spirit has gone. It is as if the symbolic has finally become so abstract that the metaphor has disincarnated, leaving an empty shell of clothing where a physical body, representing a tormented psyche, used to be. There is a freedom in these paintings, a liberation in having left an intolerable situation behind. The colors of the garments are imbued with a hopeful luminescence that we don't see again until much later.

Christina Ramberg's intelligent mind and deliberate hand guide these brilliant transitions. These paintings are as clever as the satirical similes of Jonathan Swift, who, when parodying the notion that the human form (the microcosm) is but a small mirror image of the universe (the macrocosm), wrote: "what is man himself but a micro-coat, or rather a complete suit of clothes with all its trimmings?"[13] What are Ramberg's paintings if not miniature representations of the human psyche, layered with individual and collective meaning, dream association, history, myth, and allusion—the complex process of human cognition with all its trimmings?

But just when it seems the artist's struggle is spent, that she has emptied her costumes of all living content, the paintings become sensual again and more mythically female than ever before.

In *Untitled #11* (1981) a small figure in toreador pants and elongated midriff hangs upside down, her feet secured by the waistband of a larger, equally voluptuous figure. In *Apron* (1982) a smaller apron hangs from the urnlike shape. In *Untitled #12* (1981) a small kimonolike figure, arms outstretched, appears as a dress laid over an apron, worn by a larger, full figure. And in *Apron Core* the parts and allusions to the body are finally transformed into a small complete female figure, naked, with large hips, dark like a shadow projected onto the lamp/urn, hanging from the waist of this larger figure to keep from falling. This must be the female child grasping at the mother's large aproned hips—the place a child returns to for safety and consolation. Perhaps the large pink female body in *Untitled #3* (1981) has been returned to the child, not as an object eroticized and usurped by the world but as an image of infantile desire and longing, symbolically anchored in the domestic arena by her apron. Or perhaps the child self has returned to finally accept its legitimate place within the adult woman? Whichever it may

be, this is not a completely joyous reunion. The smaller figure, which seems like an appendage, hangs onto the larger figure for dear life. It appears naked and vulnerable as it attempts to scale this large form.

If *Apron/Core* is really an allusion to the mother's aproned *corps*, then these paintings are yet another attempt to reconcile and depict an irresolvable longing and remembrance of lost cohesion. Perhaps those small aprons, or abstract figures positioned where the genitals might be, are the artist's unconscious attempt to recreate the phallic-mother, to reconcile all difference, to remember an imagined primal unity. There is a deep sadness in *Apron/Core*, a recognition of the inability to return to an original unity, an imagined time and place before differentiation (Freud's oceanic feeling) when the mother and child were one, a time before the fall into self-consciousness.

In *Pine Cone* (1982), the final painting in this series, there is an interesting reconciliation. Both the calla-lily-shaped small figure, and the pine-cone-terraced urn upon which it rests, are made of the same substance. They are of the same genus. Unified in an organic world, before or beyond human consciousness and the hierarchies of the family, perhaps they have finally met in their shared femaleness, joined by their primal sameness instead of defined by their inevitable difference. There is elegance and silence in this painting, as if the din of battle had finally subsided.

In this series of "skirted vessel" paintings Ramberg has made a serious breakthrough. She has managed to create a figure recognizably female but so abstract as to escape appropriation. The images cannot be read as erotic in any way that can be used against women and yet they are extremely female and sensual. By delving ever deeper into her imagination she has managed to leave the mundane world of exploitation behind. It is a great achievement. After this she did not paint again for five years.

The late 70s and early 80s were a difficult period that unsettled men and women alike with a concern for issues of gender, sexuality, fantasy, utopia, and desire. The female body became an arena of collective contention. The images and questions ceased to be private. It became increasingly difficult to address them in any way, without entering into the public debate. For Christina Ramberg it was time to make a change, to make a whole from the parts instead of trying to make parts represent the whole. Quilting, which the artist had always pursued, now became a place of refuge as well as a place of serious experimentation and reevaluation.

It was an extreme break and some who admired her work could not understand what had happened. Where was the torso? Where was the metaphor? The quilts, however gorgeous, confused the audience. But in fact the concerns of quiltmaking had always been in the paintings. The artist had always been interested in harmony, proportion, symmetry, patterning, and increasingly going beyond references and fetishes to abstraction. It was these concerns that had created consistency and balance in the earlier work, without which the representation of the painfully conflicted subject matter might never have appeared coherent. What better way for a woman to reconcile the upheavals of history, the confusion of gender and sexuality, than to return to a tradition that had always belonged to women, exclusively? How better to mend the individual and collective psyche than literally to sew it back together?

> God made the whole world in such an uniformity,
> such a concinnity of parts, as that it was an Instru-
> ment, perfectly in tune.
>
> —John Donne[14]

Emerging from this period of rethinking the nature of her images and of the act of painting in general, Christina Ramberg returned with new work (1987–88) that at first appears radically, dramatically different from anything done before. Are these paintings blueprints for the construction of pendulums or perpetual-motion machines? Are they representations of space launchers or interior landscapes[15] of the brain? Perhaps they are sketches of the *Primum Mobile,* the Ptolemaic 10th sphere believed to set the rest in motion. Or maybe they are charts to describe a new cosomogy? I am not sure. An invisible hand seems to have designed these. The artist has moved from cloaking the figure to dissecting and finally distilling it into an abstraction intriguing enough to represent not just the human body, but the entire divine plan.[16] These paintings are truly made cunningly, with an edge of incompleteness that adds to their sense of invention.

There is no doubt that a great deal has changed. The figure as figure has ostensibly disappeared. The intensely truncated cropping has given way. The artist now presents her viewers with some context, some sense of the area surrounding the central object. We are no longer held back by a forbidding flatness. The surface is rougher, more in motion and in transition. She has provided us with enough depth to actually enter into

the paintings. And she has finally exposed the painterly process and allowed us to see the mechanics, the inner workings.

But however remarkable the differences between new and older work may be, the similarities are also apparent.[16] Shapes, forms, isolated parts could be shown to mirror segments of earlier work. The image of vessel, beaker, or funnel is still central. The color and texture of garments found in the previous paintings have bled into the background, creating a sense of motion. In the foreground is still a central core or body, which now seems to have gone through a reverse evolution in which the outer form has given way to the armature beneath. The central image is more primitive—stripped of flesh and vestment. But it also appears more evolved—pared down, essentialized. The structure that remains, although more mechanistic, is also much more stark. There is no insulation to protect it. The psyche, divested of its layers of armoring, is now undergoing a metamorphosis; the symbolic carapace is finally shattered. The psychic body is seen truly naked for the first time. And although more vulnerable, it is also more balanced, focused, harmonious than ever before.

In *Love's Body* Norman O'Brown notes that freedom in the use of symbolism comes from the capacity to experience loss.[17] Once loss has been admitted and the sadness felt, there is no longer a need to create imagery that insulates us from the fact. These paintings seem closest to the original conception. And the conception seems closest to its execution. The artist is finally released to move on. These paintings affect us in precisely this way. Ramberg no longer needs to create a complex symbology to bridge conscious and unconscious or to protect us from what might occur if the truth were exposed. There is no longer fear that the repressed will return and destroy everything in its path. The event or presence that was anxiously anticipated has already come and gone. The damage has been done. Perhaps this trauma occurred for the artist during the middle period when the figures were quite literally coming apart at the seams. Or perhaps in the silence when she stopped painting.

It is possible that the conflicts were actually simply resolved during the "Apron" series. I can only speculate. But it is clear that these paintings have a luminosity, a sense of hopefulness, which lead us to believe that if Christina Ramberg has not as yet completely answered for herself the questions posed in the earlier work, she has at least transformed them, raised them to a higher level of representation.

The new paintings are objects of meditation in which energy is no longer trapped, restrained, or repressed but rather held steady, in a state

of potentiality. Were we to focus on them long enough, we too might achieve their state of balance.

This work marks a significant stage in Christina Ramberg's journey. She has moved to a new place of detachment, able to survey her work from a perspective she has never been able to utilize before. It would appear that, at least for a time, the artist's imagination has been freed to display "the infinite that was hid."[18]

Notes

1. The concept of urn, central to Ramberg's work, was extracted from Judith Kirshner's opening catalogue essay for a 1987 exhibition she curated at the Terra Museum of American Art: *Surfaces: Two Decades of Painting in Chicago, Seventies and Eighties* (Chicago: Terra Museum of American Art, 1987).

2. From John Donne's "Holy Sonnets" Number IV, *The Complete Poetry and Selected Prose of John Donne* (New York: Random House, 1952), 248.

3. From George Herbert, "Church Porch," *The Complete English Poems,* ed. John Tobin (London: Penguin, 1991), 11, 21.

4. "Divine Analogy" is a title of a painting by Alfred Jensen, contemporary American painter, cited by Christina Ramberg in conversation.

5. William Butler Yeats, *A Vision* (New York: Macmillan, 1938), 320.

6. A phrase from Suzanne Ghez, director of The Renaissance Society at the University of Chicago, in discussion about the Ramberg painting *Hand.*

7. Berger, John, *Ways of Seeing* (London: BBC and Penguin, 1972), 54.

8. A phrase from William Blake's poem "The Question Answer'd":

> What is it men in women require?
> The lineaments of Gratified Desire. . . .

William Blake, *The Portable Blake,* ed. Alfred Kazin (New York: Penguin, 1976), 135.

9. Berger, 47.

10. Kirshner, "Surfaces: Two Decades of Painting in Chicago, Seventies and Eighties," 17.

11. William Butler Yeats, as used by Louis Martz in the epigram of his *The Poetry of Meditation* (New Haven: Yale University Press, 1920).

12. From John Donne's "Anatomie of the World: The First Anniversary," in *The Complete Poetry and Selected Prose of John Donne,* 191.

13. From Jonathan Swift's "A Tale of a Tub." In Jonathan Swift, *A Modest Proposal and Other Satires* (Amherst: Prometheus Books, 1995), 63.

14. John Donne, *Sermons,* ed. L. P. Smith (Oxford: Clarendon Press, 1920), 162.

15. Taken from the title of the painting *Interior Landscape* by Pavel Tchelitchew, a twentieth-century Russian emigré painter.

16. I would like to thank my colleagues Susanna Coffey, Joyce Fernandez, Phil Hanson, Judith Kirshner, and Barbara Rossi for their intelligent reading of this piece.

17. Norman O'Brown, *Love's Body* (Toronto: Vintage, 1966).

18. Taken in spirit from William Blake's *The First Book of Urizen, The Portable Blake,* ed. Alfred Kazin (New York: Viking, 1976), 328–347.

Christina Ramberg, *Waiting Lady*, 1972, acrylic on Masonite, $22^{3}/_{4}$ x $32^{1}/_{4}$ inches. Courtesy of Phyllis Kind Gallery, Chicago; photo by William H. Bengtson.

Christina Ramberg, *Apron/Core*, 1982, acrylic on Masonite, $16^3/_4$ x $9^7/_8$ inches. Courtesy of Phyllis Kind Gallery, Chicago; photo by William H. Bengtson.

Christina Ramberg, *Hearing,* 1981, acrylic on Masonite, 48 x 36 inches. Courtesy of Phyllis Kind Gallery, Chicago; photo by William H. Bengtson.

Christina Ramberg, *Shady Lacy*, 1971, acrylic on Masonite, 13^{1}/$_{4}$ x 13^{1}/$_{8}$ inches. Courtesy of Phyllis Kind Gallery, Chicago; photo by William H. Bengtson.

The Prodigal Daughter

To the memory of Constance Teander Cohen

I

*Or what woman, having ten silver coins, if she loses
one coin, does not light a lamp and sweep the house
and seek diligently until she finds it?*
*And when she has found it, she calls together her
friends and neighbors, saying, "Rejoice with me, for
I have found the coin which I had lost."*
*Just so, I tell you, there is joy before the angels of
God over one sinner who repents.*
*And he said, "There was a man who had two
sons...."*

—Luke 15:8–11

Thus begins the story of the prodigal son as told in the Book of Luke. It
is a morality tale that has undergone multiple interpretations and has
served as a creative source of literature and painting for centuries.
Although it is often represented as a story focused on one wayward son,
it is actually a story about two sons: the younger son who leaves home,
squanders his inheritance, and returns, remorseful, begging forgive-
ness, and the older son who never leaves, remains loyal, serves his father
in the fields, but feels he has not been rewarded by his father for this
fidelity. In the space between the two resides the moral.

When the prodigal son returns he is taken back with open arms. His
father, so delighted to find again the younger son he thought he had lost,

celebrates by killing a fatted calf. The older son, who has felt himself denied such a celebration in his honor, looks on with anger and resentment.

A spiritual reading of the story is that, like the finding of the lost coin, the return of the son who has strayed from the path and has found his way home again is a greater triumph and brings more joy than the constancy of the one who never left. In a worldly way, with another emphasis, it tells us that a son can seek independence from his familial ties, go out into the world, learn the hard lessons of life, even disappoint, hurt, and abandon his father, and upon his return still be embraced and forgiven by the father and offered the protection of his resources once again. The word *prodigal* has become associated with one who is excessively wasteful of resources. It has also come to mean one who strays and finally returns. It is significant that this word is rarely associated with women, which is all the more reason to be intrigued by the title of this show.

There is a novel called *The Prodigal Women*,[1] written in 1942, which describes the lives of three women who "squandered" their love and their inheritance. Author Nancy Hale sets her book in what she calls the "age of waste," the years 1925–1935, but no matter how provocative her initial intent may have been, by the time the book goes to publication in 1942 there seems to have been some concern about its implications. She is forced to temper it with the copy on the book-jacket flap, written by the author herself. It begins: "Women are not natural prodigals, it takes an unbalanced era to make them so." This qualification may well have been written at her publisher's request so as not to lead women astray, into degeneracy at that most delicate time—the beginning of World War II. This statement ends with a timely and familiar plea of that moment: "Buy Bonds."

But some women are as much natural prodigals as are some men. They spend their penny, give all without moderation, want to experience the world first-hand, and follow the road of excess in the hope that William Blake is right and it will lead to the "palace of wisdom."[2] But their stories are not told with the romance and possiblity of redemption offered in the Book of Luke, nor with the idea that these adventures and explorations will lead to creative work, or that writers, artists, or composers will record these experiences. Indeed, most women devoted to their homes, mates, children, families, and friends dutifully internalize their roles and functions. But what does it mean to classify certain women, and here certain women artists, as prodigal, even if a bit tongue in cheek?

Where in the culture is there a positive image of a woman able to leave the family to experience her own adventures and then, after squandering her inheritance (assuming there ever was one), to return home and joyfully be forgiven? What would it mean for women to be allowed to set out on a journey to discover their own natures, to mature, rich with the experience of the world and then, if desired, come home and assume their rightful place of protection within the family and within the societal structures once again?

The story of most women would be comparable to that of the elder son—the one who never left and felt he was taken for granted. Historically, it has been women who most often stay close to home. In the nineteenth century if women did leave the home, they became protagonists in stories told about "the fallen woman"—the one who has sexual relations out of wedlock, who perhaps bears a child and either dies in the process, unsheltered by the world, or is taken back by the family on condition that she live as a virtual nun for the rest on her life. Strindberg's *Miss Julie,* for example, presents a women shamed who has no choice but to take her own life. In her essay "Lost and Found: Once More the Fallen Woman," critic Linda Nochlin writes:

> Lurking behind most of the fallen-women imagery of the nineteenth century is the sometimes explicit but more often unspoken assertion that the only honorable position for a young woman is her role within the family; the role of the daughter, wife, and mother.[3]

If the wandering woman is taken back to assume the role of "angel in the house," she often lives the life of a repentent. The generally accepted/acceptable life of women is one dominated by service to others. Women must therefore pay dearly for any adventure on which they embark. Missing from the developmental scenario for women has been a plan which allows women to cultivate their uniqueness, plunder their own inner lives, define the knowing of the self, the cultivation of the self as a legitimate goal in itself.

In Toni Morrison's *Sula,* centered around the intense friendship between the more conventional Nel and the irreverant and exotic Sula, Eva asks Sula, "When you gone to get married? You need to have some babies. It'll settle you." "I don't want to make somebody else," reponds Sula, "I want to make myself."[4] Sula is a prototypical prodigal. She can't help but stray from the path because the path has been cut too narrow for her liking, allowing so few versions of the life a creative woman might

choose to lead. In society at large, there is no sense that a woman could take her identity as a social activist, for example, expanding the notion of caretaker to encompass concern for the well being of society. Nor has there been an articulation of what signification it would have for women to have their *own work*. And in the articulation of what it means for women to grow, mature, delineate their own development, there has never been a prescribed route that allowed women to become artists.

II

While searching for models of the proactive, creative woman we come upon Athena:

> Patron goddess of Athens and guardian of the city, she was the daughter of Zeus by his first wife, Metis, who personified wise counsel. Zeus was warned by Gaia (Mother Earth) that his children by Metis could surpass him in wisdom and could usurp his place as king of the Gods: whereupon Zeus when he found that Metis was pregnant, swallowed her whole and absorbed all wisdom to himself. The myth was embroidered and from it developed the story of Zeus suffering from violent headaches that made him howl with pain and rage. Hermes found him on the banks of the Triton river and, knowing what trouble was, summoned Hephaestus. The smith god with a mighty blow cracked Zeus' head and Athene, fully armed, sprang forth with a shout that shook the heavens.[5]

This is why it is said of Athena, "No mother . . . gave [her] birth."[6] She was born of man. And not just of any man or even of mortal man, but of Zeus himself. Right from the start her power was great. Feared and anxiously anticipated, she caused her father to have violent headaches. The only way she could be birthed was to be smashed out of his head, and the only way she could safely emerge from such an aggressive birth was to come into this life "fully armed"—as an idea completely formed.

Certainly this daughter is as prodigal, as excessive, as overly dramatic, and as wayward as they come. She even finds her own way to earth, her own method of coming into life: refusing her gender, insisting on autonomy, and taking her god-like status as her inheritance and her due. It is interesting to note that Athena is also the patroness of all crafts, worshipped by the weavers, as well as by the potters of Samos, as their teacher. The myth of Athena's birth offers us some possibilities for look-

ing at the birth of women artists, at how unorthodox their lives need to be if they are to succeed creatively and survive.

If women leave the patriarchal order, dare to create a life outside the confines of domesticity, and refuse to accept their designated roles and the limitations of rationality and the rigidity of the law by choosing a deeper law—one more modern and simultaneously more ancient— they often find themselves isolated, alone, without protection. If they go too far, like Antigone, then there is no one to receive them upon their return. The domestic arena, with its expectations of what women will do, what they will be, what they will provide, is, more often than not, anathema to the creative work women try to do. Because most women cannot be in the family without taking care of it, and because being in it in the traditional way is stultifying, it precludes any possibility of finding their own safety in that realm. As caretakers of the ambitions, creativity, and physical well being of others, women often have little time, space, and energy for themselves. They often have had to leave the family structure to find autonomy. For most men, even male artists, the traditional home is a safe haven. By protecting, insulating, and caring for them, it provides the foundation from which they set out into the world. No wonder some men have so resisted and resented a transformation in gender roles that threatened these traditional structures.

Another necessary aspect of the creative life that is antithetical to traditional domesticity for women is solitude—the time alone with oneself when reflection, the generation of ideas, and the production of the work are carried forward. This type of psychic space is difficult for both genders to obtain, but it is almost impossible for most women, whose connections to other human beings are often quite elaborate and limitless.

For artists and writers in general, the terms with which they come to define themselves are elaborated in their work and in the world that they set up to allow them to make the work. They locate themselves within an historical continuum of other artists, writers, and intellectuals with whom they have found affinity. They know themselves less by their familial geneology than within the geneology of ideas. If they are the offsprings, the sons or daughters, of those who have come before and with whom they share creative, artistic, or intellectual goals, then they need to name these creative mothers, fathers, or siblings to recognize that they have chosen a new family, one of their own creation, within which to position themselves. It is from this new family, often held within the confines of the intellect and the imagination, that they can safely take sustenance.

III

At earlier historical moments in Western civilization, in late antiquity and for several centuries thereafter, when women wanted to be artists, writers, or intellectuals they often did well to leave society completely, to enter into a protected spiritual world where they could be left alone to develop their minds and spirits. In the seventeenth century the famous Mexican mystic Sor Juana de la Cruz confessed:

> I became a nun because, although I knew that way of life involved much that was repellent to my nature . . . nevertheless, given my total disinclination to marriage, it was the least unreasonable and most becoming choice I could make to assure my ardently desired salvation. To which my first consideration . . . such as my wish to live alone, to have no fixed occupation which might curtail my freedom to study, nor the noise of a community to interfere with the tranquil stillness of books.[7]

There buried behind convent walls, living to the greatest of excesses—fasts, vigils, intense study—their sexuality neutralized by their habits, shaven heads, veils marking their marriage to Christ, nuns and mystics like Sor Juana were able to cultivate their own inclinations, develop intellectual friendships with men, master particular bodies of thought—poetry, philosophy, art—even the knowledge of coming close to God. Of such cultivation, Sor Juana confesses:

> I began to study Latin, in which I do not believe I had twenty lessons in all, and I was so intensely studious that despite the natural concern of women—especially in the flower of their youth—with dressing their hair, I used to cut four or five fingers' width from mine, keeping track of how far it had formerly reached, and making it my rule that if by the time it grew back to that point, I did not know such-and-such a thing which I had set out to learn as it grew I would cut it again as a penalty for my dullness. . . . I did not consider it right that a head so bare of knowledge should be dressed with hair, knowledge being the more desirable ornament.[8]

Women ascetics in late antiquity often lived in households with other women. They were known as *canonicae*—"women living under rule."[9] These women made their own communities, which often defied traditional orderings of class and hierarchy. They created small cottage

industries and survived independently, interacting little with traditional societies. They did not leave home. Rather, they transformed their homes into places where domesticity itself became equated with spiritual practice.

There have also been those women who defied the path of traditional domesticity and nurturing behavior prescribed for them and have gone to other extremes—flaunting their eroticism and being deliberately "bad," defining their autonomy and determination by insisting that their bodies and sexuality must be their own. The result has often frightened men, shaking the underpinnings of patriarchal control. But this type of rebellion has often seemed somewhat adolescent in its manifestations and in its reaction to the traditional restrictions imposed on women. What would it mean for a mature woman to be truly radical to the roots, subversive to the core—not simply flaunting her sexuality but perhaps reorienting it into relationships of her choosing and into the cultivation of her own creativity?

What do mature women do when they want to subvert society, challenge its assumptions, develop their own potentiality, and carve out more space of possibility, more time, and preserve more energy for themselves? The answer in part is that they find meaningful work. They keep living and choosing their own course as much as they can. They survive in duration, bring new images into the world, and in so doing mark their own individuality. They lead lives that are of their own design, with whatever definitions of gender they choose to articulate. They take care of themselves and they achieve longevity. They make work so strong, so thoughtful, derived so much out of their own psyche that no one but they could have envisioned it. They succeed at being artists if this is their chosen path, and they find a way to make it a life.

Such women don't stick their heads in ovens, drown themselves in the sea, or totally burn themselves up in destructive relationships. They live to create and they create to live, through and beyond the day-to-day contingencies. And when they can, they pass the baton to the next generation. If they are prodigal they are so because in their need to leave home, home as it has traditionally been constructed, to find themselves through the world, they have also found a way not to get lost on the fringes, forlorn and forgotten. They come back from the outside on their own terms to touch the center, not with gratitude for finally being allowed back or as tribute to those who have helped along the way, because so few have, but with the confidence that comes from intersecting with history and with the world, and from knowing oneself. Prodi-

gality in this case transcends the moral tone of having been bad and then becoming good or having sinned and then repented. It is not about making one's peace with the faith. Instead, it implies an internal progression—a transformation that allows one to live more comfortably within oneself, defining a more expansive sense of maturity along the way.

IV

What might it mean to leave home as an artist? What does it mean to return? All artists, however "outside" they may be, actually are defined within, against, or in relationship to the history of art—the historical body of images that may or may not explain their lineage. Apart from women artists having to make their peace within the sociological contingencies of society and of being female, they also need to find their place within this art historical family, even if all they do, at every step, is refuse and refute what has come before, what was said before, what form and materials were used before.

Women artists have had to overcome their absence as protagonists from the creation of the images that comprise the history of art. They certainly have been the object of the gaze—for centuries—but they themselves have rarely determined the images that would represent them or have had the opportunity to interpret, through images of their creation, the progression of Western civilization as they have experienced and understood it. Women, comprising half the population, have been interpreted, anticipated, transformed by the imaginations of men.

It was not until the 1970s that this history of the representation of women as the object of the male gaze was fully articulated.[10] And although many women were painting and making art before this challenge occurred, they have done so with greater self-consciousness, self-confidence, and sense of solidarity since these issues have entered the domain of art world discourse. Women have now had to try to imagine what they would look like, would do, would say, would think, would wear or not wear were they protagonists at the center of the drama of their own choosing. What would be the content of the narratives they might choose to position themselves within? And how would women attempt to overcome the weight of all that had come before?

Contemporary women artists first have had to triumph over the silence of these unexpressed concerns. But this silence around the representation of women was not just a personal silence of individual

women's need to find their own voices. It was rather the silence of an entire civilization that had to be broken. As much as it was tackled as a mass phenomenon, the effects of the internalization of this collective silence had to be located within each individual woman artist, writer, and intellectual, each of whom had to come to terms with these silences within herself and then find some form to represent them or to talk about representing them. These challenges and exhilarations have propelled women artists to transform the site of their work into a space of contention where issues about the actual act of art making and women's relationship to it can be put forward.

There have also been issues of style. Can women take from the traditional forms of art making but also refuse to capitulate to traditional expectations? Does this mean that the form itself should not romanticize the tale? Is style actually the "exploitation by the artist of himself [/herself], betraying the liberty of art?"[11] Many of the women in this show have refused traditional forms of art making. Is that because it is within style that even pain can be hidden, rendered beautiful, and rescued from its horror? Is that why it must be resisted?

The work of many women artists has not been made easily palpable. If left deliberately raw or direct it is because the work is not a gimmick, not an art historical manipulation but rather a profoundly sincere attempt to give shape to some exceedingly difficult issues and to give voice—a language, a native tongue—to those who have had none and for whom speech has been a difficult developmental stage to achieve. At the core of the work of contemporary women artists is the determination to help women take their place in history as actors in the human drama.

To achieve all this, images of strength from the past are often called upon in an attempt to move toward representations of freedom, to defy those images which have always disempowered women and kept them in a narrowly circumscribed place. What was it that so threatened civilization that it could not tolerate the thought—and image—of an autonomous female form? Was it fear that women might leap out of and off the canvas? Or that they would simply choose their own path, leaving behind male-defined art history, hierarchy, and Western civilization? Was it that they would create their own history of art and that it would gain recognition and inspire generations of women to come with its purposiveness, that it would simply leave men out and in so doing that it would challenge men's ability to paint, sculpt, control the representation of women without contestation? If these were the unconscious fears they

have all become reality. Not only have women artists broken the silence and been part of the transformation that has changed the history of art making irrevocably, but they have been integral to a movement of consciousness about the role of women in society that has transformed the Western world. No wonder Athena's fearlessness gave Zeus a headache. She prefigured the strength and bravado of women to come.

Women artists in general must be/are prodigal because they have had to leave home to find out who they were and to renew, restore, reconfigure their faith unaided—not necessarily faith in God, the father, or the social order that once existed to reflect male authority, but rather faith in themselves. And through their efforts and recordings, other women have also located a way to imagine their own mythic journey. But these women cannot go home again, not because the door would inevitably be shut, the key taken out from under the mat, but because they would not want to go home, to home as it was defined before they chose to leave.

V

In a wonderful essay titled "Art is a Gynaeceum of Images," Archille Bonita Oliva writes about the work of Nancy Spero, "She does not consider art as a pathetic place of rescue."[12] It is a statement that could be made about any or all of the women included in this show. If the work functions in a healing way to them or to their audiences, it is certainly not a direct intent, nor does the healing occur in any simple way. As personal as the work actually is, its affect is not about subjectivity. Each artist makes strong statements, however ethereal in form, often reflecting important social concerns and/or deep commitments to the function of art.

At the core of a great deal of this work is something that might be termed the meeting of the "primordial and the acquired," to adapt a Buddhist concept. It touches on that which is mythic, prehistoric, pulled from the collective unconscious, as well as the images which move through history and reflect specificity—what has been "acquired" by Western civilization. Much of this work creates a world of its own. But of what are these worlds constructed? Often the work alludes to or represents landscape—however broad the use of the term—with staunchly positioned figures or moving, running, floating bodies, "sky goddesses" negotiating space.

From Judith Raphael's painterly, corporeal, almost atavistic adults and children, through the buoyant transparent bodies and pastels of Constance Cohen's images, to the apparitions that haunt Leonora Carrington's ghost-ridden dreamscapes, to Nancy Spero's heroic figures who are as light as air but who move through time and history, often in dance, almost always in movement, with great assurance, it might be said of these figures that they are "no longer the historical target of men's gaze."[13] They certainly set their own terms. They often can be understood as mythic, not a retro return to the image of the Goddess—who may or may not ever have existed—but an attempt to capture the archetypal images that dwell in the collective unconscious and in the collective desire to find an equivalence for the power of the female figure as it looms in the imaginary, forged and imprinted through the most originary experiences of life. In Leonora Carrington's tale "The Stone Door" the narrator says, "Sorcerers and alchemists knew about animal, vegeable, and mineral bodies. To hack away the crust of what we have forgotten, to rediscover things we knew before we were born."[14] Such is the act of creating this work, of alluding to the power of the female body within the imagination. The haunting memory of being carried in that body, then birthed through that same body, attached to it through the cycles of life—drawn to it for nourishment during infancy, dependent on it throughout childhood, and/or caught within its erotic orbit as an adult. The work touches on the mythologization that correlates to this weightiness of meaning and the recurrent attempts to dilute, mystify, and even squash that power by the prevailing cultural models. This breadth of significance is embodied in the traditional romanticization (fetishization) and trivialization of the female form. Here re-presented from the point of view of diverse women is the figure of woman as women artists have chosen to represent her. But within what context have they placed her?

Like the famous Bosch painting of the *Prodigal Son* (1510–1516), in which the figure moving across the landscape looks back while moving forward, these artists create similar simultaneities. They examine that which is hidden in the collective psychic past and that which continues to manifest itself in the present—the coexistence of simultaneous planes of reality, subtle glances, the look that betrays innocence, the familial drama that is primordial, the limited way in which women have been seen. They locate the moment of scrutiny in the contemporary moment or within an astral world, like that of Leonora Carrington's *Crookhey Hall*, that seems uncanny and archetypal, ancient and futuristic.

In Nancy Spero's work, glamorous figures can march into and out of an advertisement/Hollywood present while heroic Vietnamese peasant women conjure a particular moment in historical time and pagan goddesses dance the "dildo dance" into eternity. June Leaf creates images so raw, so fierce they appear bacchanalian—half beast/half human. The monster is what women know about themselves, what is hidden, what is on the other side. Not even a negative, just an "other," that which is unstated, especially by women about themselves. This is a difficult kind of exploration—not a reflection of the gaze from the outside looking in, but rather a turning of the inside-out, the spirit revealed, reified.

Audrey Flack can render a *Self Portrait,* frame herself as the artist in the most flattened, cliched pose, pallet and brush in hand, and stare at us with a comic innocence and savvy that tells us that she knows exactly what she is doing and that she is in command. Anne Noggle can ascend out of the caldron in *Stellar by Starlight* or look at us squarely in the eye as an aviator at the top of the world, fearless. The mother in Judith Raphael's *The Gift* can make an offering of food to the son, but the innocence of the act is belied by the eroticism of the moment—the inherent incestuousness in the familial dynamic, readily revealed in the glance, in the objects and sensual shapes that surround them. They are floating in an unarticulated landscape, out of time, where the resonance of the familial Oedipal drama, once isolated, can be enacted beyond the particularity of location, race, or historicity. The colossus in Constance Cohen's *Visiting the Seven Wonders* completes the broken circle, a body stretched to link the two hemispheres of the brain, creating a mythic space on the astral plane imagined by female passengers who sit belted in the airplane gazing out the window to infinity. Which is reality? Which is the dream? Who is dreaming whom and to what end? Dream within the dream.

These artists represent conflicting realities simultaneously and as in Bosch's work create a completely new world, one which reflects some artifacts of what we have known but is completely of the imaginary, a strange world peopled by strange creatures, a landscape through which women march, explore, and are active agents engaged in contemplating history as well as the workings of their own unconscious. *Vietnamese Women Totem* expands the journey, the flight, the passage to women outside Western civilization and creates a synchronicity, a sense that we are with them marching through time and space. June Leaf's nightmare world of raw power, of released energy and turmoil is a reflection of

chaos and the harnessing of such chaos that can barely be contained within the confines of the canvas. Geraldine McCollough fuses time, history, and myth in *Echo 5* to create objects of ancient ceremonial appearance—warrior gear, symbolic artifacts. But what constitutes the god or gods these images come to represent?

Nothing is too primal or too fearsome or too glorious for representation—life, birth, as in Constance Cohen's *Madonna Theme;* the sardonic perils of childhood in Judith Raphael's *Children's Hour;* the unleashed energy of dreams and aspirations. None of the work succumbs to the convenience of style; none seduces us or distracts us with purely formal concerns. There is social, feminist commentary throughout, but it comes through layerings, metaphors, the idiosyncrasies of the subtle body. The work refuses to be literal and yet it talks directly to the soul. It can come out of a conversation with oneself or, as in the case of Mary T. Smith, a conversation with God. These artists suffer no mediation.

There is struggle in this work, but it is not a battle with anyone, anything, or any tradition. The work appears to represent the moments after the battle has been won. It is as if it is now up to women to derive the world of the future from the present and to determine what will be its terms. In this new world it would appear there will be no more objectification or repression of the female figure. There will be no terrain not peopled by women, no images which deliberately exclude them. The work will attempt to face those milestones in women's lives—birth, sexuality, death—as well as the need for journey, travel, in the imagination as well as in the world. It will show women as aviators soaring and women marching into eternity. This work records freedom and, as in the case of Nancy Spero's, also does not fail to acknowledge for whom freedom is available, for whom it is witheld, and by whom it is denied.

At the core, the prodigality that is shared by all these women rests in the simple notion that if there are no worlds in which women artists can live and psychically breathe, then they must create them. These new worlds must be beholden to no one, stuck within no one tradition, inhibited by no one form, inhabited by no one demon. If these women can't go home again, if they do not want to go home again, then they will make themselves a home, one to which they can return again and again, one able to contain the full content of the journey—a representation as fierce, complex, analytic, poetic, comic, serious, layered, textured, simple, and joyous as is needed. And if Earth itself or the parameters of the canvas can't hold them, then they will take to the skies—quite literally—fly right into space like Anne Noggle, or leap off the sur-

face as Nancy Spero's courageous figures, light as air, who take to the ceiling when necessary to avoid constraint and clutter. The form they choose must afford these women the conceptual space within which to dream their own dreams, those undreamt dreams—the other half of the collective unconscious—heretofore left unimagined.

Notes

1. Nancy Hale, *The Prodigal Women* (New York: Scribners, 1942).

2. William Blake, from *The Marriage of Heaven and Hell*, in "Proverbs of Hell," *The Portable Blake*, ed. Alfred Kazin (New York: Penguin, 1946), 252.

3. Linda Nochlin, "Lost and Found: Once More the Fallen Woman," in *Women, Art, and Power, and Other Essays* (New York: Harper and Row, 1988), 61.

4. Toni Morrison, *Sula* (New York: Knopf, 1974), 79.

5. Michael Stapleton, *The Illustrated Dictionary of Greek and Roman Mythology* (New York: Peter Bedrick Books, 1986), 42.

6. Rollo May, *Love and Will* (New York: Delta, 1969), 175.

7. *A Sor Juana Anthology*, trans. Alan S. Trueblood (Cambridge: Harvard University Press, 1988), 212.

8. Ibid., 211–212.

9. Gillian Clark, *Women in Late Antiquity: Pagan and Christian Life-Styles* (Oxford: Clarendon Press, 1993), 103.

10. I am thinking here of all of Linda Nochlin's essays, those included in *Women, Art, and Power,* as well as John Berger's *Ways of Seeing,* published in 1973.

11. Archille Bonita Oliva, "Art is a Gynaeceum of Images," in *Nancy Spero Woman Breathing* (Ulmer Museum, 1992), 31.

12. Ibid., 29.

13. Ibid.

14. Leonora Carrington, *The Seventh Horse and Other Tales,* trans. Katherine Talbot and Anthony Kerrigan (New York: E. P. Dutton, 1988), 72.

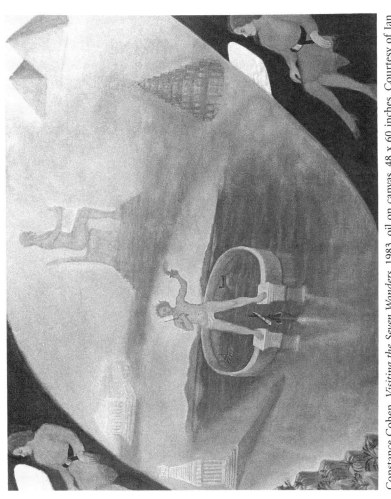

Constance Cohen, *Visiting the Seven Wonders*, 1983, oil on canvas, 48 x 60 inches. Courtesy of Jan Cicero Gallery, Chicago.

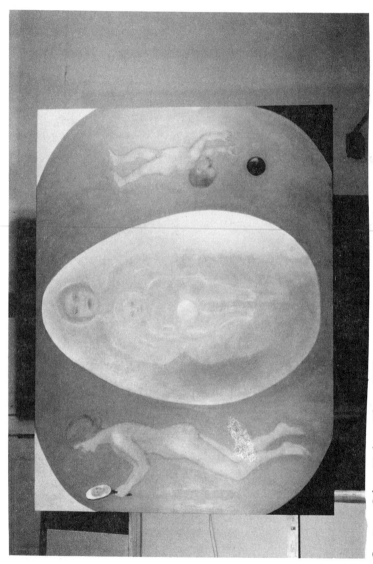

Constance Cohen, *Madonna Theme*, 1982, oil on canvas, 44 x 58 inches. Courtesy of Jan Cicero Gallery, Chicago.

Anne Noggle, *Myself as a Pilot*, 1982, black and white photograph, 16 x 20 inches. Courtesy of the artist.

Anne Noggle, *Stellar by Starlight,* 1982, black and white photograph, 16 x 20 inches. Courtesy of the artist.

Judith Raphael, *The Gift*, 1995, oil on linen, 78 x 60 inches. Courtesy of the artist.

Judith Raphael, *The Children's Hour*, 1994, oil on linen, 40 x 60 inches. Courtesy of the artist.

Nancy Spero, detail *Marlene & the Dildo Dancer*, 1990, handprinting and printed collage on paper, 19.5 x 112 inches. Courtesy of the artist, photo by David Reynolds.

Nancy Spero, detail *Vietnamese Woman*, 1985, handprinting and printed collage on paper, 20 inches x 14 feet. Courtesy of the artist, photo by David Reynolds.

Nancy Spero, detail *Sheela and Dancing Figures*, diptych, 1986, handprinting and printed collage on paper, 42 inches x 9 feet Courtesy of the artist, photo by David Reynolds.

GENDER AND CREATIVITY

CHAPTER 14 ❧

Women, Anxiety, Creativity

In *A Room of One's Own* Virginia Woolf speculates that had Shakespeare had a sister with equal creative gifts, desire for adventure, and passion and talent for words, and had this sister hoped to pursue a career as an actor and later as a playwright, she, like any other woman of ambition "born with a gift in the sixteenth century would certainly have gone crazed, shot herself, or ended her days in some lonely cottage outside the village, half witch, half wizard, feared and mocked at."[1] Such has been the fate of many talented and creative women through the centuries.

Although there is no doubt that structural, economic, and external cultural pressures still make it difficult and at times impossible for women to succeed at the level they might desire, nonetheless, it is true that women are in a much more advantageous position to pursue their chosen professions than ever before. It is no longer completely impossible for determined women to develop creative and productive careers. But as women push against external limitations that attempt to contain and control them, they continue to confront internal conflicts that also hold them back. Because women have internalized centuries of oppression, their attempts to live unorthodox lives, which they are most often not emotionally prepared for nor given permission to enjoy, have created emotional conflict and moral dilemmas that have often manifested themselves as anxiety. Even in this post-women's-movement stage of evolution, it is still true that the more radical the life choice women make—i.e., the more centered on their own development—the more likely they are to suffer anxiety.

Anxiety is a powerful and elusive emotion. It can be a progressive force, signaling danger and motivating self-protection, or it can be debilitating, a force that wracks and ruins lives. Anxiety is an anticipa-

tion of the unknown, an emotion as old as the species itself that signifies imminent, although unnamed, danger. It is thought that early humans feared lightning, thunder, the vagaries of the natural world—those forces they could not control—and experienced anxiety as a result of the precariousness of their existence. Anxiety, like fear, is a necessary emotion; it accelerates the blood, alerts the body, and prepares the organism for flight or fight.[2] Too little anxiety could leave the organism unprotected. However, unlike fear, the source of anxiety is often unknown or not understood. Anxiety is a symptomatic response to conflict. The memory of past anxieties rests in the collective psyche and can easily be triggered by events in the present that touch this archaic emotion. But the source of anxiety needn't only be that which resides in the catacombs of the unconscious; it can also be historical, as subject to evolution as the development of the individual and the species.

As humans have evolved and as civilization has progressed, a new type of anxiety has arisen. Added to the anxiety that accompanies anticipated assaults to our physical well being, referred to as objective anxiety, there are threats that trigger what we might call subjective or psychological anxiety—the result of situations perceived as dangerous to an individual's psyche. The physiological symptoms accompanying such subjective anxiety are the same as those accompanying physical threats, but the source of the conflict is psychological, motivated by guilt, fear of abandonment, fear of inadequacy, fear of success, and fear of failure. Here the threat is not one of physical annihilation but of the ego's possible psychical annihilation. Not receiving a desired promotion, not being asked to participate in a show, receiving a negative review, as well as the anticipated loss, or actual loss, of a loved one can all trigger fear of ego annihilation. A sense of failure—or even of success—can cause a person to hyperventilate, awaken at 4:00 A.M. in a sweat, suffer pains in the chest or constriction in the throat. The actual source of the problem may have little to do with life and death, but it may *feel* as if one could die.

Such extreme responses can result when people are put in situations that force them to counter a set of moral precepts that they regard as essential to their identity. Because women tend to value their interrelatedness to others most dearly and because they often see themselves responsible for maintaining connections to others through selflessness and caring, situations that present their *own* needs and desires as foremost can cause a conflict of moral anxiety.

Because woman's ego is thought to be "permeable"[3] in Chodorow's sense—fluid, existing in relationship to others—if women feel they have fallen from the internalized ideal of selflessness, they then anticipate the loss of love of those closest. This anticipation may cause abandonment anxiety, as women fear the loss of love of their mates, children, extended family, friends, peers, community, and coworkers. Many women also fear the loss of love of the universe, frightened that their actions might cause them to fall out of the protective sphere, the order of things, the place guaranteed to them if they adhere to a prescribed standard of goodness and denied if they deviate too much from this expectation.

In one clear example of this abandonment anxiety, Anais Nin tells the story of a dream she had the night before the first volume of her much-awaited *Diaries* appeared in print.[4] It had been a difficult decision for her to agree to publish these journals, which were the record of all her emotional attachments, opinions, the history of her family, her friends, the documentation of herself in the process of becoming an artist—perhaps the most comprehensive chronology of that process on record. Nin feared that her own selfishness and ambition might be the motivating force behind publishing these chronicles, using those she loved, and did not love, to further her own notoriety. She expected she might be punished for this. In her dream she opened the outside door to her home on the morning that the books were to appear in the stores and was struck down by a bolt of "mortal radiation." Killed on the spot. Annihilated by the universe's judgment that she had gone too far and that she must be punished *to the death*.

Even worse than the fear of the loss of love of the universe is the fear of the loss of love of the self. This can occur when the superego turns against the ego and throws a person into guilt or a deep sense of self-hatred. The strength of the ego determines the degree to which a person can withstand emotional conflict from within and from without.

The ego is the limiter, the outer definition of the self. Because women are trained to think of others, to put the needs of others before their own, it is very difficult for women to maintain the boundaries necessary to protect their ego from their superego—that part of the self that accuses the self of not living up to some obligation deemed essential.

This culture does not encourage women to develop an autonomous ego, so it often becomes difficult for women to withstand the bouts of anxiety that accompany acts of assertion like expressing anger, asking for what one needs, taking the necessary time, space, and energy for

one's own development, or pushing one's work to capacity—no matter what it takes.

Often woman's ego has been devalued by the culture, by the family, and by the mother—the female role model who could not sufficiently value her own identity or that of her daughter. The result is that many women tend to underestimate miserably their own talents, skills, or potential.

It is precisely women's continued willingness to keep themselves behind the scenes and out of the limelight that has made women such good muses for men, such exemplars of generosity, intelligence, elegance, so that they have become the subject of men's creative endeavors as well as the object. What has been rare, and because rare also problematic, has been when women have chosen to assert their independence and vision, to become artists in their own right. It is then that the natural link between creativity and anxiety becomes especially apparent.

Anxiety itself embodies a creative component. Since anxiety is an anticipation of the unknown, a person must imagine that which has not as yet occurred in order to generate anxiety. And one must imagine that which has not yet occurred in order to *feel* anxious. Once the free-floating anxiety attaches itself to an image, the creative act of developing that which does not yet exist has begun. The creative act, focused as it is on the unknown, dependent as it is on the confidence to allow that which does not yet exist to manifest itself, generates anxiety. Anxiety can be a creative force helping a person to act, but if there is too much anxiety connected with the creative process, anxiety can block and immobilize production.

To be creative one needs to feel the confidence to recreate the world from scratch,[5] to defy order, to break the conventional apart, to analyze and be critical of existing forms, to assert the unconscious over the conscious, to insist on the integration of both. One must make concrete objects into theories of abstract thought and transform abstract thought into the concrete. One must have the confidence to create a personal odyssey and to make one's person the center and subject of the narrative. This assertion of one's judgment, one's own sense of the world, and the aggressiveness with which one must pursue one's own interpretation of reality is particularly difficult for women, most of whom have been trained to interpret and mediate experience *through* and *for* others. Women's fulfillment is supposed to result from the bearing and raising of children, the task traditionally understood as women's true creative endeavor. It is also traditionally their job to

socialize the next generation into their prescribed roles. Such work, whose reality has been rooted in the physical, has often relegated women's wisdom and capacity for abstract understanding to the domestic arena.

Women have only recently had the freedom to admit that they are not satisfied transmitting their knowledge, power, and vision through others. The great work they are capable of may be more abstract, less one-to-one, more about carving a place for themselves in history and becoming its subject than about focusing on the direct needs of others, all of the time.

When the famous analyst and writer Otto Rank asked Anais Nin what she wanted to accomplish in her life, she said she wanted to be the wife of a great artist. It did not occur to her that she herself might become a great artist. There are aspects of the creative process for which women have little preparation. The concentrated focus on ideas, the structuring of reality around one's work have often become overwhelming for women who fear the all-or-nothing approach. Many women cannot imagine how they could give themselves over to their work without excluding all else in life that they treasure. As a result they have often chosen not to be artists, or when they have made that choice they have tried to misrepresent the practical and emotional demands of such a life. The result is that they have tended to put themselves in impossible binds and circumstances and then wondered why they could not concentrate, why they failed.

Picasso said, "Every act of creation is first of all an act of destruction."[6] One must be willing to slander, attack, ignore, annihilate, absorb, move beyond all that has come before in order to create. But this willingness to destroy has never come easily to women. Anais Nin wrote, "in order to create without destroying I nearly destroyed myself."[7] One might say that in order to create without intruding on others, without annihilating the old and obsolete systems, women have hurt themselves. They have tried to be radical, progressive in their thinking, without wanting to shake up the people close to them by too dramatically altering their reality—that which they had become accustomed to, that which provided their security.

Men often envision the creative act aggressively. They see themselves slaying or transcending the father, confident in the importance of their work, which they believe can move beyond those great artists, writers, teachers, and thinkers who came before and to whom they owe a great deal of their own development. Most women have a more difficult time

smashing the past. They often cannot imagine themselves as the father, and they know that to assume the role of the mother—their "rightful" inheritance—can only disempower them in the world's terms. And when women *do* find adequate female models for what they might become, they are often unwilling or unable to move beyond these intellectual and spiritual mentors, to transcend them and come into their own.

In her biography of Simone de Beauvoir, Carole Ascher admits that at some point during her study of the great philosopher she understood that in order to continue her own development she would have to break her ties with de Beauvoir and admit that her teacher was limited, that she did not understand the importance of the unconscious, and that this lack of intellectual recognition had held her back. Ascher had moved beyond de Beauvoir, but this progress in her own development also caused a moral dilemma. She did not want to leave de Beauvoir behind.

Women often want to take all other women past and present along with them every step of the way, a tendency linked to women's inclination to think about their lives in direct relationship to others. They value "interdependence," as those at Harvard's Stone Center have so intelligently articulated. Most women want to live *integrated* lives, lives that do not exclude such considerations as the needs and feelings of those with whom one is in close relationship.

Women want success. They want their work to be "out there." They want the privileges that accompany recognition—the mobility, the financial stability, the possibilities, the confidence of feeling needed—but they often do not want these benefits at the expense of those around them or their domestic and emotional lives. They want integration and a healthier, more radical notion of fulfillment than those expressed by the romantic myths created by male artists, who often tormented those who loved them.

We have heard the stories of the poet Rilke, who refused to live with his children and his wife, the sculptor Clara Westhoff, because he felt that such domesticity interfered with his work. Rilke did not attend his daughter's wedding, nor would he agree to meet her fiancé. He simply did not want to be disturbed. Kafka ended his relationship with his fiancée Regine Olson because he feared marriage might obliterate his melancholy, which he regarded as the inspiration for his work. There was little interest in how these actions affected those close to these artists; their only concern was for their work.

Anais Nin writes, "There is conflict between my feminine self who wants to live in harmony with men and the creator in me capable of cre-

ating a world of my own which I can't find anyone to share."[8] Women fear that their attempts to create their own creative worlds, in which they can be as powerful as they can imagine themselves being, may very well mean that they will live a life split between their work and their daily existence as women, or it may mean that they will be alone, having become too strong, too assertive to live within the parameters set by tradition.

Related to women's need to integrate their work with their life is an even more subtle and complex problem. Women often cannot simply make assertions or sustain a vision in their own work that they are unable to achieve in their lived lives. Men have been able to know, understand, be sensitive to many things in their work that they did not or could not live. But women often must work through these issues in their own lives *before* they feel the authority to present them in a creative form. Their work is a vehicle through which they become integrated. Hence the process is slow. The finished product is hard to come by. There is often less arrogance, more self-consciousness, and at times an inhibiting diffidence as women learn how to make their vision apparent.

Although women's creative process can be very different from that of men's, women still tend to measure themselves against the standards of form and content set by men. They often suffer what poet Susan Griffin calls "the voice of despair"—an internalized "patriarchal voice," that William Blake refers to as "The Accuser"—a condemning voice that tells them their work is not good enough, strong enough, rational enough, intellectual or innovative enough.

Because for centuries women did not have a strong position within the narrative, because they were the object and not the subject of art, the model and not the creator, the catalyst and not the actor, women do not always know how to create a powerful persona whose gender is female, nor do they know how to paint, sculpt, or photograph a female figure from the point of view of a woman. Rather, women have learned to read between the lines, to superimpose their sense of their own power on mythic images created by men, identifying with male heroes, inserting themselves inside the male mythos, forgetting that it was created for men and most often excludes, or even worse denounces, individuality in women.

For creative people of both sexes, the creative act often churns up unconscious confusion and ambivalence. These feelings can cause a great deal of pain in the artist until he or she works them through, gives them a shape, and moves beyond them. At times artists have become very abusive to others, "acting out"—drinking themselves to oblivion,

drowning their sorrows in multiple love affairs, demanding that the world adjust to their deviance—a modest price, they have felt, for the radical and innovative offerings made through their work. This has all been very difficult for women to participate in. But although women's ego to the world and for their work may be less developed than men's, women are often more emotionally developed than men and can in fact bear more emotional anxiety without projecting it out onto others. The result is that women's work and their personal growth are often more in unison. Women also tend to become more complete people, ultimately more integrated—often more than the world is ready to accept.

Living the creative life, taking oneself seriously as an artist, confronting a blank canvas, raw materials, an empty sheet of paper, is anxiety producing for both men and women. But apart from the psychological barriers that keep women from aggressively positioning themselves at the center, and apart from the cultural prohibitions that make such attempts to succeed twice as difficult as they might be for men, there is a very concrete problem, the repercussions of which have become part of women's shared cultural history.

We know the stories of Frida Kahlo, whose great work came out of her suffering, the result of a terrible bus accident in Mexico when she was a child, and the suffering caused by "the second accident," as she called her marriage to Diego Rivera. We have heard stories of the painter Paula Modersohn Becker, who married Otto Modersohn, also a painter, and died young and unfulfilled, in childbirth. We know that Clara Westhoff, Paula's dear friend, studied with Rodin and might have become a well-known sculptor had her life and work not been eclipsed by her marriage to Rilke. We have learned from these stories of great talent tortured and often lost that there must be a balance achieved or a great price will be paid, extracted in women's misery or even death.

Women artists have always needed and have rarely received protection and permission, both of which are naturally given to men, often by women. Most men have not had to fear that they would be abandoned if they pursued their work. They were expected to pursue their work, but there was someone, always someone, usually a wife, a lover, in Van Gogh's case a brother, willing to protect and encourage them to go still further, a person who kept loving them in spite of failure and in spite of success. Very few women artists have had such a protective situation.

Often, too, the safety men have felt has come as a result of the help of a mentor, someone who could assist them as they tried to enter into their chosen profession, a person to open doors for them when they

could not as yet open them for themselves. Unfortunately, when women have had mentors they were most often men and too often there was an implicit or explicit pressure to transform these professional relationships into sexual ones. This has undermined women's sense that they were being helped because of their talent, intelligence, and potential. When women have become romantically involved with such men, their own work has often suffered, and women's unconscious willingness to subserve their own needs for time, space, and energy into those of the men they were with has surfaced. In subtle and not-so-subtle ways, women often have alleviated the anxiety of becoming too big, of going too far by removing themselves from the struggle.

Many women painters, sculptors, photographers, and writers have taken up residence with male artists or decided to share studios with the men they were involved with, only to succumb to the interference—the static—caused by the presence of the Other. Virginia Woolf, one of the few women artists who did have a good living arrangement with her husband, Leonard, if not a good sexual one, wrote that for women to do serious creative work they must have "a room of [their] own"—a room to hide in, parameters to protect them from external interference and from psychic interference. Women must protect themselves from their inability to keep out the input of others, to say no to the needs of others, the fears, wants, and desires of others that inevitably pull them away from themselves. Perhaps Georgia O'Keeffe might never have come so far had she not spent a good deal of her time alone in the Southwest, without Stieglitz. Perhaps Frida Kahlo would have given up painting completely had she not had a studio and a house of her own to separate her psyche from that of the powerful Diego Rivera.

At this moment in history the forces weighing on women, the odds against women's ability to create are tremendous, and yet this is also a time alive with opportunities for women. As a result of the women's movement and the consciousness developed by women collectively, some women have been able to free themselves from a great deal of the pulls that have previously kept them enslaved at an unconscious level. By making the unconscious assumptions of their upbringing conscious, women have freed themselves to think impossible thoughts—to imagine themselves as successful artists, as powerful as men, often more determined than men and at times capable of an even greater vision.

Women are overcoming the anxiety caused by their own underdeveloped ego by fostering the understanding of the collective ego. By seeing themselves as part of a collective movement and development of women's

consciousness, women are changing their sense of morality to include a moral responsibility to themselves to actualize their own potential as creative activators. Women may now still feel the old pulls that have bound them to selflessness, but they often feel an even greater compulsion to create a strong sense of self represented through their work as vision. Women now fear that they may not be able to set up their lives in such a way as to actualize this desire. The conflict that this creates between past and present values may in fact produce anxiety, but it is a healthy and progressive anxiety, an energizing anxiety that at times has become the subject of women's work and which has generated imagery necessary for a new stage in women's work marked by the integration of values.

Women have now also reclaimed a tradition of women artists with whom they live in continuum. They take their strength to juggle the many conflicts in their lives from the list of women that includes painters, visual artists, writers, intellectuals, performers, and choreographers—women who, in spite of all contradictions and in the face of all opposition, managed to sustain a commitment to their own creative work. Women turn to the lives of these women not to find heroines but to find models. And they ask of these exemplary lives how the necessary balance was achieved, how the daily contradictions were resolved within a broad range of cultural and historical settings.

This tradition has served as the muse, providing inspiration. It has served as the collective ego when the individual ego could not, by itself, withstand the responsibility of causing a "rupture in the continuity" of history.[9] It has provided protection from the obliviousness and even hostility of the world, and from the internalized voices of self-recrimination that have held women back, tormenting them with debilitating anxiety. It has also provided *permission* to transform these voices into voices of affirmation. This tradition, and the sense of community past and present that it offers, has given women the courage to counter the fear of isolation and of the loss of love so often at the root of anxiety.

Notes

1. Virginia Woolf, *A Room of One's Own* (New York: Harcourt Brace, 1929), 51.

2. These concepts can be attributed to Rollo May, whose *The Meaning of Anxiety* (New York: Simon and Schuster, 1979) is still the definitive, comprehensive work on anxiety.

3. Nancy Chodorow's *The Reproduction of Mothering: Psychoanalysis and the Sociology of Gender* (Los Angeles: University of California Press, 1978) was the original text to articulate this notion, which later became more popularly understood through Carol Gilligan's *In a Different Voice.*

4. Anais Nin, *The Diaries of Anais Nin* (New York: Avon, 1973).

5. This is a variation on a quote taken from an essay by Michele Murray, "Creating Oneself from Scratch," in Janet Sternburg, *The Writer on Her Work* (New York: Norton, 1980).

6. Taken from Rollo May, *The Courage to Create* (New York: Simon and Schuster, 1979), 63.

7. Anais Nin, *The Diary of Anais Nin, Volume I* (New York: Avon, 1966).

8. Ibid.

9. A phrase borrowed from Althusser.

Male Anxiety and
the Fear of Female Authority

To the memory of Dorothy Dinnerstein

The women who launched the contemporary women's movement anticipated that patriarchal institutions would oppose the redistribution of power they were proposing. They were naive, however, in assuming that when they earned the degrees, made the necessary sacrifices, and became twice as good as men in their chosen fields of study, they would then achieve their rightful positions of authority and earn professional respect commensurate to their level of expertise and accomplishment. These women did not foresee that securing such positions would be only the beginning of a long and very arduous struggle.

Women would now have to deal with their own ambivalence about making it within a system they had already criticized as patriarchal and oppressive, and they would also have to confront their male coworkers' ambivalence toward "high-achieving" women. As women seriously challenge men's determination to dominate the workplace, they also upset men's emotional equilibrium. And as many women become more competent, successful, and self-assured outside the domestic sphere, they also become more frightening to men, many of whom react with anger and an unconscious desire to squelch women's newfound power. The source of this male psychological ambivalence toward female authority, and its effects on women's daily lives in the workplace, is the subject of this chapter.

The Problem

There always have been, and continue to be, women who have managed to reach top-level positions of authority. These women have often been so stunningly brilliant and accomplished that their abilities exceeded those of most of the men around them to such an extent that they were beyond competition. When confronted by the superiority of these women, men have often stepped aside and let them rise to the appropriate level. Other women have had no problem entering the male arena as long as they have been willing to accept back-up positions as secretaries or assistants to the men in charge.

But for the most part women in positions of power, whether as equals, or worse, as superiors, elicit in men an extreme and fearful response that causes them to try to hold women back, to exclude them, to contain them. Because many men are threatened by women's entrance into a world they have dominated for centuries—an arena that has been defined as adult *because* it has excluded women at the top— they either aggressively attempt to keep women out or passively ignore them to diminish their potency.

A great deal has already been said about the use of sexual harassment, affectionate names, aggressive sexual advances, and direct insults to women's competence, intelligence, and fitness for the job—methods that men employ overtly to keep women in unequal positions and constantly remind them of their inappropriateness as power holders within patriarchal institutions. Most women who have achieved any professional success can recount such stories. But women are particularly stunned and embarrassed when men continue their inappropriate remarks even after women have clearly earned important positions that deserve respect. In one example, when the University of Wisconsin hired Donna Shalala (now Secretary of the Department of Health and Human Services) as their new chancellor, this impressive woman, formerly the president of Hunter College, explored the campus in order to orient herself to her new environment. She encountered a building custodian and introduced herself as the new chancellor, to which the custodian responded, "Yeah, I heard they hired a girl."

Stories like this are almost funny to us, and the inappropriateness of such comments is something to marvel at. It is likely that Shalala was unaffected by the custodian's remark; his attitude, after all, could not weaken her position. But there are many situations where such com-

ments can be truly damaging to a woman's strength within the institution and to her self-esteem.

Women continue to be amazed by the degree to which men undermine their administrative authority even after they have proven themselves to be very competent at their jobs and even when they have repeatedly challenged men to change their behavior. No matter how much power a woman may have, it is often difficult for her to have an impact beyond a peripheral one on the organization, corporation, or institution with which she is affiliated. There are various ways in which men routinely exclude women from the decision-making process, even when women have reached top-level positions. For example:

- Men ignore women. When women make strong, important points, substantial corrections, insightful analyses, or useful evaluations of the topic on the floor of a meeting, the men in the room can often act as if nothing has been said. They offer no response. Only after a man in the room makes the same point, appropriating it completely as his own, is it heard and taken into account. A male friend told me that when he is in agreement with an idea presented by a woman colleague in a business meeting, he jumps in immediately to restate it in the hope of saving it from oblivion.

- Even when women hold important positions men often circumvent them, making decisions without consulting them—which is particularly frustrating when it is their area of expertise and authority that is being decided upon. To cite just one example, a woman writer and editor working for a large publishing firm proposed an idea for a map that people could refer to when standing on top of the Sears Tower and looking out at Chicago. The idea was well received, she wrote the copy, she consulted with a designer to perfect the images, and she sent it off to the printer. But when the proofs returned for final approval they went straight to the male vice-president, who never bothered to bring them back to the writer. She did not see the map again until it had already been printed—with many errors the vice-president had not taken the time to catch.

- Men tend to meet each other outside the office—to drink, play tennis, have dinner—ostensibly to socialize but also to talk shop. They do a good deal of important deliberating and deci-

sion making in this unofficial arena, one from which women often are excluded, either deliberately when they are not asked to join their male coworkers or inadvertently because they are not interested in these activities or because many women need to attend to demanding family responsibilities and are not free in the evenings or on weekends.

- Men often invalidate women's opinions by attributing them to emotional responses rather than rational considerations. More than once my male colleagues have dismissed my opinion, insisting that I voted for a particular candidate because I "liked" him or her and not because of the person's qualifications. I have also been told that I favored a male candidate because he was "cute" and that I was predisposed to another because he was "a pussycat," a "pushover" who would not be difficult to control and therefore easy to work with.

- When women try to make a valid point critical of the work or attitude of a male colleague, the man being criticized often shifts the terms of the conversation. Either he becomes seductive in his behavior or he tries to talk with the woman about his personal problems, to engage her sympathy and deflect her criticisms.

Women are susceptible to these dynamics for several reasons:

- They often do not believe they are as good at their work as they actually are. Hence they assume that if they cause any disruptions they could be "found out" to be the charlatans they fear themselves to be and could then lose their jobs.

- They know that their place in most institutions is in fact tenuous and often violates convention. They assume they will meet up with resistance and yet they often personalize this resistance when it occurs.

- They tend to value their interpersonal relationships to a great extent and simply do not want to isolate themselves further by alienating their coworkers.

- They often misread the situations they are in, blaming themselves for their inability to move more effectively and assertively within their workplace. They assume that if they did their job better or if they were smarter and more impressive, then surely they would be appreciated.

What women do not always understand is that it is often precisely *because* they are so good at what they do that they become threatening and are then ignored, put down, or kept down in order to diffuse their power. Whether these actions on the part of men are conscious or not, they have an equally debilitating effect on some women's shaky self-confidence.

The Origin of Conflict

To understand such behavior it is necessary to attempt to locate the source or sources of the psychological anxiety men experience when confronted with female authority. The conflict can be traced to the original ambivalent relationship that we all had with the most powerful female figure in our lives—the mother.

A good deal of work on this subject has been done by Nancy Chodorow, Dorothy Dinnerstein, and others to explain the origin of this deep ambivalence toward the powerful female and to explain how this original ambivalence is transformed into humiliation, abuse, and unequal treatment of women. According to Dinnerstein, this general ambivalence can be attributed to the fact that for generations children have been raised primarily by women. As a result of society's refusal to adjust parenting relationships, women have had to absorb the anger and resentment of most children's early childhood experience as helpless, vulnerable, powerless infants. Both sexes therefore associate the clinginess of babiness with the mother.

At the core of the problem is the intense nature of the connection between the child and the mother. In a society where women are primary caretakers, the bond between mother and child becomes physical and psychic. The mother can look at her child and often know what hurts, whether or not the child is telling the truth, or what the child might do next. The mother's power rests in this often unconscious understanding. But the intensity of this connection, formed by close proximity, can at times be too much. The child, completely at the mercy of the mother, is both delighted with and angered by her. When the child's needs for care are met the mother is adored; when they are not met the mother becomes the object of the child's rage. As Nancy Chodorow writes:

> Women's early mothering then creates specific conscious and unconscious attitudes or expectations in children. Girls and boys expect and

assume women's unique capacities for sacrifice, caring, and mothering, and associate women with their own fears of regression and powerlessness.[1]

The mother is the reminder of the child's vulnerability. In adult life the female is thus able to reawaken the child in the adult—specifically, the child's fear of being taken over—overwhelmed or overpowered by the female. A strong female figure can trigger the memory of this time before differentiation, an early narcissistic stage, when the child's existence was completely dependent on the mother and the child was unable to feel itself separate from the mother. This is at once an ideal and terribly vulnerable stage of development. The ambivalent recollection of this time of helplessness becomes a burden that the mother, and all women, must bear.

Not only is the mother associated with this early dependence, but she is also given the added burden of guiding the child through separation from her. She comes to represent the conflicted remembrance of this separation, which, in Dinnerstein's terms, often awakens her child's ambivalence toward her and unintentionally brings on its rejection of her and of the care she has provided.[2] This is further complicated by the mother's own ambivalence about this separation, since in enforcing such a separation she will inevitably lose some of the child's early adoration and devotion. Because this separation is difficult for the child, it is often accomplished only by a dramatic turning away from the mother in anger and sometimes even with hatred. As psychologist James Hillman writes in *The Dream and the Underworld*, "hatred uses the ego to destroy pain."[3] And the ego uses hatred to destroy pain. To compensate for the hurt and sadness of having to break this vital connection, the child develops scorn for the mother. This is exacerbated in adolescence, when the child must make a more definitive break in order to move into adulthood. At this time the male child often finds the mother's presence oppressive and begins an ambivalence towards her that frequently carries over to all subsequent relationships with women.

As a result of this unwanted break the male becomes fearful of intimacy, of being reengulfed, and then disempowered or rejected. He becomes fundamentally ambivalent toward the female, so that he often has difficulty allowing any woman to be really close to him again. He avoids his own emotions. He runs from women and, when he can, tries to control their influence on his life. This obviously can have disastrous effects on heterosexual relationships. Although some men manage to

escape this syndrome, many do not. They fear commitment, refuse to be responsible to women, and perceive all assertions of will on the part of women as oppressive and demanding restrictions on their autonomy.

Similarly, in their work situations men are often afraid to allow any woman to have authority over them or power equal to their own. They associate women in power with the smothering mother, in contrast to the idealized paternal authority, the father. In this typical socialization scenario, the father, who is often absent, becomes a romantic and idealized figure who is given a disproportionate amount of power in the child's imagination. "Even if the father's work is menial," writes Dinnerstein, "he has the status of a participant in history because he is *above* female authority."[4] He is outside the "maternal aura." In this way the male is aggrandized, while the female is diminished. In our attempts to abandon the world of the nursery—to grow up and to move on—Dinnerstein says we accept, often without question, the external authority of the father, which we perceive as more adult, reasonable, and rational than that of the mother. The arena of the female is defined as that of the home and the intimate circle of the family—the realm we must separate from—while that of the male is defined as the outside world—the world of autonomy and adulthood and the world toward which we must gravitate.

For Dinnerstein, this sets up the blind reverence for paternal authority over maternal authority, a distortion that carries over to adulthood for both males and females. Seeing themselves as a child in relation to a powerful female figure, men often react toward women in the workplace with anger and resentment. To forestall being regressed back to a childhood stage of infantile dependence, they do whatever they can to keep women out of positions of power or unconsciously undermine women's power whenever they can. Every day women suffer from the consequences of this desire to diminish female authority.

Male Bonding

A great deal of what women are up against in the workplace is the result of what we have come to refer to as male bonding. Unlike the healthy need for real friendships among men, male bonding, which so hurts and haunts women, is dependent on an unhealthy need men have to protect themselves and their power by excluding the female. It is an extreme, often phobic reaction to intimacy with women, a response to the dependence of the infant and to the rupture from the mother.

Traditionally, when the male child separates from the mother before adolescence, he must pull away his affection and his dependence on the mother and make a transference to the world of the father in order to become a man. For many boys this is an unnatural and abrupt disruption to their psyches. Once they are initiated into the world of men, they are inhibited in showing emotion, dependency, and insecurity. They must appear to be in complete control. At an emotional level they need to act as if they were free of the need for the female. And at times they must actively humiliate her to show their control of her in their psyches and to gain male approval.

This is a stance, a posture, through which men separate out other "real men" and collude with them to protect each other from the potential female power that so terrifies them. As Sam Shepherd playing Chuck Yaegger in the motion picture *The Right Stuff* says to Barbara Hershey, in the role of his wife, "I'm a fearless man, darlin', but I'm scared to death of you." To truly love a woman could most definitely terrify a "fearless" man like Yaegger. It might make him vulnerable and dependent. He might fear that she, like his mother, might know him well enough to see through him, right to the core, beyond his external bravado to the scared and needy child he hopes to keep hidden. Even though women often hold men's emotional reality in their hands, men still continue to maintain the illusion that they are completely free of women.

It is this shared feared regression to an infantile state of vulnerability and helplessness that can cause men to bond so fiercely against women. What is so damning for women is that male bonding must actively be about keeping women in their own separate place, outside the male arena. A good deal of what goes on in beer halls, locker rooms, and private men's clubs results from this compulsion. In this way men do not have to admit that male bonding might really be about the fear of women and the attraction of men for men. Men have a difficult time being honest with themselves and each other. If they could transcend their own fears they could admit that they are afraid of women and feel safer with men who do not remind them of the helplessness of infancy or of their own vulnerability. Instead many men prefer the company of other men because they allow them to continue to live their lives disjointed, disconnected from these deepest feelings that the presence of women inevitably churns up.

If men could move beyond the posture of adolescent boys who define freedom as liberation from the demands of the mother, they might be able to admit that they have difficulty relating to and exposing

the part of themselves that they have been taught to identify with the mother, that which is empathic, intuitive, caretaking—the aspects of themselves they have been compelled to keep hidden.

Why do adolescent boys and even adult men in groups yell out to women from cars or harass women with aggressive sexual comments on the street? What do they hope to achieve? It is women's disgust, annoyance, and humiliation that they often receive in response, as many women caught in this situation of aggression can confirm. This male behavior is the opposite of seduction. It announces to the world at large that although these men are crammed together in a car or in a booth in a bar, obviously enjoying themselves without women, they are not homosexual; rather, their bonding comes from the fact that they are heterosexual—but heterosexual without women, beyond the dominance of the mother, free to be with men, wildly and rebelliously.

On the other hand, there are certain men who cannot and will not bond with men in such ways. These men understand the nature of male bonding and find it offensive. But some of those men, determined not to bond with other men in ways they experience as hostile to women, are themselves hostile to women in a different way. They want to be with women or a woman as much as possible because in this way they are able to re-create the bond with the mother. But as adult men, within the patriarchal structure, they have the privilege of controlling this maternal figure as they could not control their mother in childhood. Their version of an adult relationship is one in which they are able to hold the mother figure captive, her attention riveted on them and their needs at all times. They become terrifically insecure if the woman they have chosen to bond with in this primal way attempts to assert her independence. Anger results when they fear the loss of control and anticipate the anxiety of separation originally felt in relationship to the mother as primary caretaker.

Maintaining Control

Some men have a great investment in keeping the power of the female in check. They repress that part of themselves that they identify with the mother and that they perceive as weaker, more emotional, less rational. This is the part of themselves they have had to give up in order to have power in the adult world. Such repression is not an easy accomplishment. The repressed elements fight to return and are made uneasy by

reminders from those able to express such feelings. These men project onto women all those qualities that they feel they must keep hidden. As a result they do not understand women, just as they do not understand the underdeveloped parts of themselves.

Men perceive women's "otherness" as a negative quality, something to be afraid of. Thus women's behavior seems irrational and unpredictable to them. In just one example of this, while involved in a national search to find a new president for a major Chicago cultural institution one of the top executives of the corporation told me that he was against hiring a woman for the job, even if a woman with the necessary credentials was found. "Women are unpredictable," he said. "You never know what they are going to do next. They have not come up through the ranks the same way. They cannot be trusted in the same way." Women know that men do not trust them, especially where big money is concerned. Men assume that women will be irresponsible or incompetent. Many never will believe that women can function with the same thoroughness and care to which they aspire.

In another more metaphoric example, recently a group of friends organized a baseball game of mixed teams of men and women. The men invited were well educated, kind, and considerate about issues of sexism. None of the men were jocks, yet when they got on the field something happened that amazed me and all the other women on the teams. The men immediately bonded, throwing the ball around the field to each other, excluding the women, and dividing the teams with comments along the way to indicate that two women might be worth one male player. I myself play a pretty decent first base, but every time the ball was thrown to me almost all the men on my team converged on my base, falling all over each other, trying to "cover" me. It was not concern for my well-being that drew them to me; rather, it was their fear that I might make a mistake. They seemed not to have noticed that I was quite capable of doing a good job on my own.

By the end of the game, the women, all of whom had similar experiences, were furious with the men. And the men could not understand why. After several innings of watching her male teammates look in her direction and yell to each other to "cover the hole," one woman rebelled and walked off the field, indignant. "I quit," she said. "I'm sick of being 'the hole.'" The women baseball players, like women in the workplace, had completed their analysis of male behavior before the men even knew that something was wrong.

When women's abilities are not appreciated, when they are not included in major decisions, when men ignore women's comments, when their opinions are not solicited or valued, women often feel that they are not players. Most women *want* to be on the team. Some women want to be captain, some want to be told where and how to play, but most women who have climbed the corporate or institutional ladder take their jobs seriously and expect to be taken seriously as coworkers and colleagues. But what women often encounter is simply that they are not thought about at all. And this drives them mad.

In thinking about being driven to derangement, I recalled that when I was a child in Brooklyn we played a game called "Salugi." It was a decidedly sadistic game. One child (male or female) would be playing alone with a ball; another child (always male) would come along and grab the ball off a bounce. The first child would chase after the second to retrieve it. Then a third would run over and he (always male) and the second child would throw the stolen ball between them while the first child (trying to get his or her ball back) would leap in the air, hit the others, or do whatever he or she thought might retrieve the lost object and lost esteem. If all else failed he or she would usually be reduced to tears until the ball was finally returned.

This game is reminiscent of many men's treatment of women in the workplace. Women are repeatedly forced to explain to men that they need to be consulted, that they have not been treated with respect, that their rights have been violated. Each time women do this it becomes more and more humiliating. When men finally concede, it is similar to the role of the second child giving the ball back to the first. The pleas to rational behavior have not dented the bully. He only returns the ball because he is tired of the scene he has caused. Bored with the whole thing, he gives in: "OK cry-baby, here's your ball." Even his concession is humiliating to the one whose time, space, and energy have been violated. He never really gives up control.

The Attempt at Invisibility

There is no doubt that women are enraged by the way in which their skills and competence often go unnoticed by men. But there is also a way in which women themselves consciously strive for a high degree of invisibility in the work situation. Like the kid on the block afraid to catch the eye of the bully, women know that calling certain kinds of attention to themselves can only bring them trouble.

Men have to be strategic in their jobs, working through a particular game plan to achieve their goals. But women have to be painstakingly strategic about *all* aspects of themselves—their clothes, their voice, their gestures, and especially their sexuality. A magazine article for executive women advises them to wear opaque stockings in order "not to call attention to their legs." Another tells them not to point while raising an issue in meetings: "Men don't like it. It reminds them of their grade-school teacher and their mother." Women must learn to be effective without threatening men.

The dress-for-success campaign of the 1970s was women's attempt to enter the workplace as invisibly as they could. Women believed that if they were to be accepted as equals by men they would have to diffuse their sexuality and play up an image of containment and restraint that would allow them to be taken seriously as intellectual equals. They therefore tried to neutralize themselves, to wear navy blue, gray, black, and brown, colors that might allow them to pass as male impersonators. They hoped they would, quite literally, blend in.[5]

Men, as we know, do not have to neuter themselves to be successful. Power, achievement, and assertiveness are all associated with male sexuality. And sexual attractiveness can only enhance men's powerfulness. But for women to survive they often must remake themselves, from the bottom up.

Women have had to know how to play it: how to assert themselves enough to be heard, how to impress the men around them enough to be respected, and how to be kind and nurturing enough not to turn men off, yet not sexual in ways that might turn men on. This is a difficult balance to achieve.

At times women have been able to establish good working relationships with men who have helped them and served as their mentors. Often this has been achieved because these women were willing to play the precocious daughter and the older man in a position of power was willing to play the father-teacher. In this way women have gained much-needed support to see them through their initiation into their chosen profession. But many women have said that they could not maintain such relationships because after a certain point the man had tried to sexualize the relationship and the woman's refusal to comply caused an irreconcilable split. Often women have thought that the interest a senior person has shown them was because of their talent; later they often learn that there was a romantic intent, right from the start.

Unable to maintain the limiting role of adored and adoring daughter, unable to remain desexualized or to become the lover, women have had to invent the image of the adult woman who is unthreatening yet powerful, who is not the mother or the lover but who can nonetheless be nurturing—a woman who can work closely and honestly with men without triggering their anger, resentment, or mistrust.

Sometimes women do assert themselves at the workplace, but at great risk. After years of struggling with one of my superiors, confronting him with his patriarchal behavior almost weekly, teaching him, subtly, about his deeply sexist actions, I had to stop pampering him, or stop being the good daughter, and block a proposal that he had initiated without consulting me. I knew that his plan was detrimental to the program of which I was in charge. In order to stop his proposal I had to oppose him publicly, something I had never done before, and point out the weakness of his thinking on the issue. In doing so I worried that I would no longer be regarded as a good team player and that in exposing him I had broken rank. But as hard on myself as I tried to be, I had to admit that it is difficult to be a good team player when you are excluded from the team. It affected me as it did because in standing up to my superior I had finally broken with an old alliance—an unstated pact I had made with my father years before when still a child. He would encourage me, help me, treat me as a son as long as I allowed him ultimate authority, as long as I never went against him publicly. This rule had governed my father-daughter relationship and had carried over into my adult behavior. In this work situation as well, my superior's support for me had always been contingent on my public support and defense of him. In the past I had protected him by keeping his mistakes private. In making them public I had asserted my power without protecting his. I had played it individualistically, like the men around me. I felt he had left me no other option. I had finally stopped being the daughter and forevermore he withdrew his support.

The Need for Male Aggrandizement

As women get closer to achieving men's status in the workplace, conventions break down. For centuries women have appeared to mystify the work that men do, their ability to go out into the world and "make it happen." And men have depended on this mystification to see themselves, as Virginia Woolf says (in *A Room of One's Own*), as twice as large

as they actually are. Women's distorted mirroring of men's greatness has convinced them that they could accomplish difficult tasks, conquer nations, build bridges. Woolf writes:

> Women have served all these centuries as looking glasses possessing the magic and delicious power of reflecting the figure of man at twice its natural size. Without that power probably the earth would still be swamp and jungle. That is why Napoleon and Mussolini both insist so emphatically upon the inferiority of women, for if they were not inferior, they would cease to enlarge. . . . And it serves to explain how restless they are under women's criticism; how impossible it is for women to say to them this book is bad, this picture is feeble, or whatever it may be. . . . For if women begin to tell the truth, the figure in the looking-glass shrinks, his fitness for life is diminished.[6]

In part, men feel betrayed that women, having entered into their arena, have discovered that they can function quite well within it. Women have smashed the illusion that only men can rule the world.

The problem for some women is that men's refusal to allow them their earned place within the institutions they have chosen seems so irrational that women are driven to rages like that of Medea. They cannot understand the sheer arrogance of men's refusal to *see* them, to acknowledge their presence and their rightful place. Women suspect that under all of this men have an even more complex desire—a desire for a world where women are not, a world where all the questions women raise, all the threats women pose would disappear with the women themselves and men could live in harmony together, unthreatened by women's power. It is an ancient fantasy found in most mythologies and in futuristic projections—a world in which men rule and procreate without women, a world in which men need never suffer the loss of the mother or the loss of the mothering part of themselves.

This desire is evident in the French film comedy *Three Men and a Cradle*. A baby is left on the doorstep of an apartment inhabited by three bachelors—an airplane pilot, a graphic designer, and a business executive. The note on the baby's cradle explains that the airplane pilot is the father and the mother, a model, is going to work in New York for three months, during which time she is leaving Marie, the baby, with her father. Because the pilot is away in Brazil or Argentina or some glamorous place, the two other male roommates are forced to take over. They must learn everything about child care—diapers, formula, and so

forth—from scratch. After much frustration and hilarity they do manage to learn the ropes and they soon become experts.

The unassuming pilot returns to his furious roommates and to the responsibility of fatherhood. The pilot-playboy freaks out and takes Marie to his mother in the South of France, but his mother is too busy to become a baby-sitter. The female nurse they try to hire wants to give the baby tranquilizers and almost all of the other women in the film seem to have no sympathy for children at all. And so the bachelors, abandoned by the heartless female world, must find a way to take care of Marie on their own. Of course they all nearly lose their jobs trying to juggle child care and work, even though there are three of them taking the place of one mother.

Many things happen in the course of the film, but most significant is that the child elicits from each a warm vulnerability that they have previously kept hidden from all adult women. The men actually love the baby, but they do not show this to each other until the mother comes to reclaim the child and then they are all obviously reluctant to let her go. At first they return to their old lifestyle of wild abandon and sexual trysts. But soon they begin to feel the emptiness in this. They then become despondent. The real father gets drunk, stuffs pillows in his sweater, and bemoans his inability to reproduce. One of the others is seen weeping; the third doesn't get out of bed and is shown clutching Marie's rubber giraffe to him while he cries in his sleep. They are all delighted when the poor, inexperienced single mother, unable to care for the child alone and also maintain her career, returns to them in tears with Marie in tow. She begs them to keep the baby for a few days while she rests and works to make some money. They of course are delighted to have the child back, although they still try not to show this.

As they prepare the baby's food and happily bounce around arranging her things, the exhausted mother somehow crawls into the baby's crib, where she falls asleep in a fetal position, her thumb in her mouth. The biological mother, safe in the hands of the surrogate male mothers, has regressed back to infancy. She too has become a helpless female child in need of their expert care. The three men are happy. With all the women disempowered, their situation is safe. Even the one arena where women have traditionally had some authority, the nursery, has been usurped. The matriarch is finally in check. A group of men bonded together in a perfectly organized, scientifically coordinated environment has finally gained control. Men no longer need be jealous or afraid of women. Without giving up power in the world, they have become

masters of the domestic sphere. In this film we have men as workers, playboys, and mothers all rolled into one, the power of men finally unlimited. They need no longer repress or contain the mother. They have *become* the mother.

In some ways the message in the film is progressive. Here are men who feel loving toward a baby, enjoy the job of nurturing, and learn to move in a domain from which they have historically excluded themselves. But in a more subtle way it can be seen as a revenge fantasy, a cooptation of the increasing power of women who have managed to become whole, integrated people, capable of moving within the work world quite successfully, capable of maintaining the domestic sphere, being mothers, and maintaining adult sexual relationships, all at the same time.

Historically—and, more specifically, over the past twenty years—women have tried to convince men to relinquish the need for control, to share their power, and to embrace a vision of a world where the polarizations of male and female labor need no longer dominate, a world where both men and women could function as whole, integrated beings in an agreed-upon partnership. But instead of being grateful for this vision many men have rebelled against it, too threatened by the concept of equality.

And although many men have become more involved in child rearing, women are still the primary parents associated with the dependent stages of childhood. As long as this continues to be the case, most male children will develop into adult men who are unable to relinquish their need to control women and keep them outside the adult arena and the making of history.

When this powerful cultural imbalance is finally adjusted there will no longer be such a profound need to humiliate, isolate, ignore, and disempower the female. Perhaps then men will actually help women deconstruct the artificial divisions of labor upon which patriarchal society has been built. These changes will take some time to accomplish.

In the meantime, still locked within the reality principle, women continue to struggle for respect in the workplace. They want to move towards the possibility of no longer juggling realities but *living* many realities fully, at once. And they continue to form strong bonds with other women with whom they analyze their shared situations in order to act more effectively to affect such change. Many women maintain good faith by attempting to educate, transform, and cajole less mature male coworkers into graciously relinquishing or sharing their power.

And they continue to long for, seek out, and appreciate those male coworkers secure enough in themselves to develop good working relationships with women.

Notes

1. Nancy Chodorow, *The Reproduction of Mothering: Psychoanalysis and the Sociology of Gender* (Los Angeles: University of California Press, 1978), 83.

2. See Dorothy Dinnerstein, *The Mermaid and the Minotaur* (New York: Harper and Row, 1976), 28–34.

3. James Hillman, *The Dream and the Underworld* (New York: Harper and Row, 1979), 58.

4. Dinnerstein, 176.

5. As I assemble this collection of essays in 1995, the situation of dress in the workplace has in some ways changed for women. It would now appear that there is a much larger range of possibility. But still women have been told that their "style" is sometimes distasteful to their superiors because it is too "flashy." And while the workplace is under contestation, the fashion swing for fall 1994 was clearly regressive—high, high heels and push-up bras—a return to pre-women's-movement days and the pre-liberated body. These issues are far from being resolved.

6. Virginia Woolf, *A Room of One's Own* (New York: Harcourt Brace, 1929), 35–36.

CHAPTER 16 ❧

Men in Suits

After weeks of being glued to the television, many of us became saturated with the designer presentation of the Gulf War, a war of perfect logos and musical scores. And soon we wondered guiltily how it was possible for the war to continue once our collective attention had waned, and we no longer rushed home to tune it in. Culture critics, myself included, were instantly busy sizing it all up. But what is it that we saw? Each of us probably has an image connected to the war that we will never forget, one we might wish to explore. I have an awfully lonely one, an historic one that involves men in suits.

It is hard to recall this now, but there were those of us hopeful enough to believe that the U.S. actually wanted to negotiate with Iraq before January 15—the date of the ultimatum set by the U.S. for the Iraqis to get out of Kuwait. Therefore, the meeting between Aziz and Baker was a potentially momentous encounter: the last chance to forestall war. And so we had given ourselves over to the media representation of this event—expectantly. Perhaps this is why the final minutes of that meeting—as interpreted by CNN—have implanted themselves so deeply in my visual memory. I remember it like this: at first we saw a long shot of a conference table, men flanking either side, some in dark suits, some in white Arab kaffirs. All men, talking, but we heard no voices. Then in seconds, as if a gong had sounded, the silent conversation ceased, the men stood up and turned toward the door. The newscaster then announced that the meeting had ended and no agreement had been reached. The Iraqis had refused to be bullied by the ultimatum. This last chance for peace had come and gone. In news time a door was immediately flung open, the men exited briskly, joined by more men in suits outside, bodyguards perhaps, and then the unforgettable moment: a line of men's backs—Baker, Aziz, the entourage—marching down the corridor, those

little slits at the bottom of their traditional suit jackets flapping in unison as they walked away. They then vanished instantly, unwilling, unable to overcome difference, to negotiate. At that moment, turning their backs on the world, the decision was reached: these men would lead us to war.

The next five days of coverage confirmed all my fears that men still rule the world. There they were on television, more men in suits, relating to the war like Nintendo, simulated bombs attacking simulated targets—years of video games having created a visual audience for this electronic devastation. Men in uniforms or in camouflage, pointers in hand, jabbed with exuberance at blown-up images of the Middle East. Weathermen in blue suits and red ties positioned proudly in front of high-tech maps of Saudi Arabia and Kuwait motioning to menacing cold fronts, fog banks, and rain clouds destined to overtake the region. All these men in suits and uniforms pleased that their sophisticated machinery was working so well, were happy to present such a sanitized, electronic war. And here *I* was—my class, race, and economic analysis quickly going down the drain—as I returned to pure, unabashed gender politics. Why had we trusted that men could talk to each other? When had they *ever* really been able to talk to each other? Why do some men so love machines, missiles, Scuds, and other devices? Why are we so powerless to stop their lust for technological warfare—and left to rave at an unresponsive television set?

There were few positive images of women in these early days of war coverage: some women commentators, reporters, and experts speaking with knowledge and intelligence; often they too were in suits. But mostly there were women crying—wives, lovers, sisters, mothers, hysterical women, tearful yet invariably stalwart. "I support my president," they would say. "I support my son and my husband. I will wait patiently for their return"—women's stoic response to men at war. And although this time there also were many women on the front, so many that newscasters had to refer to "our men and women in the gulf," the experience of their absence was portrayed in a manner completely different from that of the men. Where were the crying-out-of-control husbands? There must have been some, yet there were no images of their pain. In fact, twice on NPR I heard the same Chicago man interviewed about his wife in the gulf. This man was actually angry about her absence. He appeared to be overwhelmed by a full-time job and two young children to care for—a situation many mothers can well appreciate. But what he invariably focused on, and the reason I was less than sympathetic to his plight,

was that he said his children were having difficulty *remembering* their mother, and in fact he felt his infant daughter had *already* forgotten her. He told us that his daughter only knew her mother as portrayed in a photo. When she saw this image she would say, "mommy," and this meant to him that the rest of the time she was not thinking about her mother, who had become only "an idea."

So while women in the military were risking their lives every day, probably agonizing with loneliness for their children, certain husbands were saying that, because of their absence, these women had become nothing but abstractions for their families. I almost felt that there was something pleasurable in the newscaster's or producer's decision to bring this man back to repeat his sad story. They were communicating to all women who might go to battle that if they did leave, they needn't worry about their children, because their children would soon forget them. When has anyone in modern history interviewed a wife about her husband at the front and heard her say that his children had *forgotten* him? This would probably be thought of as treason.

Such incidents only remind me that women can rarely win. They are too often punished for their attempts to gain more access to the world, often in a passive-aggressive way. It should be remembered that many women who were in the gulf, the women who enlisted or those who joined the reserves, were for the most part working-class women from small towns, and of color, who had few options, who could not afford to get an education or a job in any other way and who needed the money they could earn and the training they could receive. When interviewed, these women appeared dedicated, determined, trying to assert themselves in the most difficult arena of all, that which has always been the exclusive domain of men—war.

I mention these gender dilemmas here because it was difficult to think of anything else at that time. Contradictions women witness every day when engaged in the battle for equality in civilian life, but which remian hidden, were made apparent during that time of rampant, overt sexism. But I do not intend to use these issues to insist that the situation of women is as dismal as it has always been. I am around young feminists each day and I often hear them say, with great certainty, that nothing has changed for women, that it is still as it has always been. Yet even now in my depressed state reflecting on the war I still believe that things *have* changed. When young women studying art and culture sport purple hair, long johns under miniskirts, unlaced combat boots, nose rings and tatoos and tell me nothing has changed, I say, "Look at yourselves."

Could young women have dared to make such an extreme anti-fashion statement in the 50s? Could they have confronted patriarchy as directly as young women now do? But the real questions are: What has changed and what has not, and could such a survey illuminate some aspect of the Gulf War or the generic rage I have come to feel when I see large groups of men in suits?

To pursue this a bit further I must digress to a time twenty years ago—the origins of the women's movement. I was then in graduate school at the University of California, San Diego. We had formed a small group of rather strong women: artists, writers, intellectuals, organizers, one literature graduate student who had been a Black Panther. For a year we had been talking together about the problems facing women when we decided to teach a course on the place of women in society. Our problem was that no one felt prepared to teach it alone. So we decided to do it together. We created a curriculum, divided the topics among ourselves, proposed it to adult education, and had about a month to learn enough to face the women who had registered. As I remember, many of the guest lecturers for that first course were men, because we simply didn't know enough women outside the group able to talk about the issues of women in contemporary society with confidence.

And so there we were, with hardly any texts to turn to (we had not yet discovered Alexandria Kollontai, Emma Goldman, Tillie Olsen, Rebecca Harding Davis, or Zora Neale Hurston). At first we were inventing theory along with practice. We were both students and teachers, just beginning to grasp the complexity of the issues we had engaged. In those days we wrote documents collectively, compiling information about the history of the women's movement in the nineteenth century, sex roles and stereotypes, conflicts around birth control. We wrote everything under the name of the collective; it was the style of the times. (Indeed, it was during this period that the ground-breaking *Our Bodies Ourselves,* a collective effort, was first published by a small publisher; it was only later picked up by one of the large conglomerates after it had already become an underground best-seller.) We had training sessions in which each of us gave a presentation on women's equality while the rest of the group, pretending to be the audience, asked outrageous questions, heckled, and trashed the speaker—a tactic we developed to help train each other to confront adversity. I now realize how much I learned from the rigorous trials we put each other through. And all the while we read. At first all we had was a small anthology by Robin Morgan titled *Sisterhood is Powerful.* There was also Kate Millet's *Sexual Politics,* some

pamphlets by Meredith Tax, some writing by Vivian Gornick, and little else. And so we began to read seminal documents: Marx's *Capital*, Engels's *On the Origin of the Family.*

We worked on the problems of women's liberation all the time. Everything else was background, static, or more fuel for our sense that we were onto something big. Some weeks we ate dinner together six out of seven nights. Too busy to cook, we stopped at the convenience stores on our way to the dinners, where it seemed everyone had brought frozen Sara Lee cheesecakes. (Some meals we had all four kinds but little else.) And along with thousands of other women across the country we relied upon the structure of the consciousness-raising group, where we became each other's confessors and teachers. These collective activities changed our lives. They encouraged us to complete our Ph.D.s, law degrees, medical degrees, to take risks as writers, artists, scientists. There was passion and fire and, most important, a sense of purpose.

We believed that we would become strong, educated, and powerful, and then we would educate the men we knew. And while writing manifestoes and accomplishing these modest goals, we would also educate the men we did not know. We would change them all and, once transformed, they would willingly, gratefully share the world with us. We never wanted it all, just our half, and we were determined to use it— sanely, wisely, creatively. Were we to succeed, we were committed to stopping ecological destruction, war, racism, sexism, abuse of all kinds. As the women who had grown up opposing the war in Vietnam, our purpose had always been to combat social injustice, wherever it occurred. But it wasn't easy to maintain this purity of thought. We fought among ourselves, we had personal conflicts, ideological differences; we got involved with each other's partners. Marriages split up. Friendships ended, while some were built for life.

I realize only now how truly radical we were. We had no models for any of this. When I studied English and American literature as an undergraduate, the only women writers I ever read were Jane Austen and George Eliot. When I went to graduate school as an Americanist doctoral candidate, not once was I assigned a woman writer in any seminar I took. There was not one woman faculty member with whom I could work; I had no mentors at the university who were women and Americanists. I had no living role models for most of my adult life, women from whom I could extract a plan for a life. My one older woman friend-mentor, Dorothy Healey, from whom I learned everything, had been secretary of the Communist party in southern Califor-

nia for decades and had been jailed during the McCarthy era. She was an undeniably extreme role model and the most brilliant and courageous I would ever have.

Also, my generation often chose between career and family. Few could go as far as they wanted and do both, and even fewer had the support that would have allowed them even to *consider* doing both.

This is not to say that it was so hard for women then and it is so much easier now. I don't think it is at all easy now and, in fact, in an emotional way, I think we had much more solidarity and support on a daily basis then than most young women have today. We had an active movement behind everything we tried to do. We made history. But young women today at least know *what* the questions are, right from the start, and that gives them a lead. Where there was once only one book for us all to buy and read together, there are now bookstores filled with women's literature. And there are mountains of theoretical material, waiting to be digested. The lives of women who have made certain choices are there to scrutinize. The young men raised by mothers who worked jobs, raised families alone, and participated in some aspect of the women's movement are more pliable, more accepting, more willing to allow women to be whole people than did men of other generations. Women's sexuality is more openly discussed, written about, shown, made visible. Sexual possibilities exist for women outside of marriage. The recent television series on the 60s presented the statistic that, in 1968, 43 percent of women interviewed admitted that they had had sexual relationships before marriage; in 1990 the figure had jumped to 83 percent. What this means is that women are living with partners, experimenting, trying to decide what their sexuality is, and finding lifestyles that can accommodate it. So, some things most assuredly have changed. But the god-awful Gulf War has forced me to ask: What still has not changed, after we have all worked so hard for so long?

Watch CNN with gender politics in mind. I dare you. Observe the British, Chinese, Greek, and Spanish parliaments, and our own Congress; almost all you will see are men in suits. Women *are* coming into politics—slowly. An African-American woman mayor of Washington, D.C., represents no small feat. But like the issue of race relations in this country, I pray that this progress is not too little, too late to save us and the planet. It already has been too slow to stave off homelessness, the breakdown of the educational system, and the devastation of war.

I am really not naive; I don't believe that women in power will of necessity be progressive. The 80s showed us that women were capable

of moving into corporate yuppie America with the same gusto and obliviousness to those outside their own monied class as were men. When women internalize corporate values—the traditional immorality of capitalism—they become part of the problem. It is not the generic *woman* I believe in; rather, it is in serious feminist thinking that I put my trust. I believe in *feminism*: as an intellectual tool, as a vehicle for questioning society, and as a way of operating in the world. Rigorous feminism can be a moral-philosophical stance demanding an equality of opportunity that cuts across race, class, ethnicity, and gender. Once women demand their own equality—from issues relating to pay to those of equal sexual satisfaction—the underpinnings of patriarchy can no longer remain hidden.

Feminism as a method of analysis forces women to ask, How free are all individuals in this society to determine their destiny? I think this is why, traditionally, so many women have been against war. They understand how the rages, obsessions, hatreds of few determine the fate of many. I don't care what women say when the television camera is on them; when women are alone, imagining the loss of their husbands or their nineteen-, twenty-, or twenty-one-year-old sons to war, they cannot in their hearts accept the "necessity" for war. And now, as women themselves go to the front lines, not only will men have to find a way to justify the loss of their sons, they also will have to justify the loss of their daughters, wives, lovers, friends, and the mothers of their children. The stakes have simply doubled, and one would hope that the idea behind the war will have to matter that much more, be that much clearer, that much more justified. And because this particular war does not make that kind of sense, we are seeing a new type of anti-war protest, one that started up immediately, one that says, "We support our men and women at the front, but we do not support the philosophical-political policy that has brought us to this point." Such a strategic approach is the result of lessons learned from Vietnam and from the women's movement: how not to alienate the very people you hope to win over; how to put the blame where it belongs.

As a result of the Gulf War, we learned that the types of familial splits that had occurred between fathers and sons over Vietnam could now occur between fathers and daughters. Women can't put on the same uniform as men and inconspicuously become part of the machinery. During the Gulf War Stephanie Atkinson appeared on "Nightline." On one-half of a split screen viewers saw Stephanie, a college student at Southern Illinois University, a reservist, who had refused to go to the gulf. On the other

side of the screen was her father. They had not had this conversation about her decision in private, and so, in a very American way, they were having it for the first time on national television, moderated by Ted Koppel. Stephanie talked about why she did not believe in this war. Her father, "the son of a Marine Corps daddy," had hoped she would be gung-ho enough to go to the Middle East "to help take this man out," a reference to Saddam Hussein. It was painful to watch as Stephanie bit her lip to hold back the tears, resolved, but obviously upset to be at such odds with her father, whose rage was projected across America.

One would hope that, even among women soldiers who *did* go to the front, their ways of working together, their goals would be more humanitarian, more egalitarian. Many women have been profoundly changed by this experience, as were soldiers returning from Vietnam. Certainly the presence of women challenges the mythic vitality and aura of war. Perhaps now war itself will become less attractive, less alluring, because it will no longer exclude women—the mother, the lover, the sister, the female in the male or the male in the female. It will no longer sanction a pure, primitive version of gender roles, once comforting to those who longed for an archaic, prefeminist past. Perhaps the infiltration of women will decathect this unconscious desire to regress to a time before law and order, a time when men still ruled the world with a club and killing was not yet taboo. Perhaps the presence of women, the deaths of women, and the collective analysis offered by women will force society to bring the unconscious thinking about war into the twentieth century and in so doing eliminate the desired regression to bestiality that war always represents—no matter how sanitized and slick its oxymoronic media representation.

When times are rough, as I believe they now are, when human life and its accomplishments are lost by the minute, I return to a fundamental question upon which the women's movement was founded: Why? In those early days we asked: Why are we in Vietnam? Why are blacks treated differently from whites? Why are women deemed less equal than men? Why have we allowed biology to determine destiny? Why are people tracked into often undesired roles of heterosexuality? Why is discrimination permitted in a supposedly free society? The answers to these questions are obviously still unresolved because now we are forced to ask again: Why, after the lessons of Vietnam, did we once again find ourselves involved in a bloody war about which so little is understood? And why, even after women have infiltrated all aspects of modern life, are middle-aged men in suits still determining the fate of the world?

CHAPTER 17 ❖

The Institution as
Dysfunctional Family

Those who have worked within institutional structures have undoubt-edly noticed the parallel between the psychodynamics of institutions and those of traditional nuclear and extended families. The typical institu-tional configuration is all too familiar. At the top a patriarch serves as figurehead and final arbitrator, possessing the bulk of the decision-mak-ing power—the father. Often second in command is a woman who works closely with him as advisor, confidant, mediator, interceptor—the mother. And several other males and females assist him in his leadership and relate to the hierarchy of the institution as they did to their parents, and to their peers as if they were siblings. These, of course, are the children.

Like a dream begging analysis, this configuration is outrageously overdetermined and one could endlessly pursue its resolution from each possible point of view. I focus here on one aspect: that of the woman who threatens to wreck this most conventional of all familial configurations by assuming a position of leadership within the institution, the woman who dares to challenge the father's absolute authority by asserting her own. For such a woman the most difficult aspect of her situation is that of understanding her identity. Her presence unseats ancient laws of dom-ination and provokes some difficult questions. For example, can a woman in a patriarchal society gain real power within an institution where traditionally a male or surrogate father has been at the head? Should she even attempt to become the father—simulate his manner of rule, his demeanor, his gestures, his confidence? *Could* she ever become the father? If she is unable to become the father but refuses the role of mother, what identity is left for her? Although we can easily imagine such a struggle resulting in pain, how might it ever lead to pleasure?

In the early days of the recent women's movement, women often denied their desire for power and authority. They feared that if they were to become successful they would get caught up, as men have often done, in a crass assertion of ego. They feared that they would become obsessed with power and, out of an inability to control this obsession, would abuse their authority and use it against others. They were concerned that power would separate them from others, especially from other women. They also worried that they would have to split themselves into two distinct selves: a professional, cold, and heartless self, and a personal or private, vulnerable self. Because there was such a stigma attached to these polarizations, it never occurred to most women to admit that they might take pleasure in authority.

There will always be those who say that women can never truly have power; that because society is fundamentally patriarchal, those women who have worked their way into positions of authority are rendered somewhat impotent by their isolation in a male-dominated world. Or one could argue that the small sphere of influence women may claim in the workplace barely rivals the control that society exercises over most aspects of their lives. Nonetheless, now, more than twenty years after the onset of the women's movement, some of the same women who feared the possibility of power are actually in powerful positions. They have achieved recognition; they make decisions about how to shape programs, departments, schools, curricula, galleries, museums, funding policies; they write and publish their writing; they paint, make installations, do performances, and show their work. Their questions and gutsiness set trends, up the ante, initiate new discourse, have an impact. But the more hidden issues of power remain complex.

If one digs deeply enough to discern the relationship between the institution, the nuclear family, and the distribution of power, it becomes clear that the issue of adultness, how men and women grow up (or don't grow up) within this society, is at the core. One of the strongest culturally agreed upon mythopoeic dramas that has been handed down within the Western tradition to explain the designation of sex roles is Freud's version of "the myth of the primal horde." An interesting metaphoric fable, it conveys how Western society imagines the development of adult authority. It is particularly revelatory in relation to the position of women in Western societies.

In Freud's tale there is an original family structured as a patriarchal institution, with mother, sons, and daughters all living under the reign of a tyrannical father. One day the sons decide to rebel against the

father's repressive authority, and in so doing, to liberate their own suppressed sexuality. In their attempt to usurp an identity, they kill the father and take the mother and sisters as concubines. Now, as the collective head of the family, the sons begin to experience the body of the dead father as an object of taboo, or as Freud offers in *Totem and Taboo*, they experience "holy dred."[1] Attempting to rid themselves of the memory, but also to ingest the power embodied in the father, they cook him up and serve him to each other in a sacrificial feast. But once they have devoured him, they are overcome with guilt and anxiety. Their first act as makers of the law is to set up rules and prohibitions that are designed to protect themselves, so that what happened to the father will never happen to them—hence the taboos against patricide, regicide, incest, and murder. The sons have now become the father; the boys have now become men. They have laid down the law, and as men they must rule. They have abolished one authority in order to set themselves up as a new authority.

The obvious question that Freud's fabrication raises is, what was the women's role in all of this? What did the mother think about and what might she have said? Did she go willingly to mate with her own offspring? Did she passively allow her sons to rape her daughters? Were the mother and daughters all so glad to be rid of the domineering patriarch that they did not resist the rebellious sons? Or did the women plot to kill the men in their sleep and take all the power? Was the absented father—for the women, as for the sons—the source of fear and trembling associated with God? Was this drama (for the women, as for the sons) the origin of guilt and remorse? Freud has no obvious answers to these questions, in part because it never seems to have occurred to him to give the mother or the daughters an active role, voice, or volition.

If the ramifications of this drama, marking the movement of the son to the role of father and to maturity, are so articulated and unconsciously absorbed within the culture, what does it mean that there is no comparable drama for women? As a culture we tend to equate maturation in men with a seizure of power, accomplishments in the world, conquests, usurpations, mythic heroic journeys from Odysseus on. Women, who maintain the home and the hearth, take care of the men so that they may go out into the world and hunt for deer or make a killing in the stock market. In contrast to men, women in a position of authority in the world have no models, no archetypal psychotypes to draw upon, no map, and few ancestors to emulate. They must invent

themselves, give themselves resonance. Here rests the pain and also, surprisingly, the pleasure.

Some might say that women gain adult authority through childbearing. Yet the mother's power in the outside world is quite limited. And although her power within the domestic arena is often omnipotent, it is so only *until* the father comes home. Indeed, the primary obstacle confronting the woman who tries to test herself in the world is that there is no positive image in the collective conscious and unconscious for a powerful woman—other than that of the mother. This creates an identity pivoted around issues of ambivalence. The mother looms gigantic in the imagination of the child. She is the one with whom the child first falls in love, with whom the child is the most vulnerable and dependent—and thus the focus of the child's greatest adoration and rage. And since she occupies the center of the domestic sphere, she must be left behind if one is ever to pursue work in the world outside.

A woman who rises to the top of an institution is therefore in a difficult situation. Most members of the institution, as players in the psychosocial drama, will position her in the role of mother. However much she resists, they will see her either as the nurturing, supportive figure from whom they will ask unconditional acceptance—the "good mother"—or as the withholding ice queen, the stepmother, or the female sibling who has won the father's favors and has now become, inappropriately, the head of the household—the bad mother. Each option poses its own minefields.

One could say that the role of the father is equally riddled with conflict and contradiction. But what children desire from the father is fundamentally more mature and therefore more easily translatable into the adult world. From him they want approval and admiration. They hope to absorb his potency and expertise. They do not expect his emotional care or concern. They anticipate his rule will be capricious and his personality dominant. They assume they will meet him in the adult world where they also hope to take their place as grown-up and masterful.

After twenty years of feminism we know that certain dynamics will occur when the absolute of male authority is inverted and women adopt a different position in relationship to power. Ontological insecurity is created when the father is no longer in his place on top of the hierarchy. There is a queasy sense that all is not well, not stable. Even when the female is a better manager, when she creates an objectively more secure

environment and is a more vigilant leader, her presence as a power holder still creates mistrust and anxiety.

Another aspect of this discomfort is that women often relate to power in new, and thus disconcerting, ways. For example, women are often more egalitarian managers. They frequently encourage a more collective approach, ruling less with their egos and encouraging others to take more initiative, to assume more control of the institution and their own place within it. In other words, they are willing to share authority as well as recognition. This seriously challenges the traditional infantilizing of the institution, creating the possibility that everyone in the institution might become an adult. The result is that those who cannot cope with this expectation of freedom and accompanying responsibility become nervous and begin to act out against the one whose presence undermines the ancient status quo.

There are many variations to this behavior, which we term, colloquially, "acting out"—externalizing the psychodrama within. For example, old-guard men try to ignore the woman in power or directly undermine her, in the hope that she will disappear and the authority designated to her will be returned to the pool of inevitable male authority from which it has been wrenched. They try to humiliate her, come between her and others when possible. And no matter how carefully she constructs the world around her, or asserts her presence, or completes the tasks she has been given, she never gains their respect—at least not publicly. And if it *is* given to her publicly, it is then withheld privately. Men who are less entrenched, but who are nonetheless rebellious against authority, resent the intrusion of a woman in the sphere where they hope to perpetuate an unmediated testing relationship to the father. Many younger men, those who do not need as strong a relationship to the father or who may have grown up in a single-parent household with the mother at the head, may welcome, support, and make room for her.

As for the women working under a woman's authority, one would be incorrect in assuming that all of them would be grateful for the presence of a powerful woman who can affect the situation of all women. In truth many women within institutions have become quite comfortable in their role as daughter. They want to stay angry at the institution in order to prolong their rage at their original family. They like negotiating with the father for what they need, even if their method of doing so requires them to be seductive or to appease the father's narcissism. An adult woman at the top mediates the daughter's relationship to the father.

For some women it is more comfortable to feel that women simply cannot have power within the institution, which justifies their own inability to wrest power for themselves. If the relationship of women within the institution to their own mothers was problematic, as it most often was, then the woman in authority will bear the brunt of that. She will pay for their jealousy in relationship to the father as well as for the ambivalent desire women also have to receive the love and approval of the mother.

Although within institutions, as within families, many act out on the father as well as on the mother, there is considerably less of the former. The need to preserve decency and adultness in relationship to the father does not exist in relationship to the mother. If there is anger at the father, it is often kept hidden or discussed among the siblings, who take pleasure in collectively criticizing the father behind his back. Because of the ambiguous position of woman as leader and permissive patterns of behavior learned in childhood in relationship to the mother, acting out will be launched directly at the female in command. In the mother-child cathexis there is more possibility for hysteria. From the reports of Latin-American and Asian-American friends with whom I have talked, being a woman of color only increases the willingness of others to act out on you in the most humiliating and undignified ways, testing not only your authority but your authenticity, your credentials, your knowledge, and your sophistication. After an African-American woman, who had worked hard, long, and impressively, was appointed to a prominent position in the health-care field, a white male colleague of twenty years said, "Isn't it great what affirmative action can do?" In one sentence he attempted to take away all her years of struggle.

One might ask, why, given their role of *persona non grata* within the Oedipal drama and within the world, would women want to struggle with these deep-seated prejudices? What do women hope to get out of it all?

In *The Second Sex* Simone de Beauvoir made the convincing argument that to become adult, women need to feel part of history. They need to see themselves reflected in the world coming up against those resistances, both internal and external, that hold them back, and that it is through this externalization—this extension out of subjectivity—that women truly may attain a sense of self. The woman in authority tests herself and is tested, in a very literal sense, hour by hour. She learns to manage the day-to-day complexity of her responsibilities, to master the work that is expected of her, to balance her personal life and her professional career, to develop a public persona as well as the internal strength to resist the judgments and pressures of others. She impacts on society.

To return to Freud's story for a moment, it is hard not to speculate what might have happened if the mother in the Oedipal drama had been given voice. Were the mother able to speak when the rebellious sons threatened the life of the father, she might have warned them that there was no need to be so literal, no need actually to kill the father. She might have spared them and the entire history of Western civilization the guilt and remorse that supposedly followed. Or she might have been the one to offer an analysis of what was going on *as* it was going on—the first female theorist, hypothesizing from the cave—one who could step outside and refuse to participate in the power dynamics precisely because she understood them so well.

I think we must thank Freud for leaving the mother blank, for making her a non-entity—the one who is fought over but who has no defined self. Instead of being stuck forever in the purgatory of repetition, women are more free than men to create their own drama of maturation and to take on what is wonderful and dreadful about such an enactment.

Woman's freedom to invent herself makes her more able to transform the familial structure of the institution precisely because it is not to her advantage to maintain it. Her power rests in her willingness to subvert the institution and, in so doing, to write herself a speaking part. She is threatening precisely because she has nothing to lose. She can see better than most men how the traditional structures infantilize everyone. The father is allowed to assert his aggrandized narcissistic will unchallenged; the children are pitted against each other in sibling rivalries; everyone imposes contradictory needs and expectations on her if she attains power. It is therefore to her advantage to break down the hierarchies, to create new roles that are more egalitarian, to liberate the cathected energy that binds us all to primal rites of passage as manifested in the traditional Western family and its offshoot institutions. Once freed of such oppressive ancient structures, we may all finally find a way to grow up. It is in *this* dream that I find a great deal of pleasure.

Note

1. This is a reference to Sigmund Freud's treatise in *Totem and Taboo: Resemblances Between the Psychic Lives of Savages and Neurotics,* trans. A. A. Brill (New York: Vintage, 1918).

NOTES ON CHAPTERS

1. Art Thrust into the Public Sphere

Written as a lecture originally delivered at the College Art Association annual meeting in New York City, February 1990, this chapter was later published in the College Art Association publication *Art Journal*, Fall 1991, Volume 50, Number 3, 65–68.

2. When Cultures Come Into Contention

Written as an address to the American Association of Art Museum Directors, Chicago, June 1990. The theme of the meeting was "The Social, Cultural, Historical Framework for Change in the American Museum." Later published in *Different Voices* (New York: American Association of Art Museum Directors, 1992), 58–71.

3. Social Responsibility and the Place of the Arist in Society

Prepared for a panel discussion with Suzi Gablik and Vito Acconci at Artemisia Gallery in Chicago, January 1990, this chapter was then published as a pamphlet by Lake View Press. It was later reprinted in *Culture and Democracy*, ed. Andrew Buchwalter (Boulder, Colo.: Westville Press, 1992), 239–249.

4. Herbert Marcuse and the Subversive Potential of Art

This chapter was included in my book, *The Subversive Imagination:Artists, Society, and Social Responsibility* (New York: Routledge, 1994), 113–130. An earlier version was written for Marcuse; *From the Left to the Next Left*, ed. John Bokina and Timothy Lukes (Kansas City: University of Kansas Press, 1994), 170–186.

5. The Education of Artists and the Issue of Audience

Originally published in *Cultural Studies*, ed. Henry A. Giroux and Peter McLaren, Volume 7, Number l, January 1993, 46–57, this chapter was

later published in the book that was formed from that issue titled *Between Borders: Pedagogy and the Politics of Cultural Studies*, ed. Henry A. Giroux and Peter McLaren (New York: Routledge, 1994), 101–112.

6. Private Fantasies Shape Public Events and Public Events Invade and Shape Our Dreams

Written for the anthology *Art in the Public Interest*, ed. Arlene Raven (Ann Arbor, Mich.: UMI Research Press, 1989), 231–252.

7. Reimagining Art Schools

Presented as the keynote address for a faculty retreat at The California College of Arts and Crafts, January 1994, this chapter was later presented to the National Council of Arts Administrators in November 1994.

8. Imaginative Geography

Andries Botha is one of South Africa's foremost sculptors. I first met him in Chicago in 1986 when he came to raise funds for the Community Arts Workshop in Durban. This chapter about his work, written before the end of apartheid, was published in the catalogue that accompanied the show celebrating his Standard Bank Young Artists Award: *Andries Botha: Standard Bank Young Artists Award* (Johannesburg: Standard Bank, 1991), 22–24.

9. Goat Island's *We Got a Date*

This chapter was written for an issue of *TDR: The Drama Review*, Volume 35, Number 4, (T132), Winter 1991, 50–62, that featured the work of artist, educator, Lin Hixson. She is the director of Goat Island, a Chicago-based collaborative performance company that formed in 1986. I first became interested in their work when I saw an early piece, "Soldier, Child, Tortured Man," at the Wellington Church in Chicago, November 1986. I have followed them closely since that time, as they have solidified the work and attracted an international audience.

10. From Tantrums to Prayer

Originally published in *TDR: The Drama Review*, Volume 35, Number 4 (T132), Winter 1991, 63–65.

11. Drawing from the Subtle Body

Barbara Rossi is a Chicago-based painter. This chapter was published in the catalogue for her mid-career retrospective at the Renaissance Society at the University of Chicago in 1991: *Barbara Rossi: Selected Works: 1967-1990* (Chicago: The Renaissance Society at the University of Chicago, 1990), 17–27.

12. Lineaments of Desire

Christina Ramberg's work has often been associated with that of the Chicago Imagists. This chapter was written for a catalogue to accompany her mid-career retrospective at the Renaissance Society at the University of Chicago in 1988: *Christina Ramberg: A Retrospective 1968–1988* (Chicago: The Renaissance Society at the University of Chicago, 1988), 17–30. Soon after this exhibition, Christina Ramberg became seriously ill and has since passed away. I am deeply grateful to have had the opportunity to know her, and to discuss her work with her at length in preparation for this essay.

13. The Prodigal Daughter

This chapter was written as a catalogue essay for a show curated and conceptualized by artist Susanna Coffey for the Rockford College Art Gallery, Rockford, Illinois. The show opened on March 24, 1995, and included works by Nancy Spero, Anne Noggle, Leonora Carrington, Audrey Flack, Geraldine McCullough, Judith Raphael, Mary T. Smith, Constance Teander Cohen, and June Leaf.

14. Women, Anxiety, Creativity

First presented at the conference, "Women and the Visual Arts," held at Skidmore College, Saratoga Springs, New York, March 1988.

15. Male Anxiety and the Fear of Female Authority

Read at a conference of the International Society of Political Psychology, San Francisco, May 1987.

16. Men in Suits

Originally given as a talk at Artemisia Gallery in Chicago, this chapter was then published in *Journal of Urban and Cultural Studies*, Volume 2, Number 1, 1991, 93–98, a special issue devoted to the Gulf War entitled "The Pedagogy of Peace and War."

17. The Institution as Dysfunctional Family

This chapter was first presented at a session of the College Art Association's annual meeting held in Chicago, February 1992, which I chaired with writer B. Ruby Rich. The session title was "Women/Power/Pleasure/Pain," and included the two chairs as well as Amina Dickerson and Miriam Shapiro. More than a thousand people, mostly women, gathered to hear our analysis of what power has to do with pleasure and what it might have to do with pain.

INDEX

Page numbers in boldface refer to illustrations.